N
85
.B37

Bassett, Richard.
 The open eye in learning; the role of art in general education. Richard Bassett, editor. Cambridge, Mass., MIT Press [1969]
 vii, 216 p. illus. (part col.) 24 cm.
 "Undertaken as the report of a Special Committee on the Study of Art."
 Bibliography: p. [205]-209.
 1. Art—Study and teaching. 2. Art and society. I. Special Committee on the Study of Art. II. Title.

**The Open Eye
in Learning:**
The Role
of Art
in General
Education

The MIT Press
Massachusetts Institute of Technology
Cambridge, Massachusetts, and London, England

**The Open Eye
in Learning:**
The Role
of Art
in General
Education

Richard Bassett
Editor

Special Committee on the Study of Art

Richard Bassett
Formerly Instructor in Art, Milton Academy
Chairman and Editor

William W. Barber Jr.
Headmaster, St. Mark's School

Gordon Bensley
Instructor in Art, Phillips Academy, Andover

Mrs. Alexander Crane
Formerly Headmistress, Abbot Academy

Oliver H. Larkin
Professor of Art, Emeritus, Smith College

Norman L. Rice
Dean, College of Fine Arts, Carnegie-Mellon University

Theodore R. Sizer
Dean, Harvard Graduate School of Education

John C. E. Taylor
Professor of Art, Trinity College

Foreword

Vision is instantaneous. A thing seen is more vivid than a thing read of. Yet since the printed word began, our formal schooling has been almost entirely a matter of words.

The reasons are obvious. Words are easy to circulate, easy to preserve, easy to accumulate. Civilization has grown by them, and science, which has enabled us to master our environment, is the legitimate offspring of recorded knowledge. But the environment we have mastered leaves a good deal to be desired. In mastering it, we have not looked at it; our verbal education teaches us to see as little of it as possible. If we are aware of it at all, it is from the corner of the eye where painful impressions are easily blurred; but this sidelong awareness is always with us and in the long run exerts a subtle influence over our lives. We may well pause and wonder whether instead of mastering our environment we are not actually wallowing helplessly in it.

A subtly degrading environment is not the worst consequence of neglecting the education of our eyes. When we become uncritical of one aspect of living, we tend to become uncritical of others. We slip easily into a distrust of our ability to change anything. Blindness to environment thus becomes an aspect of conformity. Keen observation, on the other hand, is an instrument of individuality, of direct personal reactions, of an intuition that is quicker than reason. It is no accident that language borrows the metaphors of vision. The words "imagination," "foresight," "scope," and a host of others all bear witness to the fact that a good look at a thing is a condition of understanding it.

In an age that is most criticized for its neglect of personal judgments, it would seem plausible to try training the eyes, and this in fact has been recommended by many leaders of educational thought from Pestalozzi to Dewey. Nothing they have written on the subject, of course, has altered the common practices of education. Their best arguments have not been verbal ones and are therefore difficult to present in places where decisions are made.

vii

The world of commerce, meanwhile, has proved more amenable to visual appeal. Business people have recognized the ease of communicating with their markets through television, movies, and advertising, and these media now play so large a part in shaping the public mind that many a teacher has despaired of competing with them. As Kayo, the kid brother of the immortal Moon Mullins, once pointed out on presenting his report card, it is no longer strictly necessary for a boy to learn to read. It is necessary, however, for a boy who grows up and becomes a salesman for a big company to be wise in such visual matters as streamlining and functional design because businessmen are aware of eye appeal and of a public yearning for order and simplicity. They wish to exploit it.

Education, on the whole has been caught napping in its estimate of public needs. A very large area of contemporary culture lies outside of its purview, and the gap between is widening. In small ways educators are becoming aware of this; visual aids are creeping into the classroom. But it would certainly be reasonable for them, as a next step, to examine the resources of the one item in their curriculum that attempts a systematic training of the eyes—the art course. To look at this item thoroughly and impartially, to estimate its real worth to an individual or to the community, to study its logical place in the school system—these are the objectives of this volume.

Eye training, of course, is mind training, and part of our job will be to determine what areas of the mind are used when the experience of the senses enters into our calculations. However, any attempt to mark out a particular area will force us to explain what we are separating it from, and we are led, inevitably, to a general scrutiny of education in its theoretical as well as its practical aspects.

Richard Bassett
Milton, Massachusetts
January 1968

Acknowledgments

This volume was undertaken as the report of a Special Committee on the Study of Art, appointed by the Executive Committee of the National Association of Independent Schools. Planned originally as a publication of the Association, its scope later became a more general one, and its public appearance was finally assured by The M.I.T. Press, although the Committee in charge remained intact as a sponsoring group.

The help given its editor in preparing the book came from so many sources that it would be impossible to mention them all and perhaps unfair to connect the names of generous friends with a work that they were never permitted to read in its entirety. We do feel able, however, to thank Bartlett H. Hayes of the Addison Gallery at Andover for his patient nurture of ideas among us and for endless help in the detail of making them into a book. We are grateful, too, to Professor Robert Ulich and Professor Robert Iglehart for their careful appraisals of the manuscript and for encouraging us to believe that at least some of our aims were attainable.

Our first debt of all is still to the Executive Committee and the officers of the National Association of Independent Schools for lifting the project off the ground and keeping it alive during a costly period. In this they were generously assisted by Professor Henry L. Seaver, who had somehow acquired a belief in its ultimate success. The book would never have made the trip to the printer, however, without the deft services of many other people, and these include some former colleagues on the Committee, Mary Chase of Wellesley, whose membership was cut short by her tragic death, Wilbur J. Bender, William G. Saltonstall, and Roland B. Greeley.

For the Committee,
Richard Bassett, Chairman

Contents

**The Open Eye
in Learning:**
The Role
of Art
in General
Education

**Art and
the Educated
Citizen**

[1]1

The Dream

and

the Reality

1

Alexis de Tocqueville was one of the first observers of our new society to speculate on the role that the arts would play in a democratic scheme of things. In contrast to older and more aristocratic nations, there would be no rigid dictatorship of taste imposed by a small, sophisticated, and privileged elite. The development of taste would be slow and hesitant, depending on what people wished for rather than what they could be forced to accept. As in other spheres of activity, so in the realm of artistic experience; a far greater equality of opportunity would prevail. Furthermore, with economic progress would come greater leisure for the cultivation of taste and wider opportunities for possessing and patronizing art.

Since de Tocqueville's day, many a critic has pointed out the conflict that has developed between the downward leveling of democratic behavior and the notion of artistic excellence; but the more enlightened of these commentators have recognized that there is no fundamental incompatibility between these two. The goal of a democratic society, after all, is the production of fully developed individuals, each capable of playing a rich and rewarding part in the life of the community. As William Schuman says,[1] "No form of societal organization relies more heavily on the full development of the talents of its citizens than a democracy." Indeed, the historian could point out that the two periods in our past when the arts were most eagerly encouraged, when the importance of art in the national life was most often stressed, and when artists themselves were inspired to portray and interpret that life, were also periods of vigorous democratic aspiration—the age of Jackson and the age of Franklin D. Roosevelt.

The difference between philosophy and practice in the making of our culture has been described by our writers with varying degrees of hope and pessimism. Even the sympathetic de Tocqueville feared a thinning out and lowering of taste that could result from the

pressures of an uninformed majority and prophesied that a "trading spirit" would enter the arts, with unhappy consequences. Jacques Barzun[2] in our day has deplored the fact that only about three out of one hundred Americans actively patronize the arts, but he also finds ground for optimism in the availability of good literature and music in inexpensive forms and in the exposure to the visual arts through reproductions and articles in magazines with wide popular circulation. On the other hand, Louis Kronenberger[3] pronounces the American climate hostile to art, which has no place in the actual shaping of most people's lives, and concludes that we are not an artistic people in any real sense of those words. David Reisman recognizes the gap that has existed between high culture and mass culture but asserts that we are beginning to close that gap: "The taste of the most advanced sections of the population is ever more rapidly diffused to strata formerly excluded from all but the most primitive exercise of taste."[4]

Clearly one's evaluation of progress or decline depends on one's definition of taste. It should not be conceived as a prevailing fad or fashion, nor is it a snobbish attachment to the latest new vagary in art. It is not the mere announcement of one's preference for Rembrandt over Grant Wood by people who cannot sense, feel, or understand what makes the one preferable to the other. Fundamentally, taste is the ability to separate the excellent from the shoddy, the beautifully designed from the cleverly assembled, the eloquent from the noisily assertive, the appropriate from the misplaced, the product of the imagination from that of ingenuity, the experience that enlarges and transforms one's state of mind from the one that offers no challenge to indifference and complacency. And taste begins at home. If the taste of a people is not likely to be better than its wallpapers and shop fronts (Figure 1), a closer way of measuring that taste is simply to observe a people's objects of use and adornment, to study the kind of environment that it creates for itself (Figure 2).

This approach to the problem yields depressing re-

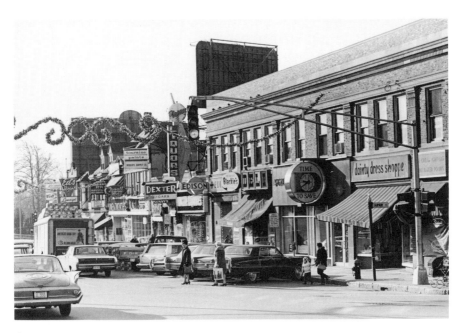

1.
*Under the slogan
of free initiative.*
Photograph by
Bradford Herzog.

2.
*Articles of use and
adornment.* Photo-
graph by Bradford
Herzog.

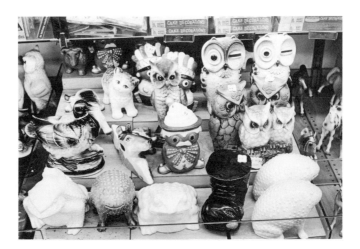

sults. The student of past civilizations knows that they stamped with their high quality not only their buildings, statues, and paintings but even the simple things of daily use—the small carved discs that protected Japanese sword blades, the jugs from which the Greeks poured water and wine, the spoons of the Egyptians. By way of contrast, what can be said for the jerry-built "modernistic" boxes that line our streets, garish in color, awkward in proportion, with ill-placed windows and characterless iron grilles? No people with a developed taste would tolerate our crudely designed fabrics nor the hideous framed landscapes to be found in our dime stores. Our towns and cities are a confused assemblage of streets, and the handsome roadways that connect them are disfigured by ugly signboards, vast smoking dumps, and the graveyards of defunct motorcars. The tall commercial structures of Main Street stand beside vacant lots, some of which once held fine historic buildings that now have been sacrificed, along with the sense of the past they embodied, in the interest of parking. No community with a sense of values would thus destroy forever its own architectural heritage, nor would it raze a line of ancient elms to gain a few feet for the impatient motorist. Our indifference to the living landscape is matched only by our failure to create a man-made one; under the slogan of free initiative we tolerate the bunglers who deform the spaces in which we live and move. Christopher Tunnard is only one of many writers to deplore "public indifference to public beauty," concluding that "if we are to justify modern American civilization before our own growing population and in the eyes of the world, the creation of a more appropriate physical shape for that society is one of the urgent tasks ahead."[5] The ruthless desecration of the American scene has been amply documented with text and picture in Peter Blake's recent book, *God's Own Junkyard.*

[1]2
Obstacles
to Progress

For America's failure to fulfill her cultural promise, many reasons can be found, some of them historical and others contemporary. De Tocqueville noted one

of them when he remarked that our people would habitually prefer the useful to the beautiful, the practical to the aesthetic. The founding fathers were by background and by necessity hard-thinking men who, if they considered the graces of life at all, thought of them as a product of the dim future when man's physical needs had been met. In the meantime the anonymous author of a pamphlet of 1719 sharply defined the New England attitude when he wrote that the plowman who raised grain was more useful to mankind than the painter "who draws only to please the eye." The persistence of this point of view can be documented by the negative response of a congressional committee in the year 1954 to a proposal that public funds be appropriated for the encouragement of the arts; these gentlemen observed that such supporting action "cannot be sustained as an absolute necessity." Thus a false dichotomy continues to exist in men's minds, by which the practice and enjoyment of the arts are placed in a remote and special category of human experience, divorced from what are taken to be the really important concerns of life.

This false distinction leads to another. Since the arts are said to have no essential relation to that part of a man's life which is spent in labor, they tend to become no more than a pleasant antidote to fatigue, an agreeable way of filling the hours of leisure. Their true role of enlightenment and inspiration is ignored.

In this frame of mind, many an American prefers that kind of soporific experience in art which makes no demands on the imagination and requires no significant departure from familiar themes and easily recognized forms. Ours is an increasingly complex world in which man's inventiveness and the vast expansion of sheer knowledge discourage one's effort to understand and to participate in the human adventure. The task of comprehending the work of the creative artist has always been baffling and difficult, and it has become more so in recent years when our most truly original artists have launched a violent challenge to tradition. It is easier for many people to assume, as Robert Oppenheimer says, that only those

things that can be comprehended without effort are really important—hence our tendency in the past and in the present to dismiss or reject those men of talent who have dared to break with artistic forms they consider no longer relevant. The genius of Frank Lloyd Wright was first recognized not here but in Europe; the records of painting in this country abound in careers thwarted or destroyed by lack of support and sympathy; Philistinism reared its ugly head in Los Angeles not long ago when a piece of modern sculpture was placed on one of its public buildings; in New York, pickets marched in front of a museum where the work of abstract sculptors was being shown. One could cite many other instances today in which the work of art has been rejected out of hand and the artist himself despised and insulted as a disturber of the visual peace. "We need a sense of hospitality," Oppenheimer asserts, "an openness, a willingness to make room for the strange, for the thing that does not fit. . . . We need to insist that what is difficult, what is recondite, what is obscure, what is specialized, is a great part of the human treasure."[7]

Partly a result of Philistine intolerance is that rejection of the public by the artist which is an obvious feature of the contemporary scene. One painter recently noted the "stony illiteracy" of most Americans; another disclaims any wish or hope of being intelligible to John Doe; still another blames the crass materialism of our society, its pursuit of the false goals of money, security, and power for the gap that yawns between people and artist. In such a society, he believes, the artist can have no significant place; its false gods are rejected by him, and its values do not lend themselves to celebration in the visual-symbolic language of art. This isolation from the community, however understandable, tends only to confirm the Philistine's stereotype of the artist as an abnormal creature who lives in a mad world of his own. One sadly contrasts this isolation with the close working relation between artist and craftsman on the one hand and his patrons on the other which existed during the Renaissance and in many subsequent times and

places, a mutual responsiveness that was healthy for both, especially in those fields of design that are closest to the life of every day. Between public and designer today stands the entrepreneur with his inevitable tendency to downgrade quality and to discourage originality. Yet there never was a time in history when a normal interplay was more necessary between the man who creates and the man who receives the creation. The vast scale of world problems, the greatly increased threats to human survival, the complexity of life itself in the modern world, all of these are giving to the individual, in the absence of counterreassurance, a shrinking sense of his own importance, a frustrating conviction of his inability to direct and control his destiny. In discussing art as man's eternal challenge to fate, André Malraux reminds us that all fine art, past and present, is a direct affirmation of man's sovereign importance in the scheme of things, a constant assurance that he is no mere cog in a mechanical universe. This silent voice is more urgently needed today than in any past age.

Another discouraging phenomenon of today is the abdication of the critic of art. His earlier function as a writer was a kind of mediation, an effort to bring the observer closer to the work of art, to hint at its meanings or lack of meanings, to present the sensitive responses of the critic himself for whatever they might be worth to the less perceptive. Never before have so many millions of words been written about the arts; yet they fall too often into one of two equally unsatisfactory categories. The highbrow critic writes a language that is as unintelligible as the forms of the work under discussion, producing a verbal parallel to the visual experience. He directs his critique to those art journals that will be read by the "advanced" connoisseur, the man who is in the know. This critic preaches to the converted. The writer of popular articles, on the other hand, serves a far wider and more naïve reading public, presenting art and the problems of the artist in a brisk, picturesque, and oversimplified way. The power of the printed word is enormous, and large numbers of people nowadays

seem to substitute the glibly expressed opinions of the critic for their own tentative ones. They seem to prefer a written description and commentary on a building, a sculpture, or a painting to their own fumbling, firsthand encounter with it. The first of these two critics surrenders an important part of his function; the second cheapens and degrades that function.

We need to remind ourselves, in the midst of this flood of words, that verbal interpretation can only imperfectly convey the essential character of a visual experience, its quality, and its impact on the senses and spirit of the observer. A translation of the reality, however vivid, is not the reality itself. "More and more of us," John Kouwenhoven points out, "experience the arts . . . filtered through some translating device."

What de Tocqueville called the "trading spirit" must be reckoned with in this connection—the obvious fact that in the media of mass entertainment it has become profitable to package art and to vulgarize it, offering it in terms considered appropriately obvious and simple for a public whose intelligence is systematically underestimated by the makers of films, television, and widely read periodicals. Hence the insistent commercials of TV which destroy the continuity of the best dramatic presentations; hence the filmed biographies of artists which convey little or nothing of the quality of their lives and work but make the most of whatever was abnormal or sensational; hence the interminable reproductions of past and present art in magazines of wide circulation, mendaciously described as being faithful to the originals; hence the tempting promise, "You too can paint a Van Gogh," if you purchase a painting kit and a book of instructions. The do-it-yourself motive, itself an admirable one, is here corrupted in order to exploit a dawning interest in art for the profit of the exploiters. Art descends once more to the level of a pleasant therapy or a topic for after-dinner conversation or the leisure-time consumption of ready-made and predigested aesthetic experience.

To our other cultural shortcomings we must add

the failure in this sphere of our educational processes, with their emphasis on what might be called "verbal thinking" and their neglect of "sight-thinking." When we ask ourselves why art is a "not unfeared, half-welcome guest" in our schools, we find several attitudes and practices that work against its acceptance as a basic discipline. Among these is a kind of vocationalism which mistakenly assumes that the man who works is a different creature from the man who plays. Neither work nor play has meaning except for the resourceful individual, the person who has developed not only his powers of analysis, his factual knowledge, and his technical skills but also his imagination, his creative capacities, and his sensitiveness to visual experience. L. P. Jacks has challenged the narrow definition of what constitutes an education by stating that it is a process of lifelong duration, "addressed throughout to the making of whole men, and vocational only in the sense that it prepares man for his grand vocation as a member of society and a citizen of the world. . . . It teaches every man a better way of doing the work he has to do and living the life he has to live."[9] The truly educated man, he asserts, will not need to allow his leisure to be invaded and exploited by others in their own interests, for "leisure is that part of a man's life where the struggle between white angels and black for the possession of his soul goes on with the greatest intensity." And Jacks concludes that the humanities and the arts will never flourish until a closer connection is made between the work of society and its culture.

A pertinent illustration of the snubbing of the arts in our schools is the failure to provide our young people with an indispensable means of knowing the civilizations of the past, which are revealed to us in great measure through their artistic achievements. Thus fifteen million or more young Americans, according to one estimate,[10] are being deprived of any deep understanding of "man's oldest form of communication." This ignorance of what mankind has

done is a poor preparation for grasping the nature of the present world.

A further cause for concern is the displacement of the humanities by the sciences which seems largely the consequence of the international situation. Always a marginal subject in our schools, art has been pushed further toward the curricular fringes by our current preoccupation with technological and scientific requirements. A report of President Kennedy's Science Advisory Committee emphasized the need for developing leadership; and it proceeded to identify these desired leaders as doctors, scholars, and engineers, with no mention whatever of artists, writers, musicians, or philosophers—an appallingly one-sided view of the nature and purpose of the American adventure. Fortunately Kennedy listened to other advisors as well,[11] and fortunately, too, a few scientists and businessmen can be found who deplore this view, among them the Chairman of the Board of I.B.M., Thomas J. Watson who recently warned us that "in the blazing light of man-made comets, the continuing need for an appropriate balance between science and the humanities has been blotted out."[12] Even the most intricate of machines, he reminds us, is incapable of making value judgments. Other critics have pointed out that a bare intellectualism is an inadequate instrument for coping with the problems that face modern man; they have also noted that the alleged contrast between science and art rests on a misconception of both. Several scientists have recently affirmed the importance of aesthetic sensibility and of imaginative power in their own work. A research chemist, for example, observes that the thought which guides the tool is as important as the tool itself; Einstein reached his concepts by a process that was both artistic and scientific, and essentially creative. No less an authority than the President of M.I.T. deplores that excessive intellectualism which deprives learning of its human content; in the midst of so much that is analytical and abstract, we need to regain a sense of the concrete, "the capacity to see, a sense of form and shape and design, a feeling for the plasticity of matter."[13]

Another weakness in artistic education is its lack of continuity from one level to another for those students who move from secondary to higher institutions, and continuity is just as essential for the development of one's knowledge and taste in this field as in the study of languages. What we have is at best a sporadic contact with the subject at the various levels, with no meaningful continuity and very little mutual comprehension or co-operation in this matter between those who teach art in the secondary schools and those who instruct in colleges and universities.

If students in secondary schools show faint interest in this vital subject, their indifference can in some degree be attributed to the way in which it is presented to them. To be sure, there is no one best way of instruction, but there are several poor ways, among them the imitation on this level of methods employed on the higher ones, especially the tiresome historical survey, studded with names and dates, which may actually inhibit the student's powers of observation and appreciation. Any method that opens one's eyes, develops one's sensibilities, and stimulates one's awareness of the qualities and the expressive powers of the artist's language is sure to be helpful. Any approach to art that substitutes factual knowledge for perception and discrimination may do more harm than good. It is a common complaint among college teachers of art that even those pupils who come to them with some preliminary work in this field have not developed that capacity for *seeing* which is a prerequisite to further study. From the very beginning it is important that art be understood as a noble part of man's long effort to shape his environment and express his values. The emphasis at the secondary level might well be placed on the former, if only to emphasize that art is not something in a museum, but that it is ubiquitous. At this stage a superficial glance at Rembrandt or Michelangelo may be less useful than a critical study of the student's own environment, the houses on his own streets, the family car, the statue in the square.

To remedy flaws in education so clearly traceable

to pressures from without may appear at first glance to be hopeless, the more obvious direction of attack being against the pressures themselves; yet when we cast about for a weapon against social pressures, we can scarcely find a better one in the democratic arsenal than educational leadership. To deny its power would be to deny the power of a democracy to elevate itself.

We must assume then, in good existentialist fashion, that our national quality is the sum of qualities in our institutions and proceed to lift the one of them we are dealing with according to our lights. In the popular eye the light of the humanities, and of its special filaments, the arts, has grown menacingly dim. If we wish it to burn brightly again, and burn enduringly, we had better be sure of its power sources and look carefully, even remotely, into the motives of education as well as into the resources of the mind and spirit behind them. It is to this careful examination that the succeeding chapters will be devoted.

Notes

1. William Schuman, "Have We a Culture?" in *The New York Times Magazine,* Sept. 22, 1963, p. 84.
2. Jacques Barzun, *God's Country and Mine,* Paperback edition, Vintage Books, Random House, Inc., New York, 1954.
3. Louis Kronenberger, *Company Manners,* Bobbs, Merrill, Indianapolis, 1954.
4. David Riesman, *The Lonely Crowd,* Yale University Press, New Haven, 1961, p. 339.
5. Christoper Tunnard and Boris Pushkarev, *Man-Made America: Chaos or Control?,* Yale University Press, New Haven, 1963, p. ix.
6. *An Addition to the Present Melancholy Circumstances of the Province Considered,* Boston, 1719.
7. J. Robert Oppenheimer, "Tradition and Discovery," in the American Council of Learned Societies *Newsletter,* Vol. X, New York, Oct. 1959, p. 18.
8. John Kouwenhoven, *American Studies: Words or Things?,* Wemyss Foundation, Wilmington, Del., 1963, p. 16.
9. L. P. Jacks, *The Education of the Whole Man,* University of London Press, London, 1931, pp. 36, 39.
10. G. Scott Wright, Jr., "The Ignorant Silence," in *The Saturday Review,* Vol. 44, Mar. 18, 1961, pp. 52, 53.
11. August Heckscher, *Report to the President,* Senate Document No. 28, 88th Congress, First Session, May 28, 1963, U.S. Government Printing Office, Washington.
12. Thomas J. Watson, Jr., "The Case for Balance," in the American Council of Learned Societies *Newsletter,* Vol. XIV, New York, Nov. 1963, p. 2.
13. Dr. Julius A. Stratton, "Abstract and Concrete," in *The Palette,* Weston, Conn., Winter 1961, p. 18.

Art and the Human Equipment

2

When we undertake to say what part art plays in general education, we run at once into an embarrassing difficulty. There is no accepted notion of the nature of education itself. The various statements of educational motive we can think of have never been united in a popular summary; without one, any statement we can make will lack a point of reference and fall into the category of vain assertion, of passes at windmills.

[2]1
The Nature of Education

It may seem a rash step to improvise a theory of education in black and white, but when you look at it squarely, it is something that any honest educator ought to be able to do, if only for his own use. If he cannot distinguish what is valuable to him in the welter of opinion about him, it is doubtful whether he ought to be in the business of teaching. At the very least he can ask himself a few questions.

What part of a person can be educated, and why do people want an education anyway? The second question may be answered by the reasonable assumption that everyone wants to cultivate his individual qualities, and more consciously, he wants to prepare himself for life in his environment. The two motives are mutually dependent and can be found in nearly every bit of formal education, art included. The fulfillment of personality prepares a person for practical living, and the pursuit of technical knowledge carries with it an intellectual unfolding all its own.

According to popular definition, personality is made up of the fixed qualities of temperament—or that part of temperament inherited with one's genes—and the flexible qualities of mind and character. Only the latter are educable, and character is usually formed by influences beyond the control of formal schooling, even though schoolmasters like to display their concern over it. The schools, then, are really left to cope with the mind and the mind alone. How do they fancy that the mind wants to be used?

14 Chapter Two

[2]2
Uses of
the Mind

When he was faced with the problem of assuming certain delightful new responsibilities, a certain character in Gilbert and Sullivan reassured his audience by saying that he had "got a little list." Lists are a nuisance—outside of Gilbert and Sullivan—but occasionally they are unavoidable. If any provision is to be made for the activities of the mind, it is advisable to map them out before exploring them.

A black pencil and a little brain-cudgeling might picture the mind as

1. A means of *Apprehension* through the senses.
2. A means of *Perception*, of discerning quality in an experience.
3. A medium of *Discovery*.
4. An instrument of *Creation*, of putting experiences together.
5. A mechanism of *Reason*.
6. A device for *Calculating*.
7. An estimator, an instrument of *Judgment*. By judgment, of course, we arrive at standards or values, and values added together produce an ideal.
8. A receptacle of *Religious Experience*.
9. A means of *Communication*.

Such a list is perhaps not very scientific. If we wanted to classify its items, we could probably fit them all into Jung's four areas of awareness—the senses, the emotions, the intellect, and the intuition; but classification is not our aim. We want merely to explore the common uses of the mind, with a sidelong glance at art, and these items cover a wide sweep of mental territory.

[2]2.1
Apprehension

It would be silly, of course, to pretend that any use of the mind occurred singly; the mechanism of thinking is not like that, but it *is* possible for all of us to isolate an object conceptually as a fact without finding any particular personal significance in it. Pure statistical information is often despised in education, but it is a simple truth that the mind likes to acquire it, and many a descriptive scientist is content with doing essentially that. He may count the rings of a felled tree, he may note the form, the structure, the processes of Nature, and store it away as recorded information.

It may have a use some day, but the main object, and a fanatical one for some people, is to observe it accurately.

A large part of what we observe in this elementary fashion comes to us through our eyes, and we might expect this practice to improve our knowledge of familiar objects. The opposite is usually true. We even rely on habitual association to obscure what we don't want to see. Proust speaks affectionately of this power of habit, which had softened the harsh lines of his childhood bedroom, and Americans have a facility already noted for ignoring the ugly aspects of Main Street or Railroad Avenue.

But ugliness is a *quality*, and with quality we are already in another realm of the mind—perception. Ought we to try to distinguish between the two functions (Figures 3 and 4) if they are joined together so automatically? Ought we to try to train the eyes as mere registers of fact, apart from any significance the facts may have for the observer? An artist living today would say no, but there has been art training in the past that did little more than that. Mechanical systems for training the visual memory were invented and used in the nineteenth century, and no lesser person than Pestalozzi exposed his children to exercises of this sort—with what results we can only speculate.

[2]2.2
Perception

With perception we are more at home. It is the artist's province. We may describe it fondly as the second look at Nature, the look in which the quality of an object is mysteriously established—and fortified by the memory of things seen before, or perhaps by the memory of the race (in accordance with Dr. Jung's theory of the "collective unconscious"). We *perceive* the luxuriance of spring grass, the delicacy of apple blossoms, the grandeur of St. Peter's Square, the nobility of Socrates. The faculty grows with our experience in the world and can be developed in school by a teacher with any sense of natural wonder. Science and history are fertile territories for it, but usually it is relegated to the English class, where the criticism of literature and the practice of writing make a somewhat inadequate bid to sustain it.

3.
A simple *record.*
Radiograph of a
living plant. Cour-
tesy of Eastman
Kodak Company

4.
A study in quality.
Chinese painting of
lotus flowers and
leaves. Courtesy of
the Museum of
Fine Arts, Boston.

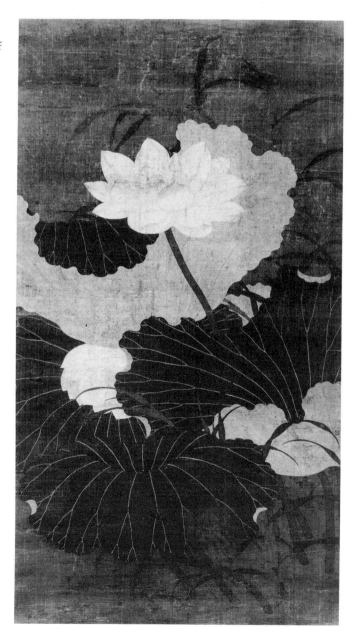

Art and music, of course, begin their work with perception. Art students of any age *perceive* when they look for material in nature, perceive again when they look at a work of art, and perceive a third time when they stand off and look at their own work. Whatever they do with art in later life, a sharpened perception gained in this way is a permanent possession. The failure to acquire any such power, or the taste and judgment that go with it, is largely accountable for the conditions described in the first chapter. With no recognition of perceptiveness or its uses in our scheme, our children mature without knowing the choices before them. They do not realize that an army of designers is always toiling to supply the articles they use or place about them and that the only inducement needed to make these designers supply good houses, good furniture, good anything is to have it in demand among the graduates of our school system.

[2]2.3
Discovery

The third item on our Gilbertian list, discovery, does not refer to a separate use of the mind but to a special mental experience connected with the other two that anyone will recognize. At a given moment in his routine an active-minded person will hit upon a truth that is supremely illuminating—a long-awaited experience in some cases but one that appears without warning. The excitement attending it may set him going in an entirely new direction. The threads of his endeavor are suddenly drawn together, and a line flung into the future. The consequences to his educational development are considerable.

Discovery may occur in any department of education, although the most romantic cases of it are probably in science, where they mark the route of an unending progress. The discoveries of art are more personal, but they are also more frequent, being the result of a speedier and more intuitive process. The art student is always discovering exciting new meanings in natural phenomena or in the actual use of technique. As in other fields it spurs him into action, and this brings us to the fourth item on our list, creativity.

[2]2.4
Creativity

Whatever miseries an art teacher has to endure under an educational system not especially designed for him, he will never understand why creativity in general, apart from any interests of his own, is given so small a place in a school program. It is only sensible, he thinks, to apply knowledge as soon as it is learned, and how can it be better applied than in making something?

Within limits he is right. The use of knowledge is often deferred too long, and the creative act, if we accept a reasonable definition of it, does have a unique value in education. But definitions have become careless, and "creativity" has become a bad word among educators, either by including too much, and making them feel that the thing is already covered by what they do, or by setting it apart in a spirit of snobbery, in which case they turn their backs on it. The honest psychologist hasn't helped the argument much because most of his writing tends to make the subject seem elusive, and elusive material on a busy desk is marked for the file or the waste basket.

Without disputing the fact that there may be an especially creative person, we may agree that the word itself can be used to denote a simple process, familiar to everyone, and no more elusive than any other natural phenomenon. The child who writes a paragraph on, say, an awesome experience in a drifting boat and succeeds in conveying the impression of his fear by his choice of words and the arrangement of his paragraph is creative. The child who does the same thing with color and pattern in a picture is equally so (Figure 5). But if either child limits himself to a bald recital of chronological events, the creativity disappears. The key to the process is a discriminating choice of structure and detail. If the work comes off, the separate elements click together and produce an *effect.* They "go good."

The following compositions by two fifth-grade girls will illustrate the difference:

1. This summer I went with my grandparents to Ver-

5.
Common experience
as a creative motive.
A Sudden Storm.
Milton Academy,
Grade 9.

6.
Religious mystery
is not unusual. *The
Wise Men.* Milton
Academy, Grade 8.

mont. On our way we stopped for an ice-cream cone. When we got to Vermont, we left my grandfather at the country club golf course. Then my grandmother took me out to eat. Then we went to the place where we were staying. My grandfather came back later with some friends. Then he took us to a swimming pool. Later on we went for dinner. We watched T.V. before going to bed.

The next day I played a little golf at the miniature putting hole. Then we started home. We stopped at a pool for a swim and at a snack bar, then they drove me to Connecticut and I met my family. We went the rest of the way home. My grandparents stayed at their house.

2. I woke up one morning very happy. Today I was going to climb Mount Chocorua. We started around ten o'clock driving along in our car until the foot of the mountain. About half an hour later we started up the mountain.

We walked for a long time through small marshes and the path was quite wet and muddy. Many streams cut across the path, making it very wet in places. I noticed after a while that we hadn't been walking up, but around the mountain instead. We walked along, until suddenly the muddy, wet path started climbing up and getting rocky.

As we got farther along the path, pine trees were all around us. We also found the cones and pine needles made the path harder to follow, so after making some mistakes we found the path again. Exhausted, we sat down to rest. Soon everybody wanted to start up again, so we did.

We soon noticed the path getting a lot steeper, and there were not so many trees. We also noticed rocks in our path, and had to climb over them; but on the other side were more rocks. So for the rest of the trip we climbed over rocks until we reached the top.

What a beautiful sight! It was foggy, but it was still fun. We could see the tops of the trees all grey and misty. Then we all thought about lunch. So after opening up the knapsack, we found lunch was soggy sandwiches. But we ate them.

Now for the trip down!

In the formal arts the same process has been described as "giving outward form to inner experience," presenting one's experience, that is, to someone else in a manner calculated to make him share it. The ex-

perience may be of any sort, emotional or sensory, so long as it is both definite and complete. The visual artist, in fact, is not limited to a visual experience for getting him started. He may start with a feeling, a mood, or a human sentiment and then find something in his medium that will convey it.

But have art and music and literature a monopoly of this process? Not at all. Creativity occurs when any person uses his initiative, his instinct, and his experience to put something together and put his own stamp on it. The paper boy who organizes a paper route may be creative and so may the teacher who starts a school or the businessman who starts a business. It can even be asserted that the ability to create is transferable from one field to another; it is no anomaly that a successful "lit" man or an art major in college may become a successful wool manufacturer in later life or that a scientist trying to plan a program of research may be able to sketch his first ideas through having once stared at a blank sheet of drawing paper.

The real value of creativity in education is that it helps a student to be definite in his attitudes and enlarges his general capacity for perceiving, thinking, and feeling. With a bit of serious work of his own staring him in the face, he usually learns something about himself; more important than this perhaps, he is given a focus for his initiative, and this may turn into momentum and affect his general confidence. On this important topic we shall say more later.[1] The main achievement of creativity, meanwhile, is that it gives a person the feeling of putting himself across.

[2]2.5,6

Reason, Calculation

It is not necessary to elaborate on the thought processes involved in reason and calculation because the words have an everyday meaning that is good enough for the purposes at hand. Along with communication they form the main objectives of current education and are sometimes referred to as the "verbal and mathematical skills" to distinguish them from the intuitive skills of the arts. The distinction, to be sure, is misleading because artistic people use reasoning about as much as anyone else, and some of them use

it more than most. Architects, for example, are artists and usually begin their work with a series of mental acrobatics over the requirements of the job. A certain kind of architect may even tell you that there is an *infallible* connection between the logical use of a building and its outward beauty.

There is a fascinating connection, indeed, between the patterns of art and the patterns of mathematics. Jay Hambidge, a mathematician, once spent a large part of his life in speculating on the precise nature of this connection, and various painters of his generation followed his rules of proportion in planning their pictures. These experiments, plus the fact that the words "estimate" and "value" along with many others have a mathematical as well as an intuitive meaning, suggest a further link between the calculating faculty and another item on our list, the faculty of evaluation which, disturbingly enough, is often intuitive.

[2]2.7
Judgment

The linkage is a tantalizing one and suggests that there are other things that may in an obscure way be calculable that are now left to personal estimation. Whatever the future of mathematics in these departments, judgment is still one of the sharpest mental instruments and a precious human attribute, as well. We associate it with a mature individual, a civilized man, and are more concerned here with its use than its structure.

By judgment we are able to estimate with greater or less accuracy what is right or appropriate in a situation. We weigh importance, we determine the essential nature of a person's character, or an idea, or a visual object. In all probability we are doing something very much like perceiving quality, as we described it earlier, since the results for art are a continuing taste and an eye for proportion, but the use of it is different. With the help of judgment we can act on experience or find the materials we need for generalization. A habit of using it in a certain situation, moreover, results in an attitude of mind, and an articulate —and refined—attitude of mind may pass into an ideal. Whether an ideal develops further and begs, say, a

religious experience, or whether an intervening revelation is required, is something that we do not care to go into now. The earlier part of the sequence is an interesting one—from perception to ideal—and suggests an ancient sequence described in Plato's *Symposium*.

In education judgment is, or ought to be, a main objective, whether we are studying history, language, economics, sociology, mathematics, art, or philosophy. It is the mark of original thinking, the badge of personality, and as such is indispensable at any level of training. Unfortunately, it is so associated in the minds of teachers with maturity that it gets little attention in elementary and secondary schooling. Teachers at these levels ordinarily teach "from the book" and write examinations with the assumption that there are right and wrong answers to be given, rather than situations to be appraised. The only course—at least in the lower grades—that can be depended on to use judgment in a systematic fashion is actually the art course, where a child in the act of making a drawing is always being forced to decide what is important to him. An account of what happens there and an inkling of the critical importances of childhood will be given in a later chapter.

Except for these experiences, which many educators regard as peripheral to learning, the question of children's values is usually left to parents or to the casual example of teachers and athletic directors, who are often startled by the stark judgments and the passionate adherence to code declared by their youngsters. There is abundant evidence, at any rate, that children could determine a lot of things for themselves—a lot more, that is, than they are presently allowed to determine.

[2]2.8

Religion

If religion cannot be given a quick rating as an activity of the mind, its record as a preoccupation of man still suggests that it be included on our list. A democratic system of education feels obliged to ignore it because simple religious attitudes cannot be conveyed without a sectarian bias; the churches are therefore invited to take over the job, and a good many educa-

tors feel that this is an abdication of responsibility.

There is little to be said about the sectarian argument. In actual practice it is not as much applied as threatened, and most of the schools could notice religion more than they do without incurring the wrath of Protestant, Catholic, or Jew. The great religious legends could furnish subject matter in English or art at any level, and the ethics associated with the different faiths could be discussed in secondary school —if the authorities so wished.

Entirely apart from its importance as a primary experience, religion is useful in education as an imaginative spur. It appeals to a child's natural sense of wonder and awe, and it is a continuing source of mystery to his older brothers and sisters. In art class religious projects are usually successful (Figure 6) because the students feel a little more privacy in the media of art (Figure 10) and even come in for a certain public approval if they take part in, say, a Christmas project. Art teachers, however, are often backward in cultivating these attitudes. The Christmas and the Easter motifs are notorious outlets for sentimentality and cliché, and art, they think, is a cut above this. They forget, perhaps, that religion provided the mainspring of art for many centuries and supplied us with some of our most familiar imagery. Education may have escaped from religious authority; it has not entirely shed its religious heritage.

[2]2.9 Communication

Communication, the last item on our list, is the one given first place in the ideology of our present schooling. It is taught directly in language courses and indirectly in everything else, but most of it is in the medium of the written and spoken word. Obviously words are not the only way to communicate; any kind of prearranged signal to the senses—from a doorbell to a mathematical formula—will carry a message, and visual messages are in great demand nowadays, taking the form of advertising, movies, and television, without which an average American would find life unbearable.

It would serve no purpose to undervalue the study

of words, whose history is closely identified with that of civilized life. Words will always be the readiest means of communication, but they are also among the most complicated. Since they are arbitrary symbols at best, they carry a good many secondary meanings which differ in different contexts, and we are often hard put to it to frame a wording that will convey an exact thought.

To gain accuracy, language has resorted to metaphor, and it is curious how often metaphor, whether in everyday language or in literature, becomes visual. A garage mechanic who is explaining to you the condition of your motor will want to know if you "get the picture." A poet wanting to describe an emotional state may begin with a sunset:[2]

now that fierce few
flowers(stealthily)
in the alive west
begin

requiescat this six
feet of Breton big good
body, . . .

This ought to be enough to suggest that vision offers a means of instant comprehension; in fact, its instantaneous quality is both its advantage and its weakness. Time is no object to it. A billboard hits you in the face before the train gets by. In the reading of a story, however, or in listening to the unfolding of a melody, the time dimension becomes an advantage and a necessary part of the effect.

The relative effect of sounds, sights, and verbal symbols on the senses is a fascinating subject, but it lies beyond the scope of our inquiry. It is only pertinent here to note that communication through the various artistic forms, visual, musical, or literary, is probably the closest communication that ever happens between mind and mind. A poem by this token is more communicative than a police report. Not only does it suggest the exact nature of an experience described through its choice of metaphor, but it tells you something about the speaker and his state of

mind by its mere sound and rhythm. Music, of course, is even better than poetry in the latter respect.

All the arts command subtleties that respond directly to the personalities of their producers and leave works shaped in their image, the architectural and sculptural relics of history being the most enduring. If we know anything at all about the Egyptians, it is because they have left us temples and sculpture; and while we are grateful to have a remnant of Greek literature, the actual life of the Greeks is better revealed to us in marble and in the clay shards we are still digging up. (Figures 7 and 8)

A visual monument speaks to us directly, but this does not mean that its language is always easy to understand. It is nearly as difficult, in fact, as a written language. *Something* is gained from the first glimpse of the Parthenon or the tympanum at Vézelay, but a real understanding of them comes only with a knowledge of the vocabulary of architecture. The vocabularies of the arts are worth knowing, though, and artistic understanding is not the only good to be had from them. The close personal *communication* we have referred to is equally important, for the intimacy derived from it can remove barriers between people hopelessly separated. Old people and young people come together through art, the opposite sexes meet on common ground, persons living centuries and thousands of miles apart realize that they are all children of Adam together.

This kind of communication—of communion, indeed—is available to people who study the language of the arts, but on one condition only: in the presence of a work of art, which represents the experience of a person, a viewer must bring to it a somewhat similar experience of his own and, to a certain extent, a similar mood. Human experiences are enough alike for us to expect certain chords to vibrate in sympathy with the artist on ordinary occasions, but then again other chords may not. And moods vary. There is a right and a wrong moment for artistic understanding. One cannot appreciate a Rubens on an empty stom-

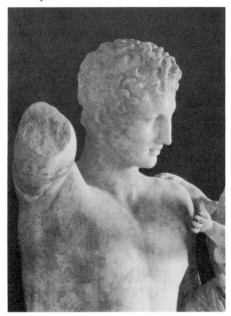

7.
Intimacy with a
fourth-century
Greek. The *Hermes*
of Praxiteles.
Museum at
Olympia.

8.
Eloquence in lime-
stone. An Egyptian
message on divinity.
Temple relief at
Edfu.

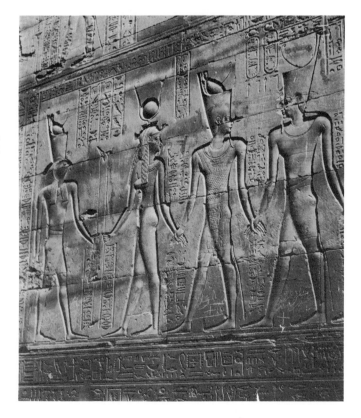

ach or understand a Fragonard at all unless one's education—and natural refinement—has unlocked the door to the world he lived in. But the chords do vibrate some of the time, and not merely between artist and observer but between two people who are observing together. People discover one another through art, and this is perhaps the most poignant communication of all.

Notes

1. See pp. 69, 147.

2. e. e. cummings, *Collected Poems* (Is 5, Three, I), Harcourt, Brace and World, New York, 1955.

The Educational Scheme

3

In the foregoing chapter we examined an informal theory of how the mind "wanted to be used" and how art came into it. Although it was presented informally, it embodied the experience of a good many educators and formed a necessary preliminary to our study. If art seemed a little ubiquitous in it, we have only to reflect that all subjects penetrate many fields; art is just a little stronger in the fields of perception, creativity, and personal communication. The mind, however, does not function in a vacuum. Its development is determined by our social heritage and by the emotional factors implied in "temperament." Our theory, therefore, is not properly one of education until it includes a pattern of practice in which art, presumably, may take a part.

Any respectable theory of education is supposed to do three things: it should state an aim, it should specify the materials used, and it should describe its methods of using them. We may as well observe this formula in our improvisation and begin by saying that the aim was covered when we said that education developed a person's full resources, whether these were later applied to citizenship or to his personal happiness.

Full resources are moral as well as intellectual, and we do not wish to appear to neglect their moral aspect. We hasten, therefore, to explain how *character* may come into a formal plan, since our earlier statement declared that character often depended on circumstances beyond the teacher's control. "Often," however, is not "always," and in the long run the influence of the teacher adds up. The question here is whether any theory of ours can undertake to guide him.

To a certain extent the school he works for does just this. it lays down rules of behavior, it metes out justice, it organizes student government and co-operative enterprises, it is hospitable to religion and to high-minded visitors; it may, in short, provide a favorable moral climate, and in this of course it is entirely praiseworthy. The main task, however, still seems to

be up to the individual instructor, and it would be sheer presumption on anyone's part to do more than make suggestions. On a thousand occasions in his daily routine he will be called upon to make a decision or set an example that may be crucial in a student's career. An unusual teacher may be an angel of salvation to him; an average teacher, a firm support. The best of teachers will realize that he is not the only influence at work; the church, the family, and the ball team are usually in there ahead of him, and he will recognize them as his staunch allies.

[3]2
Educational
Materials

Coming to the materials of education, we may say that these also have been covered in the catalogue of mental processes, "material" being anything that stimulates the use of the mind. Formal education, though, has inherited a curriculum of subject matter by which it hopes to accumulate experience in the various processes—and memory of that experience in the form of knowledge. These subjects may be of two kinds: the ones that supply the student with rational and impersonal meanings that are pretty much the same for everyone, and the ones that supply personal and variable meanings through the use of intuition, which we will associate with *perception* and *judgment*, prominent members of our list. The first group corresponds roughly with the sciences, and the second with the humanities. Neither group, to be sure, is limited to one thing or the other. The scientist has often been a romantic explorer spurred on by his discoveries and the humanist, just as often, a detached analyst, as when, for example, he studies grammar in language or anatomy in art.

On the whole the distinction is useful. Scientific or mathematical truths, like the square root of two or the displacement of a given body in water, will be the same for the entire class, but the best choice of words in a topical essay in English will vary according to the imagination and condition of each individual member. In general the elementary science courses look for right answers rather than relative ones. The humanities look for answers that are fitting to a partic-

ular moment of his career or of his emotional life. The emotional and sensory content of the humanities is strong; that of the sciences, relatively weak.

Of course the present curriculum does not observe these classifications. The catalogue mentions an intruder in the academic family, the social sciences, and these are said to include even history whose lineage goes back to Parnassus. The humanities at the moment appear to be limited to literature, philosophy, the ancient languages, art, and music—the modern languages occupying a position out in limbo. This is the result of applying scientific method to the study of human behavior and of the birth—out of the head of Zeus, presumably—of the departments of psychology, sociology, anthropology, and economics. The humanist looks fondly, if a little anxiously, at these wayward children whose preoccupation with human beings will doubtless lead them one day back to the fold. He is willing to indulge their need to rationalize, as he has often indulged his own, but he believes that they will ultimately fall back on a sagacity something like his. His attitude, though a sentimental one, is correct insofar as it still distinguishes between the two kinds of truth. The social scientist is not always able to do this.

There is a second and totally different balance of material which it may be useful to bear in mind. It may be either *enlightening* or *productive.* One may study in order to enlarge one's understanding, as one studies equations in mathematics or Plato's theory of Ideas, or one may pursue knowledge through a productive act, which may or may not be "creative." Dewey refused to admit that there was any such distinction as this, maintaining that all original thought was creative.[1] His idea, though a powerful one, appears to leave the notion of *presentation* out of account. There is a difference between a permanent synthesis, like a work of art, and a mere constructive step. One may induce a student to rediscover Newton's theory for himself, as Dewey suggests we do, and in doing so make him perform a constructive act from which further knowledge may be derived. The student has a fair illusion

of making something happen; actually, he has simply carried something forward by a series of logical steps—a very different procedure from the act of a literary or musical composer who draws chosen units of language or music into a complete unit and presents it to the world. Although he may have learned from the thing he produces, he expects nothing to grow out of it. It stands on its own merits. The world for him may consist of one person or be wholly imaginary; it is still something outside of himself, an audience.

Productivity in the narrower or creative sense appears unequally in the different fields of study. In English composition and studio art it is inescapable, in the laboratory sciences it is perfectly possible, in foreign languages it tends to disappear, in history and the behavioral sciences people are eying it. There have been a good many efforts, in fact, to extend its scope outside of the obvious areas, but usually these efforts end up with the "constructive" process just described. Any consideration of these, however, belongs more properly to the discussion of *method*, which we shall soon come to.

One more observation may be made about material. Because the mental processes we described in Chapter 1 cross academic lines, the relationship between courses should be close, and a stimulating experience in one area ought to be reflected in other areas. Until recently there was a tendency to deny that transfer of this sort ever happened. There seemed to be a little academic jealousy in the matter. This attitude may be diminishing, but the various subjects in the curriculum still suffer from isolation. They need to co-operate—but here the topic of method is really upon us.

[3]3
Method
and Its
Dilemmas

What are the means of putting these various kinds of subject matter across? Well, generalities in this area are no harder than anywhere else, and we may as well begin by saying that (1) the means must be designed for everyone, while still accommodating themselves to the individual, and (2) they must be geared to the intellectual and emotional growth of the young person.

In doing this, they have an immense store of practice and vital experiment to call upon. Method should be a means of ensuring vitality in training, but it is very often the opposite of that.

When we are called upon to state our preferred methods, however, we are dismayed to discover how little we know with any certainty. Elementary questions puzzle us still, as they puzzled the Greeks. Do we learn by imitation or solely by original experience? Precisely where does intuition come into learning? Does a school accept the values of its community, or has it a mandate to lift the values to a higher level? Is the public school system an effective answer to the question of public education, anyway? Many cultures have done without mass education, and there are many situations in our own culture where learning seems to move at a faster clip than in school.

To add to the weight of these uncertainties, we face the demoralizing fact that any genuine wisdom we have distilled from a hundred years of public education is difficult to apply. Flexibility in method, for example, is an ideal that most of us accept, but public school systems are notoriously inflexible, and enlightened teachers—with their books prescribed for them—have a hard time being anything but dogmatic. They even yield to the argument that dogma is necessary for continuity in the student's work and for purposeful teaching on their own part.

Our most cherished beliefs run into similar obstacles. We commonly recognize that all stages in a student's development, from childhood to maturity, are of equal importance and that childhood is a value in itself; but we allow the colleges to post requirements of the schools, based on the idea that school is a tooling period, dominated by the three R's, whose mastery will permit the student to begin his *genuine* education as a college freshman.

We know, theoretically, that there is value in applying knowledge as soon as it is acquired, but we force a student, as we said earlier, to stow most of what he has learned under hatches, from which we need not be surprised to see it emerge a few years later in

a somewhat moldy or desiccated condition. But it is not an easy matter to remedy this in a crowded curriculum where no student can carry too much forward at a time. We resort to speed-up plans, to an exchange of teachers and materials between courses, realizing all the while that these are mere palliatives.[2]

We believe that students of different abilities must be allowed to follow different paces and that excellence must have its chance, but the concept of the school as a social institution has focused teaching effort on the average, or at least the well-adjusted, pupil rather than upon the exceptional one. There is no reason for supposing that Professor Dewey's faith in the capacity of the human organism to grow under normal social conditions involved any endorsement of mediocrity or that the windows of his schoolroom opened solely upon Main Street and never upon the civilized past; but the efforts of his well-meaning followers have resulted in just that. We are caught in a conflict of feeling over the Dewey methods and have to struggle to retain the real wisdom behind his recognition of social factors, a wisdom that represents a long accumulation of educational thought.

We believe in general education as well as particular training for a job; we think that a person is better able to get along with himself and with his community or even with his own specialty for knowing something of its context among world interests. In the last few hectic years, however, we have witnessed a mad rush toward a narrow technical training which insists, doggedly, that only certain studies can prepare for it: more language, more science, and more mathematics.

[3]4
Method in
Time

In the face of these academic disasters there is still a hopeful attitude toward method which a serious educator will do his best to preserve. Method at its best is experimental and always will be. Experiment is its guarantee of growth and of freshness. We may face difficulties greater than any that Dewey counted on, but we can face them in the spirit of the nuclear age, the spirit of willful survival. With the caution, and yet with the hardihood, of persons emerging from a

bomb shelter, we propose here to lay down certain directions of experiment and to indicate what is secure and what is promising in each track.

Our first statement about method was that it had to provide for general needs without neglecting individual ones and that it also had to be geared to a student's development in time. Since the second requirement has less in the way of method to meet it, we will deal with it first.

The time pattern is, in fact, one of the thorniest and most unsettled questions in all education. There is no accurate knowledge of the conditions surrounding it, no scientific scaling of the capacity to learn, although behaviorists have not failed to attack its sequences. Most of us will accept the doctrine, first enunciated by Pestalozzi,[3] that the emotional needs of a child must be satisfied if we are to start him off properly, and we assume that as he proceeds, intellectual curiosity will gradually balance his impulses as a motive for learning until he becomes a rational being, ready to face the onslaught of textbooks. Whether he is ready or not, a flood of purely rational material will soon envelop him, and he must swim through it as best he can.

As to the age when the more complicated concepts can be brought to him, there is wide disagreement. Some educators have thought that his facilities could be mobilized far earlier than is expected in American education, or even in Europe and Russia. Introducing higher mathematics into secondary schools, and secondary school mathematics into primary schools, has been done experimentally, but nothing has been carried forward on a broad front. It is well to remember, though, that in the field of art, where the evidence is at least visible, a good deal of psychological research has been carried out—and more could be done. The sequences of development that appear in art may well furnish a clue to what is happening elsewhere.

Art teachers, as well as other teachers, are particularly baffled by the changes that appear in a student at adolescence, when a certain kind of awareness and

sensitivity seemingly disappears. It is usually said that adult standards creep into a child's mind at this point, making him ashamed of his own immaturity and ready to imitate anything plausible to escape it. Is this merely a temporary thing, or could it be that certain abilities are lost for good if they do not receive nourishment at this time?

It used to be said among artists in Europe that if a boy didn't learn to draw before he was fourteen, he never would draw. If there is any truth in this assertion, the implications for education are serious; one wonders why they are the object of so little concern. The answer probably lies in the fact that most pupils shift teachers at this age, and a single teacher does not see the whole transformation.

In a provocative essay, which used to receive greater attention than it does now, Alfred North Whitehead deals with the problem in a general way[4]—although he does not appear to notice its particular soreness—and provides the nearest approach to an educational timetable that anyone has drawn up. He considers education a rhythmic process, rhythmic in its totality and full of interlacing minor rhythms in the separate subjects. Politely assuming that all this was familiar to teachers, Whitehead said that the mastery of any subject was accomplished in three stages, the stage of "romance" or excited discovery, the stage of "precision" or analysis, and the stage of "generalization," when the fruits of analysis and system could be garnered with a return of the original enthusiasm. These cycles, according to him, begin with a child's discovery of the world, and of language as a precise manner of dealing with it, and will normally recur in an indefinite fashion if inflexible systems of training do not interfere with them. To restore their orderly function, he proposes an education that would emphasize one area of subject matter at a time.

When the first grand period of romance is completed—at about twelve—he recommends a period mainly devoted to precision in language, lasting till fifteen; then a brief period of precision in science and mathematics, during which language in turn would

become generalized through the enjoyment of literature and ideas. At sixteen, or two years ahead of the American schedule, the student would enter into his higher training which Whitehead thought of as devoted to general ideas and their application in specific situations.

Whatever objections may be raised to his theory, it has the merit of extreme simplicity, and it remains virtually without competition as a bit of scheduling.

[3]5
Method
without
Time

So much for the timetable. In those areas of method where time is not primarily a factor and where individual and general needs are the question, we have selected the following topics of exploration:
1. Social experience
2. Motivation in general
3. Personal motivation
4. Intuitive and rational learning
5. Special devices and techniques

[3]5.1
Social
Experience

That education is conditioned by social experience is obvious, whether we agree with Dewey in other respects or not. Method itself is very largely, though by no means entirely, a means of dealing with this experience, which occurs automatically even when we do not attempt to control it. What a child learns from the example of others, from competition, from the need to communicate or receive communication, from sympathy, from censure, from intolerance and other harsh realities is clearly, as Dewey said, a major part of learning. Not all of it is desirable, to be sure. The force of group opinion can destroy development; conformity to type and the cultivation of the norm often prove an insidious manner of weakening both the individual and the social structure. The social organism, like any other organism, will grow in all directions unless it is thwarted; when it puts out feelers in a direction that may be considered wrong, it is up to the "better" elements in the community to block it and open up new paths. What the better elements in a community may be is another matter, but we must assume that the school is aligned with public conscience and reason and will occasionally accept the

responsibilities of leadership rather than provide a mere sounding board for banality.

The techniques of utilizing social relations in school are legion, and we have indicated how they are applied in moral issues. On the intellectual front there is one sector that we have mentioned earlier in the chapter as a trouble point. Segregation of ability implies the freedom to move forward and function with one's peers, but precisely how is this move to be accomplished? A step in this direction was taken when advance placement programs in college cut across the four-year social scheme, and there have been further steps in various high schools, notably the now-famous high school of Melbourne, Florida, where the directors have sought to eliminate *all* arbitrary division into school years. By dividing each subject instead into several "phases" of graduated difficulty, these schools allow pupils to move freely from one stage of difficulty to another—within the subject and according to their ability. Apparently this is accomplished without any social stigma when the pupils move backward; they haven't a class status to lose. Pupils often find themselves in the same class with others who have been in school longer; they leave when they have completed the highest phase in enough subjects regardless of the number of years it has taken. Such a system would seem better adapted to a big school than to a smaller one.

A few small private schools, nonetheless, have tried the experiment of hiring enough teachers to supervise pupils individually and let every child follow his own pace with no competition other than that of his own capacity. Essentially, of course, this was accomplished under a single teacher and without segregation in the old red schoolhouse, when children of all ages and abilities studied under the village schoolmistress and got out when they had learned all she had to teach. In this way Abraham Lincoln acquired a large part of what he needed in later life. We seem to be back at the point where speculation started.

What it amounts to is that certain facts of education do not change and that children advance in spite

of obstacles when they have a motive. The red school-house was a simple laboratory in social method. In it a child learned by imitation as a first step, by competition as a second, by the exchange of ideas with equals as a third, and by the benevolent encouragement of the teacher at all steps. Confidence, the most precious ingredient in education, could be gained in these surroundings as well as in any others.

Our own laboratory facilities for community learning would seem to be infinitely greater. We can organize co-operative projects on a large scale in a big city, and with many pupils to choose from we can single out and recognize a great variety of skills. We can establish special kinds of high schools with experimental programs from start to finish. We can try emphasizing certain areas of study, like science or language, or try accelerating learning as a whole, so that either the present goal may be reached in a shorter time or a much higher goal in the same time. The mechanism for experiment is there, and it is occasionally used. The obstacles in the way of adopting its findings are those inherent in a decentralized system. Where authority is vested in many thousands of school boards that are exposed to local demands and prejudices, an idea has to gain enormous prestige before it is given a general trial. It takes a Dewey to start a trend—and an atomic threat to counteract it.

[3]5.2
Motivation
in General

Behind all the efforts of teachers and administrators to provide effective social influences lies a concern for the student's own legitimate desires, desires that lead to self-fulfillment or a creditable role in the public eye. Desire is an emotion, and the emotional element in education has not yet been singled out for any particular attention here, although it clearly furnishes a good part of the motive power. No school would assume full charge of the emotional life of a child, but a school would be derelict if it ignored it altogether.

In the daily routine this is usually pretty well understood by teachers. Lower school teachers are often extremely good at mobilizing impulses of children and drawing responses from them, although they are some-

times inclined to overdo rewards and penalties as a stimulus to learning and to ignore the satisfactions of learning itself—which are still a primary motive. College teachers, however, lose this form of personal contact, and no plan that replaces it has yet been devised.

In the absence of one, it would seem reasonable to pay more attention to the things in education that give the emotional life a positive direction, and *these are to be found in the humanities,* which are reservoirs of human experience; any student who fishes among them may find reflections of his own inner life and start refurbishing it. The humanities are not just a balancing element in the curriculum but an organized contact with the world. With or without guidance a student may cast among them for motives close to his heart, for ideas, for heroes, for religion, for man-made and natural beauty—for anything that leads him out of the commonplace.

We might go further. If we could require an element of self-appraisal in ordinary courses dealing with ideas—if college teachers, who are notoriously unconcerned with students' private lives, would reverse their attitudes and give the class a philosophical challenge—they might do a real job for motivation. A student needs to ask the questions, "What does this mean to me?" and "To what point does this bring me?" and to ask them habitually, not merely at the end of his senior year. Would it be hard to give him such a habit? This does not mean, of course, that the humanities are useful only in college. Their attitudes toward imagination, their use of experience with the senses, their cultivation of judgment and standards are obvious needs in early education, since their acquisition involves discipline and long practice. The absence of any humanistic beginnings, in fact, is one of the commonest reasons for a student's failure to respond maturely in college.

[3]5.3
Personal
Motivation

An intelligent use of the imagination, and consequently of one's emotional and sensory experience, may be one of the general objectives of method, but there are more particular motives to stimulate, and of these

we have selected two as matters of current urgency. One of them is based on a common psychological fact, the partnership between physical and mental activity, and the other is tied in with the apprentice system of learning, which derives its stimulus from the social scene.

[3]5.3.1
Intellectual
and Physical
Partnership
as a Motive

The sense of well-being growing out of a combined mental and physical activity has been a central idea in a number of plans of education, notably that of the Greeks, who considered "gymnastics" about half of a gentleman's training. Although it often seems to swallow up the American school or college, the modern interest in athletics is in reality less inclusive than the Greek one, its advantages being usually advertised in terms of morale, teamwork, and the desirability of having a healthy body to house a healthy mind. Psychologists, however, consider the partnership a more intimate one, and even though an element of mystery pervades it, the layman will readily follow their argument. A writer—or an artist—fingers a pencil even before his ideas are formed. A physicist runs over his apparatus to get the "feel" of the experiment; why? —because the physical part of the process is suggestive of the whole. It is not entirely a figure of speech to say that we have knowledge "at our finger tips."

To the educationist this suggests the possibility of making all subjects more alive by giving attention to their physical or laboratory moments. These occur naturally in the sciences and the arts (Figure 9) but can be transposed into history, for example, by requiring the class to map out a new territory, plan its settlement, organize its defenses and its economy, turning then to a physical re-enactment of events in some form of drama or perhaps merely producing a historical exhibit. This example may be familiar, but there are newer ones. Professor Bruner has described an experiment in teaching quadratic equations to a class of seven-year-olds. The class, already aware of mathematical notation, was shown a brass balance beam, immobilized by a brake, with a series of equally spaced hooks on either side of a fulcrum. They were asked to choose a value for x, to be represented by

9.
The open studio . . .

10.
. . . where privacy
of thought is per-
fectly attainable.
Motherhood. Phillips
Academy, Andover.

a number of rings placed on a hook. They chose 5, deciding next that x^2 could be represented by 5 rings on the fifth hook. Proceeding from there, they decided that $(x+2)^2$ could be represented by 7 rings on the seventh hook and continued, with mounting excitement, to set up an entire equation in brass: $(x+2)^2 = x^2 + 4x + 4$. Here $4x$ was represented by 5 rings on hook 4, and 4 was finally represented by 4 rings on hook 1. When the thing was completed, the brake on the beam was released, and to everyone's delight the equation balanced! The written equation had been found to equal something produced by hand. To what lengths can this kind of experiment be extended?

The communist world, meanwhile, has been using a simpler means of keeping education on a physical basis. With labor at the center of its ideology it merely encourages or requires a student to do manual labor at stated intervals throughout his studies, thus avoiding the stuffiness of a full academic routine and making the cleavage between work and study in the Western nations seem more artificial than ever.

Ben Shahn, who is no communist, voiced a similar attitude in his Norton Lectures at Harvard, when he advised an aspiring artist to take a tough physical job at some point in his studies, admonishing him at the same time to "get all the education he could." "Getting it," to him no doubt, meant seizing it wherever it could be found, as *he* once got it in the public library after a long day in a lithographer's shop. Like so many others of his generation, Mr. Shahn forged a key to our cultural heritage with the tools of an active profession which commenced for him at fourteen.

[3]5.3.2
The Apprentice
System
of Learning

This is a primary lesson in motivation, beautifully illustrated by Mr. Shahn's career. The apprentice takes a job about which he knows little or nothing at the beginning, but which nevertheless has an immediate pecuniary value that increases with everything he learns. He becomes part of a live organism, a grown-up instead of a school child, and his ego takes a leap forward. If he is intelligent, he may realize that he

needs a better general education and takes steps to obtain it because it makes him a better workman. He learns the special knowledge connected with his profession more rapidly than he would acquire it alone, not merely because he *must* acquire it but because the operations of his employer are on a larger scale than those of an independent beginner and acquaint him with a greater amount of professional detail. He observes other workmen, moreover, and, by comparing his efforts with theirs, discerns the channels best suited to his. These are advantages enough, even if we ignore the human motive of ambition that will cause him to dream of acquiring a business of his own and ascending the ladder of success by well-marked steps.

The apprentice system accounted for a large part of education in the Middle Ages and was the accepted training for the higher professions during most of the nineteenth century, when more complicated technical requirements caused the establishment of law schools, medical schools, and teacher's colleges. It survives today in many professions, including business, but its central role in education disappeared with the arrival of the public school.

No one wishes a return to medievalism, but the schools *are* slow, and slower yet because the public values their custodial function and is in no hurry to see it terminate. Serious educators have decried the isolation from community life that results from this and have often speculated on the possibility of recapturing a few of the motives inherent in apprentice learning. The best of these seem to focus on a current *value* for something that is produced—a value, that is, in someone else's eyes. It is possible to attain it in a small way of course in some of the extracurricular activities in school; through jobs on the school paper, through responsibilities in student organizations, through dramatic productions, art exhibitions, and the like; it is possible above all to find it in summer jobs, which are actual excursions into the adult economy

and whose popularity in America almost puts us in rivalry with Russia.

A few colleges have gone all the way toward apprenticeship by alternating study programs with working programs, but the query remains as to whether we may not achieve something in the classroom itself.

One feature of apprenticeship, though not the "value" feature, was aimed at in the progressive schools when pupils were encouraged to learn by doing, the doer being given a problem a little too hard for him and allowed to struggle with the mechanics of it for a while, until he had either solved it or was in a position to appreciate mechanical help from the teacher. This, of course, happens when a workman is trained on the job, and it is usually effective under professional conditions. When the progressive schools tried to imitate the method, however, they were roundly criticized for faulty basic training, and their procedures have been far too easily forgotten.

The nearest approach to a value motive in the classroom seems to occur in those courses described earlier as productive, where the student produces something tangible by his efforts and can show it to either his teacher or his contemporaries or at the very least contemplate it himself. This may be either a literary or an artistic product, a scientific or historical exhibit, or merely a perfect piece of typing, if he is a commercial student. If it is well done, it will contribute to his self-esteem, and the teacher may fortify his confidence by placing it on display.

We do not wish to claim too much for this experience in education. No doubt it has been overvalued by the partisans of the arts, who have no actual means of measuring its importance. We simply feel that it *is* satisfying to *produce*. As to the value concerned we are mindful of the hierarchy of subjects usually accepted in the school and the community and realize that if the subjects in which production takes place do not rank very high in popular esteem, no achievement in them will rank very high either. The student's ego cannot soar higher than the prevailing currents will carry it. He may have to face disappointment and

draw whatever confidence he can from the mere habit of producing. Fortunately for him this is worth something.

[3]5.4
Intuitive and
Rational
Learning

Until now we have been considering method as a means of meeting situations imposed by environment or emotional life, and this is easily its most complicated aspect. Concerning the application of method to the mind alone, we have selected only one topic to examine, but it is an important one—the appropriate uses of reason and intuition in learning.

If we refer to the list of mental activities in Chapter 1, we will note that most of them imply some sort of intuition. Perception, as we have described it, is intuitive. Discovery is the result of intuitive exploration and leads to further intuitions. Creativity is largely intuitive, and so is judgment. Communication of anything but the most impersonal facts is intuitive, and this applies to the communications of history, whose meanings may be partly rationalized but depend at some point on sensitive guesswork. Finally, many of the most interesting ideas that have been contributed to educational theory, including Plato's, have originated out of sheer intuition; but Plato did not recognize the value of intuitive knowledge, and rational processes have guided the course of schooling ever since.

With such a large portion of our mental equipment lying outside the rational area, it is hard to believe that so little has been done to organize and train the intuitive powers, particularly when they are necessary partners in any scientific speculation. We might take an example from our own field of inquiry. A person trying to formulate a theory of instruction or state a theory of learning will normally commence his labors by putting forward a set of propositions that he has pulled out of the blue. Some of them, no doubt, will have logical antecedents: they might bear a family resemblance to other propositions he has known about or represent an intelligent choice among a set of obvious alternatives; but others will reflect deep personal attitudes of which he himself may not be aware, and still others will appear to be derived from nothing at all—nothing but a mysterious ability to guess.

In deciding which of these he will keep, he looks for evidence in his files and conducts experiments according to rigorous rules of logic. Some of his propositions, however, will not measure up to any definite classification; yet he believes them to be right, and he retains them, hoping that some future research will confirm them. The whole process is a clear alternation of guessing and reasoning and is actually the method by which scientific discoveries are made.

A speculation of Professor Bruner's about the learning process will illustrate the point a little further. In approaching a theory of instruction,[6] he found it necessary to describe three ways in which a person could represent his knowledge of a subject: first, by an expert act, second, by a capacity to picture, and third, by an ability to describe its logical structure. A group of children in following this sequence might know about seesaws—first, by being able to use them, then in a few cases by being able to draw a picture of a seesaw or mention some visual equivalent—but all of them would have to wait for a high school science course to describe the mechanics of the contraption.

The interesting thing about this concept of knowledge is that two thirds of it is intuitive. A child can't learn to balance a seesaw by thinking it out, nor can he grasp the salient characteristics of it in a picture without an intuitive sense of what describes its quality. The true scientist is willing to accept intuitions like these because they make for understanding. He recognizes a sort of hierarchy, to be sure, among these three kinds of knowledge, even though Bruner says each one is capable of enriching the other.[7] The intellectual understanding of a subject appears to him to be the most highly developed, but the world will put a different value on the other two in many obvious cases.

The theory is open to criticism from academic sources, incidentally, for not giving enough information on the kind of learning involved in certain curricular subjects. While the third manner of representing knowledge may apply beautifully to the sciences, it applies less well to history and applies dubiously

to the arts, in which logical analysis has yet to be proved effective in pin-pointing the quality of a given work or in distinguishing between a great and a mediocre work. In fact, the qualitative aspect of knowledge is not very well provided for in the theory, unless ultimate quality—the main thing in a work of art—is the result of an ability to "picture." That classification will satisfy neither the artist nor the historian, the latter being keyed to an enlightened sympathy with the past, a grasp of its culture, an understanding of its personalities and ideas, and perhaps a sense of tragedy before the spectacle of mistaken endeavor. Knowledge of this sort is abundant in the humanities but somewhat rarer in mathematics. Wherever it is found, though, it is always attained by an intuitive process.

The use of reason in education is as important as ever, of course, and is not to be described by saying what it *cannot* do. If it has aroused some grumpy comment in this study, it is because it has enjoyed a monopoly in certain minds, and no mind should be allowed the mistake of identifying perfect logic with truth. If we want to describe the function of rational method, however, we shall get little help from the people who profess to believe in it most. The zealots themselves are not noted for their ability to put out clear and simple statements of their beliefs, and the available literature on classification, while growing—with Professor Bruner's aid—is still extremely small.

Contemporary experiment, though, and ordinary family experience identify the rational appeal as one of the very earliest in education. Very young children notice that things happen in a regular manner in nature and automatically look for the reasons. When they have found a reason and applied it, they have taken the first step in the mastery of their environment—and proceed, of course, to look for new generalizations and new mastery. A few experimental classes in social studies have capitalized on this interest of children in solving situations for themselves by showing them films on how primitive men deal with their

daily situations and work out rules of behavior and a body of personal knowledge. The children put themselves in the same positions and work their way out in the same manner, in a kind of game. Anyone who wins an encounter with, say, an Arctic ice pack, is accounted a good Eskimo.

The same technique was applied long before this to the re-enactment of historical episodes in the history class, and the whole idea is only one step ahead of what used to happen in the civics class where the students elected a "government" and proceeded to deal with a local crisis through their own officers.

The social studies group could work in this manner at any age level, but science and mathematics are perhaps more obvious fields for a growing logical mind, although present courses in these subjects are apt to ignore all elements of personal solution and insist on a rigid adherence to the propositions and proofs in the book. Yet the possibilities are there. A natural habit of inductive thinking, of seeking hypotheses and alternative solutions, may come to any student whose curiosity has been aroused, and after the beginning of adolescence he is as likely as not to taste the pleasure of using his skill in thinking for its own sake. He reasons deliberately from then on and may one day acquire the feeling of the true scientist that the ceiling for speculation is the endless sky above him—as long as new evidence begets new generalizations and new generalizations beget new hypotheses. This is an exhilarating feeling, and the confidence that arises from it is very like the confidence of creativity. Attaining it, unfortunately, depends a good deal on the school and eventually on the ability of a student to organize his own education. The sciences may hold the whip hand over the humanities in matters of administration, but at the academic table they are often glad to share the same crust of bread.

[3]5.5
Special
Devices and
Techniques

Our references to reason and intuition actually conclude our treatment of method, but it is impossible to leave the subject altogether without noticing a group of miscellaneous teaching expedients that do not slip

into any convenient classification. Some of them, like the mechanical aids, have an appearance of being spanking new; others, like "drill," are as old as mankind. Teaching machines, however, are really only an extension of drill, since they are used to test the memory of a set of correct answers supplied by the programer. A pupil's response must ordinarily *confine itself to the thinking of the programer,* and there is serious question as to whether anything but mathematics should be learned in this way. For many years educators have tended to minimize drill, believing that facts can be retained better by the use of natural association. The temptations of the machine, however, seem to be very great, and it is rapidly taking its place in our equipment.

The "canned" lecture is a different matter because, like a live lecture, it comes to a student in the form of opinion that can be discussed later on in class. Recording a lecture is simply a means of spreading a teacher's time and can be a means of bringing an unusual teacher to an audience he has never seen. What wouldn't we give for the lectures of Whitehead —or Socrates—on tape?

The expanding audio-visual field is a promising one and has many lessons in it not only for the student but also for the teacher who, in listening to and watching his own presentation of a subject, is given his first chance to criticize himself. In the sound film, moreover, or in its poor relation, the slide tape, we can achieve the long-desired union of several subjects, such as language and history, geography and economics, art and music. The episodes chosen may provide the student with a somewhat cursory experience, and he may one day become too used to these devices and find them stale, but they now appear to extend the walls of the classroom and the pages of the textbook. Perhaps they will also prove to be the first step in a condensation or a realignment of subject matter, thus lowering the barriers between materials that are naturally related but have been divided by custom.

We could prolong the discussion of specific tech-

niques almost indefinitely and give every teacher a chance to recognize his favorite approaches, but our purposes here do not require a catalogue or even an attempt at an inclusive summary. They do require us to reiterate that experimental technique is the active front in education. While it may often seem to lose itself in dogma and complication—and to produce unreadable literature—we must remember that from a similar ferment all our knowledge of education has been distilled. The color of a mixture in process may be no clue to the color of what comes out.

[3]6

Art in
the Pattern

It would defeat the purpose of our inquiry if we sought a larger role for the visual arts in the scene we have just depicted than the one they actually play. What we have been leading up to in this chapter is an impartial scrutiny of their mechanics—in educational material and method. The detail of their operations will appear in the next three chapters when we describe the actual happenings in art at the different levels.

In the meantime it ought to be easy to see the general position of the visual arts in the scheme we have outlined. They are personal stuff. They supply personal meanings, reflect personal feelings, contribute to a person's own particular development. If we think that these things are minimized in our present system, then the visual arts along with the other humanities have a corresponding importance. If they have anything *unique* to contribute, it is the direct training of the eyes and the enlargement of visual experience. Psychologists, as we remarked, look upon this as a large part of total experience, but even without their expert opinion we should feel that an education ignoring the eyes was short-sighted.

They are also productive. English courses are productive, but these two elements of the present curriculum bear the burden of productive learning. Art and English turn something out. It is easy of course to understand the reluctance of educators and of the

public to accord a monopoly of this function, seemingly important and seemingly transferable, to subjects that do not share the material objectives of our times. If such people succeed in transplanting it into other areas, it will be a gain for realism in education, but this will not be accomplished without a revamping of the entire fabric.

In the "time" aspect of method the contribution of art is at least illuminating. It responds directly to a student's impulses as they unfold, it gives play to his motives in learning, it is geared to his general psychological development—but art teachers do not think of it as merely symptomatic of this development. The requirements of its discipline, they will tell you, bring order to the impulses and are therefore educative by definition. Art teachers will not for a moment deny, however, that a student's product during a sequence of years provides one of the best arrays of symptoms that a psychologist could ask for. Studio art, they will add, is an interesting example of continuity in teaching because one phase of it leads directly into another, without loss of momentum, or can be made to do so. If it is pursued in a sequential manner, it enjoys the academic efficiency we have often longed for in other subjects. Knowledge can be applied as soon as it is learned, and the tools of it need not go rusty.

In terms of social experience and the methods derived from that, art is not very different from any other subject. Its students function in a normal climate of opinion where everyone knows the difficulties of technique and is apt to be tolerant of honest mistakes. Originality, of course, is at a premium, and eccentricity, contrary to popular belief, does not claim very much attention. One is comparatively free to affirm one's own ideas or, in a critical course, one's opinions, which are probably arrived at in discussion with the class. In either a practicing or a critical course, however, one may isolate one's self from opinion long enough to pursue one's own meanings, for other peo-

ple are likely to be absorbed in theirs. The common error is, in fact, to take one's ideas a bit too seriously. At any rate there is little pressure to conform, except during adolescence when the disturbances of the period take a hand.

The media of art are, as we have indicated, uncommonly sensitive to *central* motivation, for, in spite of the clarity that we have claimed for visual expression, the student finds the privacy in it we have spoken of. After all, words are the commoner medium. He will commit his intimate thoughts and aspirations to a picture sooner than he will talk of them to a friend. With regard to the *particular* kinds of motivation we have examined, the motor impulses find their most convenient expression in art, and the same is true of the motives associated with apprentice learning. The student is easily persuaded that his work has some value when he knows that he has put his best effort into it—and it may be observed that he does not need an examination to tell him when he has done this.

Since ideas at their best are derived from original experience, his mind is used in all the ways that we listed at the beginning, rational ways as well as intuitive ones. He leans more heavily on intuition, to be sure, sharpening his perception and his judgment, communicating by instinct, sharing the elation of discovery, but this can really be said of any good student. The sensitive art student "creates," however, a bit more freely than another; that was always his claim, and the evidence supports it.

Notes

1. John Dewey, *Democracy and Education,* The Macmillan Company, New York, 1938, Ch. 12. Also in Free Press paperbacks.
2. Professor Jerome S. Bruner, in *The Process of Education* (Harvard University Press, Cambridge, 1962, p. 18) has suggested a more fundamental approach to the problem when he proposes that the basic subjects "be re-written and their teaching material revamped in such a way that the *pervading and powerful ideas and attitudes* (our italics) relating to them are given a central role." He assumes, in other words, that there are basic concepts in, say, mathematics or the social studies that can be implanted in a child's mind at an early age and that these can be constantly broadened and strengthened as the curriculum advances until an organic body of knowledge results. At no time would significant material lie fallow; the elements of knowledge would remain active throughout.

3. See Johann Heinrich Pestalozzi, *How Gertrude Teaches Her Children,* Letter 13. Tr. by Lucy E. Holland and Frances C. Turner and edited by Ebenezer Cook, 5th ed., C. W. Bardeen, Syracuse, N.Y., 1915.
4. Alfred North Whitehead, "The Rhythm of Education," in *The Aims of Education and Other Essays,* The Macmillan Company, New York, 1929.
5. Ben Shahn, "The Education of an Artist," in *The Shape of Content,* Harvard University Press, Cambridge, 1957.
6. Jerome S. Bruner, *Toward a Theory of Instruction,* Harvard University Press, Cambridge, 1966, pp. 61–66.
7. *Ibid.,* p. 45. The three ways of representing are *enactive, iconic,* and *symbolic.*

The Art Course in Practice: Elementary Art

4

Mr. Arthur Perry, Headmaster of Milton Academy, once regaled a commencement gathering with the following essay, alleged to have been written by a ten-year-old boy in his junior department. The class, he explained, had been asked to write an essay about a bird and a beast:

The bird I am going to write about is the Owl. The Owl cannot see at all by day and at night is as blind as a bat.

I do not know much about the Owl, so I will go on to the beast which I am going to choose. It is the Cow. The Cow is a mammal. It has six sides—right, left, and upper and below. At the back it has a tail on which hangs a brush. With this it sends the flies away so that they do not fall into the milk.

The head is for the purpose of growing horns and so that the mouth can be somewhere. The horns are to butt with, and the mouth is to moo with. Under the cow hangs the milk. It is arranged for milking. When people milk, the milk comes, and there is never an end to the supply. How the cow does it I have not yet realized, but it makes more and more. The cow has a fine sense of smell; one can smell it far away. This is the reason for the fresh air in the country.

The man cow is called an Ox. It is not a mammal. The cow does not eat much, but what it eats it eats twice, so that it gets enough. When it is hungry it moos, and when it says nothing it is because its inside is all full up with grass.

Did the author illustrate his essay? We hope so. If he didn't, any art teacher, and maybe a few parents, would be able to imagine the drawing: the businesslike horns, the paintbrush tail, the plaintive mouth designed for mooing, and the mysterious arrangements underneath for milking. Many a drawing of this kind has been found among the pictures Jimmy brought home in June and often, it may be added, has gone unnoticed. Parents for some reason expect a higher degree of realism in a drawing than in an English essay.

Art teachers know better. Realism in drawing has

usually not begun to appear at ten; the drawing then is the product of the same maturity as the essay. There are, to be sure, a few differences, and not wholly in favor of the latter. At ten Jimmy has put more English composition under his belt than art and has learned to follow an adult form of writing, albeit with a fine sense of boredom. He has also accumulated a certain amount of scientific information, which he manages to hand back with a twist of his own. Under the circumstances the essay is perhaps a little more of an achievement than the drawing, being produced under more arbitrary conditions. Its literary quality at any rate is a reassuring example of how originality and the values of childhood may survive six years of primary schooling.

We may well be grateful for the toughness of kids! Bringing out the best in them is a difficult, a fearful business. The thing to recognize is that it is just as hard in one department as another. It is just as hard to train the eyes and the hands as it is to teach the handling of words. If we consider the eyes important, we can expect a slow process of education.

How do we go about it and what can we point to that will equalize it, in the eyes of authority, to other "disciplines"? Our first answer is a defensive one. Art teachers behave like other teachers. They bring forward material that seems appropriate to the age, they observe reactions, note how interest is engaged and how it moves from point to point; they try expedients, encourage the development of skill, respect individuality, and praise results. Could anyone quarrel with this?

There are important differences in the classroom business of art, however, and among these are items that lower its respectability. Art is not usually taught from textbooks, although the teacher may in his own mind be following a text. There are no printed exercises of graduated difficulty and, consequently, no testing to see whether a student meets the standard determined for him. There is very little repetitious "practice," and all of this interferes with the keeping

of records. One wonders at times how much of our teaching is the result of having to keep records.

A more significant difference in terms of educational theory—and this may be startling to some—is that an art teacher sets the best example in empirical method that you will find in the school. He or she actually proceeds in the manner of the experimental scientist, guessing at what may be needed by the class, setting the task, handing out the tools, and then looking sharply at the results. In no other class in school is teaching so dependent on direct evidence.

An art teacher is often a rather superior educationist. His defensive position, his comparative freedom from rule, and perhaps the nature of the subject itself combine at least to make him analytical. He makes a fetish of original effort among his pupils and is in a rather better position than most teachers to take stock of it. Conformity has no appeal for him: he is automatically on the side of excellence. His commonest fault is a sentimental enthusiasm for the work of children and a tendency, greater than in other teachers, to overprotect them. When you talk with art teachers, you are always running into the opinion that a timid pupil is to be shielded from criticism, from competition, and from the grading system, lest his flickering confidence in himself be extinguished. We shall have something to say of this as an educational tenet, but at the moment we may think of it as the product of zeal.

[4]1
The First
Experience

Procedures in art vary enormously. The ones illustrated in these chapters will be recognized by most art teachers, if only to provoke the comment that they can be improved upon. The first one is in the kindergarten.

When the kindergarten bell rings, the youngsters know that they are having art because pans of poster colors appear along with sponges and flat bristle brushes. They start pushing the brush around a sheet of paper as automatically as they performed the last task. The colors run together, new colors appear from the mixture, and then with a little encouragement from

the teacher the whole business of color and pattern assumes a deliberate character. The essential process of training hand and eye begins without a demonstration from anyone.

Children are said to be more interested in the process than in the results, which may be spoiled by too much experiment, but they are not averse to having something to show at the end of the period and not at all insensitive to praise, which the teacher can honestly give because a child's instinct for color and arrangement is often, though not invariably, good (Plate I). That he produces an arrangement at all is in fact an achievement. If a parent is inclined to doubt this, let dad face a blank sheet of paper with a coarse brush when he plays with the kids in the evening, and if he manages to produce more than a few lame representational strokes, he will be a very exceptional fellow.

The span of attention of a four-year-old is supposed to be short, and he may find himself provided with a lump of clay before the end of the period and invited to prod it, dig in it, bang it on the table, or roll it out in strips. He likes handling clay. It has a good squdgy feeling, and soon he is preoccupied again with discovering what kind of look you can give to it. Unlike paint, however, it has an automatic third dimension, and an accidental squeeze may suggest the shape of a familiar object. In this way the possibility of representing objects may dawn on him. His first deliberate shapings of the lump or his first attempts to assemble little chunks of it—the two methods that every art teacher knows about—may not result in anything that can be identified by anyone else, but he is glad to name them for you. Before long the products may start living up to the name, after a fashion. The teacher—let's assume it is a woman—comments on this pleasantly, but if she is a purist, she makes no attempt to take a hand.

An up-to-date art teacher usually has a variety of "media" up her sleeve. She will bring out bits of colored paper, cloth, leather, wood, or what not, which the child likes to assemble, or can be induced to as-

semble in collages, mobiles, stabiles, or similar contrivances; but it is doubtful whether his artistic education at this time needs more than just three items to work with: a manageable kind of paint, a malleable material like clay, and something to make a line with.

Simple as these beginnings are, his innocent head is shadowed over by a dichotomy in training which will haunt him all his days and which only the most enlightened teacher can keep in balance. It is not the dichotomy you might expect, between abstract and representational art, but rather between pleasing the eye and recording personal experience, whether the record be attractive or not. The teacher with an aesthetic slant favors products that have "charm," or show an "interesting" use of material. The teacher with an interest in psychology may see in a child's product nothing but a symptom of development. Biased teachers are often good teachers, but the bias itself is not defensible. Ideally, the two objectives should be harmonized.

In this context you may test the leanings of a teacher by his attitude toward plain pencil drawing. A pencil, or even a fat crayon, is about the hardest thing for a child to manage and the least rewarding in quick effect. One cannot say how often a child would naturally choose it; usually the choice is not left to him. But children do like to make lines, partly perhaps because of the challenge in them and partly because they state facts squarely and allow for more detail. On the whole they are a better medium for conveying experience, and the group of teachers that shies away from the scratchiness of them, or worse still seeks deliverance from the constant repetition of conventional circles and straight strokes, may be forgetting a large area of the child's mind and ignoring the commonest means a child has of establishing his mastery over a process—doing it again and again.

Make no mistake about the excitement of a child's early attempts at representation. Rudolf Arnheim has given an excellent account of it.[1] The first circle on a blank sheet of paper is like the creation of matter. It captures something out of the void. And the first

almost-straight line is a miracle of muscular control. All the mechanics of the hand and arm conspire to thwart it. When children master these two things, they use them for everything, and people say, of course, that they do not observe nature. They observe nature very well and would never mistake one of their friends for another—but with limited means at their disposal they draw them both alike (Figure 12). A drawing, after all, is a *drawing*. It is not what you see but what you can *do*. A child's keenest visual experience at this age comes from an attentive *doing*.

Not all the time in the kindergarten is spent in rapt attention. Children move about freely and talk projects with their teacher, proposing topics from their immediate experience (Figure 11)—the bulldozer across the street or the last story read in class. The canny teacher will see that their visual diet is enlivened, not only because variety is good in itself but because every child has one thing that he can do better than anything else; if you try long enough, you may hit upon his specialty and give a backward child a lucky chance to excel. There will be grand topics and frivolous ones, mechanical ones and sentimental ones, topics for boys and topics for girls. (See also Plate I.)

Variety serves the further purpose of enlarging the working vocabulary, that is, the number of objects for which a visual equivalent has been found. When very young children are in the habit of drawing people without bodies, connecting the arms and legs directly to the head, a story mentioning a man's fat belly will force them to find an equivalent for "belly" and make bodiless figures things of the past. A vocabulary grows very slowly by these methods and may not be very large at the end of the year, but everything in it is a record of something needed; every new shape represents a minor conquest for the child.

[4]2
The Fourth
Grade

It is a long span between the kindergarten and the fourth grade, and if we pick that as a next visiting point, we expect to find a very different classroom and a very different art pupil, though he still draws

11.
Interest in environment appears early
. . . *Fire Engine.*
Newton (Mass.)
Public Schools,
Grade 1.

12.
. . . coupled with an interest in one's friends. *Portrait.*
Newton Public Schools, Grade 1.

like a child (Figures 13, 14, 15, 16). A well-adjusted member of the class, whom we may as well call "Jimmy," has taken on the air of a professional schoolgoer by now. He knows the ropes, has read all the stories on the shelf and considers them baby stuff. He can write a fair paragraph but has attempted nothing quite as ambitious as an essay on a bird and a beast. He does long division well, provided it comes out evenly. His attitude toward art is nonchalant. He knows three "media," in the sense that he can control his hands in them and produce effective combinations of the forms he has mastered. What are we doing today? Oh, poster colors—better than English.

In crossing the room to get a piece of charcoal, Jimmy finds time to steal the thumbtacks from his friend Bobby's board. Bobby discovers the theft and is poised to flip a brushful of red paint after him when the teacher intervenes. Both boys retire, grinning, to their desks, ready for further mischief but ready also to broach the project talked of, the class picnic.

The picnic took place at the lake, and water means boats. Jimmy wonders if Bobby thought of boats and looks cautiously over his shoulder. No, same old thing. Line across the bottom of the page. Telegraph pole. Man carrying a basket. Jimmy decides he can do better than that and creates a boat in full sail in the top center, putting a dock to the left, high out of water with a ladder going straight up. Then he puts in a few fellow classmen—lower right—building a fire, with Mr. Thomas and a girl or two watching. All his figures are stiff and competent with round heads. The girls wear triangular dresses. Finally, with a stroke of inspiration, he puts himself rowing a girl in the very middle and decides he is ready to paint. He dips his brush . . . Golly! What a blue! . . . and from now on he is well absorbed in mixing colors.

Bobby meanwhile has gone in his own direction. More thoughtful than Jimmy, he has been very careful to do his people in relative sizes, Mr. Thomas big, the girls small. He shows that they are on the ground by drawing a line under them straight across the page, the "base line" familiar to all teachers. He recalls the

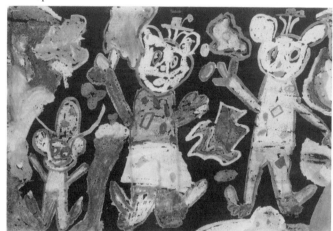

13.
Goblins. Fessenden School, Grade 4.

14.
Fisherman. Newton Public Schools, Grade 4.

The range of interest in subject matter, entirely apart from any interest in medium, is very conspicuous in the fourth grade. It may run from wild fantasy, as in Figure 13, to the whimsical poetic attitude seen in Figure 14; it may respond to the drama of nature, as in Figure 15, or proceed from mere descriptive insight, as in Figure 16.

15.
Landscape. Fessenden School, Grade 4.

16.
Road Stand. Fessenden School, Grade 4.

fact that the girls dressed very differently from one another, some of them in party dresses and some in dungarees. They carried lunch boxes, and two boys struggled from the bus with a heavy container of water. Oh yes, the bus. Can all this go on the base line? No, better have another line higher up. And since he has few devices for showing distance, he cheerfully connects the two lines with a thin rectangle—the path, in the middle of which the two water carriers stride manfully. The water of the lake he is content to show merely by a wavy line at the very bottom of the page.

When the two pictures are finished, both sheets are well filled. Jimmy's is vigorous and splashy, strong in color and curiously suggestive of the real scene. He feels satisfied. Bobby's is cautious in color and full of details that are carefully though not photographically related to one another. He stops work wishing that he had had more time. Both boys respond to the bell with alacrity, however, and rush off with the others to recess.

The last to leave the room is a shy girl with dark eyes who has been working as near the corner as she could get, and her picnic is very different. It had not been a happy occasion for her; it came on the day when Mummy and Daddy had gone away, and they had tried to ease the parting by attending the picnic.

Her picture shows a girl in a blue dress standing tragically in the center stretching much-too-long arms toward Mummy and Daddy, who turn away. The picnic guests are relegated to corners, but rising beside the girl in blue is a tall tree with a black trunk whose dark green boughs wave threateningly over her head. The whole effect is terrifying, stronger and more deliberate than anything done in class; the teacher watches it anxiously, trying to smile in encouragement. But the child rises finally from her desk and scampers away after the others—feeling immensely better.

[4]3
The Eighth Grade

In the eighth grade things start to happen, from an adult point of view at least. (See Figures 17 and 18, and Plates II and III.) Jimmy, a husky lad of thirteen,

17.
Hands. Milton
Academy, Grade 9.

18.
*A Man Fallen Among
Thieves.* Milton
Academy, Grade 9.

Work of children in the eighth and ninth grades may have all the benefit of sharpened faculties without the inhibiting effects of adolescent self-consciousness. The illustrations on this page, as well as Plates II and III, speak for themselves.

is a strong figure in the art class, strong in the eyes of the others because his pictures have a look of nature. He is self-confident, but he is willing to ask questions. How do you make the hill look far away? What's this business about the sky and the horizon? Things get in front of one another, don't they, and cover each other up. Fine! You don't have to draw the part you don't see. Even Bobby is impressed with this argument and becomes aware that two base lines are not the best means of relating many details. It might be better to crowd people in behind one another in Jimmy's manner. He suddenly realizes that there is a lot of room in a picture. It can be a mile deep and hold a hundred or maybe a thousand people.

People and things are beginning to be interesting to look at. Everybody doesn't look alike. Jimmy's ears stick out. Katie's don't. Reddy hasn't any eyebrows. Maybe that's what gives him that surprised look. He remembers a house that had a surprised look. You could make a painting out of it. You can make a picture out of nearly anything—even out of those old bottles and milkweed pods the teacher set up on the table. You could get better things than old milkweed pods, though. Maybe you could find some of those red berries in the swamp or some dead branches like the driftwood Mom brought home.

Bobby and Jimmy are equally intrigued with new ways of painting. They have been introduced to oil paint, and you can really pile it on. Bobby tries out a few brushes and finally settles on a large one, then a small one for outlines. Jimmy, who is waiting his turn, is scornful of small brushes, grabs three big ones and with a minimum of outline on his picture starts making figures and trees "just appear" out of the brush strokes.

Emmy, the dark-eyed girl, has turned into quite an artist since the fourth grade, although she is given to doing queer things—that clay head with its mouth open, which someone said was down in the principal's office, or that skinny woman banging on a closed door. Curiously enough, no one else in the class had thought of doing the project like that. The teacher had simply

said, "Show how it feels to be stopped by something," and Jimmy had made a swell picture of a roadblock with a truck trying to get by a fallen tree. It ought to have had first place, but Emmy's, somehow, was better, without half as much in it. Jimmy is pretty good in art—in math and baseball, too, but he doesn't like to study. Emmy is good at everything, especially art and English, and does like to study.

We could go on multiplying the cases with the three children or we could choose three others just as far apart and show how childish imagination can be poetic, whimsical, ingenious, dramatic, or decorative, according to the temperament at work. We could show also how the subject matter of the English class, or science, or social studies may be reflected and co-ordinated with what the children draw and paint, assuming of course that these subjects are taught with any imagination or attention to the child's interests in the first place. The art course is near the center of the departments of Imagination and Motivation, and if you want to discover what a child *is* at a given point, you can hardly do better than look at his art, although the revelation may not agree with the one presented in the school records, which are based on verbal and mathematical skills.

The cases described here refer merely to the development of three normal children in perhaps the upper third of their class, whose intelligent teaching has allowed them to follow their own peculiar interests. Encouraged by their results and helped, no doubt, by the advice of the teacher, they have found the technical means they needed in art in much the same way as they would find it in the best English class. It goes without saying that to attain proficiency in anything by one's own efforts instills a confidence that is reflected elsewhere in school. At thirteen a fair proportion of the class is doing convincing work—its quality startles even the veteran art teacher—and the total effect on attitude is considerable, particularly if the rest of the school values it.

It is perhaps this sudden effectiveness of a thirteen-year-old that led Viktor Lowenfeld to conclude that

psychological types crystallized at this age, although we have had plenty of reason for noticing types before this. Lowenfeld has been influential in American teaching, and it is worth a moment's pause to examine his theory, which is a simple one unrelated to current psychological beliefs, and not really related to any aesthetic considerations either. Children, according to him, are unequally drawn toward an outward realism and separate at this age into well-marked "visual" and "nonvisual," or "haptic," types, the latter word being coined from the Greek *haptein*, to fasten or fix upon. The "visual" child registers the appearance of things, understands distance and perspective by instinct, and treats objects in painting and sculpture with detachment, viewing incidents as a spectator. In this he differs from the haptic who is a strong participant in his scene. Being self-absorbed and complex in his emotional make-up, the latter fastens onto bits of environment have have touched him *physically*; he cannot withdraw and look at them dispassionately. His sense of perspective is rudimentary or distorted —and we are thus given an easy explanation of some of the vagaries of modern and ancient art. With a touch of naïveté Lowenfeld puts Picasso among the haptics.

Now there are a good many ways of explaining distortion, whether in Picasso or in school children, without resorting to types. A distorted perspective of the kind he describes appears in oriental and medieval art, and there is no reason for supposing that there were more haptics in those cultures than elsewhere. The devices used are simply an earlier and far-from-ineffective means of illustrating depth in a flat picture; they do not suggest a primitive mentality but only a late attention to this particular point, perspective in our sense being a late-comer to art.

We don't have to accept the Lowenfeld explanation of the phenomena he observes, but the phenomena themselves are real, so far as they go. There *are* people with objective and subjective attitudes. (See p. 168.) The child swayed by his feelings *may* be careless about his perspective, although this connection is

not very well proved. Age *does* have something to do with the maturity of a child's products, although a good deal of study is needed to prove the relative importance of age and experience.[2] It was with these facts in mind that we watched Emmy in class and watched Jimmy, her polar opposite.

Jimmy, as we saw, was a lad of strong animal spirits. He enjoyed paint and color for their own sake and presented his subjects—from a well-chosen vantage point—with the gusto of a reporter (Figure 18). Emmy for her part was an actor in her stories, projecting herself into their main characters and suffering with them (Figure 17). The background was important only as it affected them or her. It might disappear, or it might come forward and enfold them. And because she was brilliant and sensitive, these simplifications produced powerful results, giving her at the same time a release from tensions and a habit of organizing her feelings, a first step toward objectivity. A shy girl originally, she became an accepted member of her class because of her patent ability. If her limited use of perspective, however, was the result of a real block in this direction—and intelligent people often have such blocks—it would have been a fatal mistake to force her to study the conventional theory. A few despairing attempts would have finished her in art, and all her personal gains from it would have vanished.

If we really wanted to make a useful list of types, we should not stop at these two extremes of detachment and emotional participation, and we should certainly try to apply them beyond the field of art. Our friend Bobby might come in as an "intellectually curious" type, and we should probably discover "inventive," "poetic," "romantic," "reflective," or "satiric" categories, into which other children would fit in varying degrees. A good many more scientific classifications have been made, but they are difficult to use in class, and until they are simplified, the average teacher will do better to approach the classification of children[3] informally.

Authorities differ on the precise age at which the tide of free expression in children runs fullest. It is

partly dependent on the range of grades in the school. If the child has to change school after the eighth grade, as he usually does, then the inhibitions that appear with adolescence may be hastened by his new life in the high school. If the ninth grade falls within a six-year preparatory period, as it does in certain private schools, then he may have another year of grace and a brilliant one in the art class. Whatever the school system, the crisis that we spoke of in the last chapter is not to be postponed indefinitely. An awareness of adult standards comes over him as suddenly and as disastrously as a similar bit of knowledge came into Eden, and from this point onward he has to do deliberately what he has hitherto done without thinking. The headlong development of childhood appears to be over.

The relatively few art teachers who worry about this period have found expedients to bridge the gap. Lowenfeld himself has sensible advice. Children, he thinks, can be nudged toward mature techniques while they are still in their unconscious stage, and these facilities will be ready or nearly ready to shove into the breach. Some children can be brought very close to an understanding of "correct" perspective, if this is what they seem to want, by merely being asked to notice distance and the overlapping of objects, as Jimmy did for himself. Color may be a connecting link. An adolescent's interest in color is usually more subdued but not necessarily very different from that of a child. Sympathetic teaching can do a great deal to restore lost confidence—which is not confined to the art class. But the school system will not usually permit this. The average child gives up art after the eighth grade, and if he returns to it later, it will be with a totally new outlook and without a trace of his former momentum. Is his elementary training buried beyond recall? Probably not, but the secondary school teacher will have to probe for it.

[4]4
The Web
of Planning

In our description of the elementary scene we have not said much about the teacher except to imply that he or, more likely, she is a sympathetic person who

never interferes. Her activities though have been extensive, to put it mildly. She must chart and navigate the entire course with only her intuition and empirical experience to guide her. Her threefold objective is nothing short of complete personal development, effective visual training, and useful cultivation of taste, useful, that is, for future citizenship. Few other teachers undertake so much. Her job is not made any simpler by the fact that in primary school she is usually two persons, a supervisor who plans the program and a classroom teacher whose main qualification for the job is that she knows the children.

In attacking her task, she must hit upon a variety of imaginative projects, which will not only awaken the latent specialties around the class but which will remove inhibitions as well. It is good for a pupil to work outside of his specialty for a time, but it is no easy matter to keep a program with such various aims in rhythmical swing among topics that are always fresh and new. It requires a gift for simplicity and a limitless capacity to improvise.

Individual growth, moreover, is conditioned by morale, and here the teacher will have to pick her path carefully. Rewards, grading, and competition are thorny topics in an art class, and unless a policy has been laid down by the school, she must decide her attitudes for herself. Does she want to display paintings as a reward for good work—and risk hurting the pupil whose work is not shown—or does she want to risk hurting the other pupil who may need such a stimulus? The latter pupil may not be the best in the class but rather the uncertain one who has been quietly coached to the point of qualifying. It is hard to take the stand that he should not be rewarded for improvement or that a permanent shielding from criticism is better than strengthening him to meet it; but such a stand has often been taken.

The best of art teachers will find these choices hard, but how much harder will they be for a grade teacher who may never have had any interest in art! It is only too possible that she will be impressed by meretricious or precocious work and will make it the standard of

the class by putting it up for display. We cannot help her in this, nor have we any advice for her about morale. We have only one point to make in this entire area, and it is concerned with grading. The grading in art should follow the pattern of the school. If conventional grades are the rule in math, they should also be given in art. A child will respect a course much less if a school does not think that it deserves a rating, and he will never suffer any harm for having his effort and his improvement recognized.

As for training the eyes, the teacher has an easy time before the seventh grade and a much harder one after. The younger children teach themselves, as we said, by their searching attention to their own work; the older ones have begun to observe nature, but they can be tipped off on what to look for. A scientific interest sometimes gets them going. Show them how a tree grows and spreads its leaves, and they are no longer satisfied with trees that look like icecream cones. Show them how a face is made up of muscles fitted over a skull, and a jack-o'-lantern face looks foolish. The easiest way, however, of making children notice closely is to ask them to collect small objects whose intrinsic shapes, colors, and textures are good to look at—and then ask them to draw them, perhaps from memory. Memory drawing is, in fact, the quickest way to observation; when you miss something on the first glance, you look more sharply on the second.

Collecting, of course, is traditionally associated with taste or, to use a less effete word, with discrimination, which is the third part of the teacher's triple objective. Almost anything that happens in art class can involve taste, which is ultimately a matter of good looks—or perhaps a good general *look*—but there are some activities that provide for taste very directly and some that have a particular bearing on the future. Teachers with an aesthetic bias sometimes favor experiments in pure color and medium, abstractions of sorts, as well as the moving or stable constructions made with wire and bits of material. Obviously these activities give children a chance to make imaginative

choices; what must be weighed along with them is the rival appeal of live subject matter. The inclusion of crafts in a program must be weighed in a similar manner. Crafts stress the value of materials, and many a grown-up remembers what he learned in school about wood and metal and tools to work them. But crafts are time-consuming, and the novelty of them can make them time-frittering. The linoleum-cut Christmas card has been known to claim a quarter of a year's effort. Craft projects should be chosen clearly, not for their ability to provide novelty but for their ability to reinforce something already learned.

The most conspicuous other means of cultivating taste—and the hardest one for the elementary teacher to provide—is familiarity with works of adult art, and this may be a more crucial matter in education than we think. People born before 1914 sometimes had their whole lives conditioned by a Madonna in the bedroom or the sepia prints of Raphael in the library.

It is with this in mind, no doubt, that the directors of certain primary schools have provided simple picture puzzles of Picasso, Kandinsky, and Chagall for the kids to put together, thereby ensuring a suitable future patronage of the museums. In more conservative private schools children are plunged back into history and persuaded to adopt the mannerisms of Greek or medieval art in designing a play. Sometimes these projects are harmless enough, although they can become trivial or an obvious bid for parent interest. It is normally harmful, however, to suggest an adult technique for a child's work, for it prevents him from finding his own. Wherever we can recognize the look of some painter, be he Giotto or Rouault, it is a sign of bad teaching. Paradoxically enough, this is not true in work at the upper levels where the student is exploring technique deliberately and can scarcely be prevented from trying out a method that he has seen somewhere. If imitation had always been excluded from *professional* art, our cultural history would have followed another course.

The best way for a child to look at works of art is to know them as articles of furniture in his life. The

teacher should make them available on walls, in books, and in anecdote and should see to it that they are of many kinds. To ask young children to analyze them and recognize that artists are really doing the same sort of thing as they smacks of adult procedure and returns us also to the now-familiar dichotomy between the aesthetic outlook and the developmental one.

Our attempts to sketch the elementary picture must stop here. When all is taken into account, it is a more complete picture of general education than we shall be able to paint later on. What will follow will be more fragmentary, more experimental, but it is a part of the same continuity.

Notes

1. Arnheim, in common with most psychologists and perhaps most art teachers, assumes that representation is a basic urge in children. Actually this is not proved. It may be that children respond to what grown-ups expect of them. The following episode suggests at least the need for wariness in teaching: An art teacher known to the Committee came upon his three-year-old daughter engaged in making a beautiful pattern in water colors. "What is it?" he asked. "Spots, Daddy," she replied. "Yes, but what is it a picture of?" "Spots, Daddy," came the steadfast reply.

2. According to the studies of Gustaf Britsch, a Swiss art teacher active in the first quarter of this century, the instinctive work of both children and adults follows a definite sequence in developing devices to represent nature. "Primitive" perspective and expanding observation, according to his theory, have nothing to do with age but depend solely on a person's experience in his medium. For a discussion of this at length see pp. 162–166 in the Teaching Supplement.

3. Classification is discussed at some length in the second section of the Teaching Supplement.

The Deliberate Approach: Secondary School Art

5

There is little doubt that art education at the secondary level is in a state of confusion. It varies tremendously from school to school and runs the full gamut from nonexistence to a fairly comprehensive program of elective courses for the talented few, with courses in "Art Appreciation"—variants to a history-of-culture program—coming somewhere in between. As a growing organism, it is caught in a bind between a nominal acceptance of its creative and cultural value and the pressure of the college entrance requirements. It is about as bizarre a beast as the magical cow in the last chapter.

One reason for the dilemma of secondary school art is an honest perplexity among educators over the special character it should assume. In elementary school we find a ready acceptance for art as therapy or as a means of bringing about a balanced personal development. In college, art is recognized as a valid major for any student inclined toward it, and as such it enjoys a departmental status. In secondary school it has no clean-cut character; it has sometimes chosen to imitate the balancing function of elementary school art, sometimes the specialization of the college course. More often it emerges as a sort of amphibian somewhere between the elementary school fish and the college fowl.

It is no great surprise that college admissions departments have chosen to ignore secondary school art courses that are either extensions of the elementary school offerings or tailored-down versions of college courses in architecture, sculpture, painting, or art history courses—ostensibly on the grounds that such courses are hard to evaluate. It is more likely that the colleges are hopeful that the secondary schools will develop the "amphibian" art course, since such a course, if properly guided, could have a direct value in general education at a time when its need is greatest.

To fix its character may require a deep breath and

a hard new look at the matter. In an age when the fragmentation of knowledge is most pronounced, the greatest need might be a device through which to see things whole. Does art furnish such a device? That has often been its role.

Take, for example, the preschool child who draws a picture of a man, a house, and a tree—and then a sun and a moon. The parent steps in and says, "You can't have the sun and the moon in the same picture. One is for day and the other is for night." But the child is right; all these things do exist together. The human animal at the beginning possesses an all-encompassing view of the universe and does not quibble over time and space.

[5]1

An Illustration
in Depth

When we first put children in a school, we tell them to forget the universe and start working with A, B, and C. We go to the opposite pole of comprehension. We steer them toward specialization from the first grade onward, starting them out with basic components and gradually increasing the size and complexity of the components, hoping somehow to attain a grasp of the whole through a study of the particular but never quite achieving it. Their faculties become dull, overloaded, paralyzed, in consequence, so that by the time they are mature, many of them have lost their innate capacity for comprehensive thought. The great need in education is for a means of bringing things together again.

The secondary school art course can contribute in three ways by

1. Developing the student's design faculties, design being the visual union of a student's thoughts and impulses.
2. Showing how man's faculties have led him to be a creative person.
3. Providing him with the physical experience of producing.

In nature an amphibian is a bridge between two biological orders. An amphibian art course seeking to bridge a similar gap reminds us of a proposal made by the late Will Rogers. "Let's build a bridge across

the Atlantic," he said. "I'll give you the idea. You work out the details."

Just how do we work out the details?

Since there are actually plenty of bridges of different types among our secondary school art programs, it may be more profitable to examine one such venture in detail rather than make an effort to cover the waterfront. The Phillips Academy program at Andover will serve our purposes, first, because its aims are fairly inclusive, and second, because it is a familiar one to at least two members of the present committee. It is interesting, too, because the history of it is a bit curious. When facilities for art were originally provided at the Academy, the diploma requirements were altered to include "an exposure to the arts" for everyone in the eleventh grade. The new program created by this abrupt fiat had the unique problem of adjusting to a captive audience.

This accident of birth determined its future role as an instrument of general education. During a quarter of a century of development two operating principles were gradually recognized: (1) that a certain balance between practice, or studio experience, and theory, or lecture and recitation, was more desirable than either experience alone, and (2) that it was essential to find media for the studio experience that *all* the students could master in a limited time, since a useful earlier experience could not be counted on.

Observing these two practical considerations—and a schedule of four classroom hours a week, unprepared—the Andover Design Course consists at present of one hour a week of photography, one hour of elementary drawing or two-dimensional design, one hour of three-dimensional design, and one hour of lecture, the practice-theory ratio being thus three to one—which seems about right. Now let's see how this format applies to the goals listed.

[5]1.1
Developing the
Student's Design
Faculties

According to the Jung analysis mentioned in an earlier chapter, the four areas of a man's awareness are to be found in his sense perceptions, his intellect, his emotions, and his intuitions. Since traditional education is clearly oriented toward the verbal and mathematical

skills, which are usually products of the intellect, it is high time we exploited some of the other areas of cognition that would appear to provide about three quarters of a person's mental equipment. The visual arts are natural operators in these areas. At the heart of invention or of creative design is an ability that leans heavily on sense perceptions and intuition, the ability to "see relationships." Man's great steps forward in either the arts or the sciences have always come when he has been able to see order in what appeared to be chaos, to see similarities of quality and pattern between fields formerly thought to be diverse. It is with an emphasis, therefore, on seeing, on perceiving visual relationships, that the photography and drawing studios are most concerned.

Photography is a great gimmick. It has the advantage of producing an image with extreme rapidity, and through darkroom procedures the image can be manipulated. The basic mechanics are simple, and contrary to popular belief it need not be expensive. Two or three cameras can be passed around the class if cut film is employed, and the student can make his photograph and develop his negative in one period. He can follow his negative through contact printing and enlargement. Photograms, too, the images of actual objects laid upon photographic sheets, provide another miraculous method of producing an instant effect (Figure 19), and these can be made with no equipment but a flashlight and photographic chemicals. They serve as a splendid way of using up out-of-date paper, incidentally.

The photographic problems given out at Andover are visual and not verbal; the emphasis is on what the eye selects, on such qualities as the play of light on texture, on visual rhythms, and on particular shapes. The point of this part of the program is *not* to train people in photographic techniques, though this happens to occur, but to encourage the students to use their eyes, to look around them and exercise their "seeing muscles." And it works! *Seeing* actually leads them to *perceiving* relationships. (Figures 20, 21, 22)

Drawing is also an exercise in selective seeing, with some hand-and-eye co-ordination thrown in. The first exercise for the students is a "shaker-upper," and consists in writing one's name normally as a signature, then backward, then upside down, and then upside down backward (Figure 23). This is really a Renaissance doodle problem, and Leonardo da Vinci was an expert. Exploratory exercises in the use of various drawing tools follow: contours done with bamboo-reed pens, convolutions with crow-quills, proportion exercises, and finally selective exercises in figure drawing—just the volume of the figure (Figure 24) or just the folds in the clothing. The ability to know what to leave out is very important here and leads to a consideration where the drawing *isn't*. In line with this the next exploratory step is to create situations through black and white collages, or designs in pasted paper, where the effect is one of black on white or white on black (Figure 25) and situations where the black and the white are of equal importance (Figure 26). Work on color collages follows and occupies much of the winter term, while in the spring the students return to nature and do much of their drawing out of doors, their skill reinforced by their experience in seeing and by their realization of visual spaces in the collages.

Sometimes curious correlations occur between pattern problems and photographic ones; a purely abstract approach in a collage can yield a result astonishingly similar to that of a photograph taken from nature. In the student show at the end of the year many of these visual relationships become evident as the work from the various studios is put on display.

[5]1.2
Showing How
Man's Faculties
Have Led Him to Be
a Creative Person

The lectures, because they are for the most part visual presentations, offer a fine chance to fortify these visual relationships again; they do it through multiple projections of slides, through frequent motion pictures, and through a continual bombardment of images in general. The lectures encourage the first goal, that of developing visual perception. They are the backbone of the course, dealing first with those universal vehicles

19.
Photogram. Phillips
Academy, Andover,
Grade 11.

20.
Sensuous Surface.
Phillips Academy,
Andover, Grade 11.

21.
Strong Shape.
Phillips Academy,
Andover, Grade 11.

22.
Syncopated Series.
Phillips Academy,
Andover, Grade 11.

The photogram (Figure 19) and the classified visual experiences illustrated in Figures 20, 21, and 22 are all examples of how the camera helps a beginner to use his perception without having to clear the hurdle of a manual skill.

23.
Variations on a Signature. Phillips Academy, Andover, Grade 11.

24.
Figures Seen as Volume. Phillips Academy, Andover, Grade 11.

Skills are desirable, of course, in art as in any subject, because they promote fluency. The adroit art course will cultivate them in easy steps that allow the student to keep his full attention on the visual qualities of what he is doing.

25.
Black on White.
Phillips Academy,
Andover, Grade 11.

26.
*Black and White as
Equals.* Phillips
Academy, Andover,
Grade 11.

of design—line, rhythm, color, composition, and style —and then with the four areas of awareness, showing how four major viewpoints have arisen through which we can trace man's productive history. Perhaps this statement can be clarified with a chart.

AREAS OF AWARENESS	VISUAL EMPHASIS	POINT OF VIEW
Senses	Focus on appearance —material and texture	Naturalism
Intellect	Focus of systems of order, structure, and relationship	Classicism
Emotions	Focus on drama, expression, mood	Romanticism
Intuitions	Focus on judgment, intrinsic qualities, or unexplained relationship	Expressionism Mysticism

These four points of view enable us to trace art history in a general way without the restrictions of a chronological outline and also enable us to leave out certain styles and periods that tend to get jammed in too tightly if a time sequence is followed. Under "naturalism," for example, we can deal with man's preoccupation with the world around him whenever it occurred; we can touch on the realism of the Laocoön and the Northern realism of the "Little Dutchmen" (Figure 27), on impressionism and the twentieth-century landscapists (Figure 28), who include partisans of our industrial and microphotographic landscape (Figure 30). Under classicism we can highlight Greek proportion, Roman engineering, and scientific painting in three dimensions as developed in the Renaissance. Under romanticism we can speak of people as remote from one another as Goya and Chagall. Under the viewpoints governed by the intuitions it will be harder to discover a common quality, but a teacher's effort to explore this will in itself be illuminating. Through-

out our discussions, however, it must continually be emphasized that the creative person uses *all* of his cognitive faculties, and it is only through stressing one or another that a particular point of view results.

The plan, furthermore, does not restrict our exploration to the visual arts alone; constant reference is made to literature and music, and wherever barriers can be broken, they are. If we have decided on the Parthenon, for example, as an illustration of Greek proportion, we can begin somewhat remotely with the early Greek philosophers who searched for a primal "stuff" through observation and reason. We can proceed to Pythagoras, who became interested in *number* as a generative agent of this kind and went on to discover harmonics in music and to construct a pentagon through a mean proportion. We can show how this golden proportion seemed to recur in living organisms and how it was utilized, finally, as a mathematical symbol for life and growth in the Greek temple to Pallas Athene, Goddess of Wisdom. Thus we cut through philosophy, mathematics, music, biology, and architecture. It is much easier, of course, to do this kind of thing with pictures on a screen.

[5]1.3
Providing
a Design
Laboratory

Discovery, as we have hinted, may be a physical experience as well as a mental one, and a certain amount of this can occur in the photography and drawing studios. But the three-dimensional workshop offers perhaps the richest opportunity for discovery, for here the students work with commonplace material in new contexts. Their investigation begins with the premise that in order to organize in three dimensions, one must first know the nature of the material in use. Does it respond to bending, tearing, setting, gluing, hammering, and so forth? One must use it in a manner that takes advantage of these natural possibilities. The functional aspect of the finished product is eliminated; the yardsticks instead are "How much have I found out about the material?" and "How well have I used its possibilities to create new forms?" (Figure 32)

Paper as a material offers an infinite number of possible solutions to these problems, and we use it in sheets of sufficient weight to permit scoring or partial

27.
Vermeer.
The Concert.
Courtesy of the
Isabella Stewart
Gardner Museum,
Boston.

28.
Monet. *Rouen
Cathedral.* Courtesy
of the Museum of
Fine Arts, Boston.

29.
Roman portrait head. Courtesy of the Museum of Fine Arts, Boston.

30.
Microphotograph. *The New Landscape.* Courtesy of Gyorgy Kepes.

Four aspects of "naturalism." The radically different results attained by these four artists in their pursuit of a direct visual experience give a clue to the variety in artistic experience; variety of attitude, at least, is within the reach of even a beginning student.

31.
Discovery in the
field. The art lab.
Phillips Academy,
Andover.

32.
The resources of
method and mate-
rial. *Wood Con-
struction.* K. Gass,
Phillips Academy,
Andover, Grade 11.

cutting. The variety of folds that scoring produces, the strength of paper once curvature is applied, is amazing. At times in fact we work with precurved materials, such as drinking straws; all these explorations, however, are preliminary. Each student's early solutions lead him in a sculptural, an architectural, an engineering, or an industrial design direction, as well as into new choices of materials in plaster, wood, metal, or stone. The possibilities for personal discovery are limitless.

The individuality of the studio projects and the different directions in which students lead themselves are at times curiously similar to the laboratory procedures of science departments that emphasize originality. In any large school it is important for students to discover their identities in this way, and in the educational process it is basically the imaginative individual who educates and finds himself—once he learns to ask questions rather than give answers. As in the sciences, however, pure laboratory work is not sufficient. Interest in theory is generated by questions that arise in practical problems, and it is here, possibly, that the Andover program could go much farther.

The trouble with the Andover experiment is that it is an *early* amphibian and does not yet know whether it wants to be a frog or a turtle. It has some vestigial organs that evolution must eliminate, but mainly its problem is one of waiting for new organs to decide its direction. It has achieved a certain success for the moment, yet if its direction is toward a comprehensive form of design, it has neglected a vital propellant, the examination of comprehensive design in nature, and this should be added to the original list of objectives.

It is easy to see why such an omission might originally have been made in the Andover program. The art course was designed to supply what wasn't given in the accredited courses, and theoretically the design principles of nature, which are related to mathematics, physical geography, chemistry, physics, and biology, might have been covered by the school's general science course. Interestingly enough, the elementary sci-

ence course at Andover *is* a course that attempts to emphasize big underlying principles rather than bury the pupil under an avalanche of fact that seems to cover the ground. This would make it ripe for a marriage with the art department, but here we face a problem in academic conservatism that any new course is likely to run into; the power politics of the older courses are opposed to integration in any form, and when mere experiment is proposed, it renews the old dogfight over curricular time. To get around this impasse, an innovator simply borrows a sampling of students and a few precious hours from the schedules of the departments most involved and tries out his course.

This new offering, to be sure, must have an appropriate name, and "Art" certainly would not do. Perhaps "Synergetics" would work, synergy being defined as "the behavior of a whole system unpredicted by the behavior of its components or any subassembly of its components." The word is old stuff to the scientist, for it is the only word in the dictionary to describe the "omnioperative" behavior of the universe, but it might also be applied to art in recognition of the fact that an artistic whole is greater and more interesting than the sum of its parts. Or if we want to return to old-fashioned terminology, we could call our new course "Science-Art," which would only prove that it was not a very new idea. We have only to look back to Hellenic civilization or to the Renaissance for a model.

Yet perhaps there is a less pretentious way to go about all this. A French television program recently took as its topic "Salt." It asked first what salt looked like, then where it was found, how it was used, and of what it was composed. The questions led the viewer from microphotographs to contemporary abstract paintings, from culinary advice to a short course in atomic structure, a truly impressive sweep of interest.

Or take one other example, originating in the Bath Academy of Art in England where the students have for some time been running a summer program for children between ten and twelve. One summer they took as a sample topic "The Turtle." They brought

one into class, drew it, photographed it, even made blueprints of it and sculpted it. They did research on its habits, collected literature about it, including some Ogden Nashery, and finally dissected it. They studied the shell and tested it for structural strength through cardboard models. They discovered how the turtle was engineered and in some degree how it was made— after learning all they could about how it looked and how people reacted to it. They had already been exposed to one brief and memorable experience of how turtles react to people.

It was a very industrious and excited class and in terms of planned enlightenment ahead of its generation.

Curiosity, to be sure, is mainly a way of getting started in education. It goes with alertness and a receptive frame of mind, and its full value is savored only when it brings in food for reflection or leads to intuitive understanding. Curiosity, though, must be oiled with sympathy and directed, more often than not, by feeling. For this reason the Andover Design Course will not relinquish the quieter aspects of its studio experience—or in fact make any radical changes in its present program until experiment warrants it. The current balance seems a good one, and the popularity of the course has surprised its sponsors. Over a quarter of its students elect to go on with art after finishing the requirement, and this is in the teeth of the college requirements.

But what is it really like to take art at this level? The students here are not children; at Andover they see a great deal of contemporary art on exhibition, see it produced in their midst by resident artists and teachers; they know it as something within their grasp. What is their reaction to it?

This question is more easily answered if we look at the senior courses where the results of the required work in the year before are being applied. All of the students realize firmly by then that they are dealing with purely visual material. They have been given practice in looking; the photographic assignments given them under the euphonious headings of "Strong Shape," "Sensuous Surface," "Syncopated Series,"

"Simple Smacker," and the like (Figures 20, 21, 22) have provided them with a beginner's vocabulary in natural effect. In the department of medium and materials they are no strangers either, nor are they inhibited about the use of their hands. With the complacency of youth they have finally viewed a parade of motives and attitudes among artists and viewed it at close range. All this preparation has enabled them to return to the studio with a certain knowledge of how to begin and to return, happily enough, with the solidarity of a group of friends who are at the same level of experience. They are amused, regaled, and occasionally delighted and excited about what the other fellow does. How does the doing look to an outsider?

[5]2
Results of the
Experiment

The usual work of secondary school students, especially students who have dropped art for a while (or maybe never had any), is certainly variable in quality, and this is as true at Andover as anywhere else—in the first year. Self-consciousness has replaced insouciance, and the new awareness of adult standards has produced a hesitant manner of working. The second-year group at Andover seems remarkably free of these faults; the simple techniques they have learned have eliminated awkwardness (Figures 33, 34). Cheap forms of art, moreover, do not rate very highly with them. They seem actually to have realized that more interesting forms are available.

The boys need skill in their work, to be sure, but do not flounder for lack of skill. They have learned either to explore for it or to stay within techniques they can manage. A visiting teacher coming across a student experimenting quietly in the studio with painted forms or three-dimensional ones might be impressed with the boy's directness and assurance; almost certainly he would be impressed with the quality of the results in the spring exhibition, where a large proportion of the work looks like the product of an idea and a persistent plan. It succeeds well or less well according to the normal talent of the boy.

As one would expect, the work is highly individual and is also occasionally powerful and moving. After

33.
Knowledge of paint gained in the lab can influence the student's imaginative experience outside . . . *River Gorge.* Tom Holcombe, Milton Academy, Grade 11.

34.
. . . or another two-dimensional composition can be put together out of materials closer at hand. *Tubes.* Phillips Academy, Andover, Grade 11.

all, we are dealing with youth, and it would be a sure indication of bad teaching if we found no outward sign of the strength and sensitivity of young manhood, to say nothing of its ingenuity. A better measure of its success is the live atmosphere of the studio itself, where students in this class have settled into seminars of painting, sculpture, architecture, photography, or general design. Whether a parent likes or understands the constructions in wood or metal that greet him on every side as he enters the area, he seldom fails to notice the eagerness and the seriousness that go into them. Not much of this looks casual or thinly imitative; the ingenuity of some of it would surprise anyone, and the daring ambition of the best of it is one of the things we hope for in education.

In the Andover workshops the various work areas merge into one another; each student knows what the others are doing and may try any of the available techniques. On the whole, though, there is little time wasted in this. The premium is on continuity. Projects range from realistic landscape painting to abstract expression in iron and wood. There may be a huge "Crucifixion" in the corner, whose technique is not quite solved but whose author is clearly determined to make it belong to his century and be entirely his own. Nor is this a shallow obsession with being "modern." He has clearly realized that techniques are acquired slowly through a painstaking search for meanings, and his central idea is strong enough to make the search for detail worth while.

There are also projects with a mechanical side, which continue the explorations in material of the preceding year and connect art with the needs of contemporary living. One of the boys may have designed a chair that uses a novel system of suspension, and if you listen to him, you will find out how much it will cost in mass production with various finishes and substitution of materials. This may seem like a small achievement for a whole term of work, but in order to design his chair, the boy had to discard a number of alternative designs, to think of a great many users, to learn about machine tools and manufacturing methods

as well as about the cost of materials, and to do all this on his own initiative. In these terms it is no mean bit of education.

A different kind of ambition persuades an architectural team to design an airport terminal astride a highway, a terminal building complete with runways and parking facilities in the adjacent fields, that takes its designers directly into the problems of urban living and expanding technology. It makes no difference whether an airport like this is ever built. (The neat model makes it look at least plausible.) The boys concerned will never in their later lives observe a traffic problem or one in community design without feeling a part of it. They know that there is a solution for things like these and that they can contribute an informed opinion.

It is difficult to imagine a spot in education where the possible is so genially explored as in this crowded corner of the campus or a spot where imagination has freer play. Certainly this doesn't happen in an art school, where the sober business of acquiring skills often drives out all original ideas for a four-year period. There is nothing to be said of course against learning professional skills, and a secondary school cannot possibly undertake to teach them. But there is nothing to be said either against stretching one's imaginative powers to the limit and applying them to hard realities like wood and metal and public utility. And if doing this becomes a habit in a benevolent academic atmosphere where standards are never threatened by motives of low expediency, the students will acquire as important a skill as any that a teacher aims at, a skill in summoning their total resources. One could hardly expect a curricular course to do more.

Maturity on Trial: Art in College

6

[6]1
The Changing Scene

Although the arts in many academic settings are still given only meager attention, for a multitude of reasons and in a variety of forms they have attained an importance in some colleges during the past two or three decades that is little short of phenomenal. These years have made conspicuous the merging of two streams of education in the arts. One stream flowed from the professional schools, the art academies, which have supplied all the traditional techniques and the variety of manipulative and expressive experiences that have been demanded of practitioners in the arts; the other came from sources that generally lay hidden on college campuses, obscured by the more self-confident disciplines around them. The latter stream, however, has been more often than not a kind of polite acknowledgment of the existence of art rather than a vigorous pursuit of its principles.

In spite of this the practice of the visual arts in colleges has been conspicuous for its emergence out of sheltering departments of architecture, archaeology, home economics, or art history, and the other arts have followed similar patterns in their reach for academic respectability and independence. There has been a growing trend for all of them, in fact, to separate as discrete activities from those parent departments that once gave them refuge—physical education, English, speech, education, or whatever. Slowly they are gaining in recognition and prestige. Faculties are recruited from the ranks of well-recognized practitioners. The arts are in the colleges to stay.

This new concentration on the arts in the academic world has had its effect on the professional schools. Slowly they have changed from their early trade-school practices to a pattern of requirements and behavior very close to those of the colleges. Indeed the only real separation between some college art programs and those of the nonprofit professional schools is in the areas of supporting studies in art history, in

the social sciences, and in the humanities. The better independent schools have even achieved a number of solutions to the problems of these supporting disciplines, and their students who wish to embark on professional careers in the arts have legitimate choices between art as an adjunct to humanistic studies, art professionally projected on a college campus, and art offered with supporting humanities options in an independent professional school. All three choices offer the students *education,* as distinguished from training in selected skills. All of them have provided society with creative people. Each has its strengths and its shortcomings.

The disposition of the colleges, in increasing numbers, to move closer to the professional schools through development of admirable studio facilities and professional instruction has brought about a further rivalry with the professional schools that is not always happy in its results. Such considerations as eligibility for veterans' subsidies, state certification for teachers, and the exchange of credits between institutions have become a part of this new academic concern and have created relationships between schools and students that have little to do with the quality of art instruction. The independent schools have sought the kinds of subsidies the college art departments have automatically enjoyed—the blanket warmth of accreditation, eligibility for government grants, and so on. They have not, unfortunately, always shared endowment funds to the same extent as their friends in academic precincts; in fact, the museum-connected schools are frequently hard put to compete for available dollars with the other departments of their own institutions.

All of these considerations have tended to soften the edges that once sharply defined the differences between general and professional studies in art. For the student who is not closely briefed in the distinctions between art as a cultural base, upon which many intellectual and evocative systems can be built, and art as an experience so deeply felt as to demand the satisfactions of creative response, the growth of studio

work in the colleges has contributed its share to the confusions already present in the hearts and minds of the young.

It is no longer possible to say that art history fills the needs of today's college students or that any vague kind of appreciation course will satisfy their curiosity about the arts. To speak only about the visual and plastic arts (and there are certainly parallels in the other arts), many colleges now provide an opportunity for students to work in studio classes with artists of first-class reputation and achievement. For the general student, as distinguished from the embryo professional, this of course has a stimulating effect far beyond the limits to be achieved by surveying the great sweep of art history from the cave dwellers to Jackson Pollock. Students are seeking involvement with the arts today, just as they are seeking personal involvement on the political and educational scene generally. They are eager to participate in the creative act to whatever extent they are capable. And this involvement, surely, will continue to produce not only a thin but steady stream of professionals from professed nonprofessional sources in the colleges but also the phenomenon we have been hoping for, an increasing number of adults who accept the arts with intelligent ease, who know how art and artists can be made to function productively, and who recognize the extent to which art can enhance life. It must be on this larger audience that the arts depend for growth and support as the century moves toward its close, for out of this group will come the parents of a new generation with what we hope will prove an even clearer insight and more developed response.

If our culture is to achieve any depth through the arts, in fact, it must clearly be through this double root—the increase of well-educated as well as well-trained professionals and the enthusiastic interest of huge segments of the population—the people who vote tax money for public buildings, for schools, for monuments of all kinds, the private investors in the nation's future who are responsible for large numbers of work-

ers, who employ architects and designers for great industrial or commercial projects, who build ships and manage cities.

Many colleges have come to terms with the question of where they stand in relation to personal involvement in the arts, and most of the better professional schools have found good answers to their corresponding problems concerned with supporting studies in the humanities and sciences; but there are still confusions in the minds of many administrators (and also, unfortunately, in the minds of some faculty members) about the roles the arts will play as they develop with increasing intensity in the years ahead. A university or a college that has for years considered its preoccupation to be with the "liberal arts," rather than with any kind of professional specialization, finds itself admitting students who have been subjected to an intensive degree of specialization even at precollege levels. They have gone to Saturday classes in some college or museum. They have had intensive if not always enlightened guidance at secondary school levels. They have seen the arts in action in increasing strength in their own communities, especially if they come from urban centers, and they know that the arts are providing a livelihood for increasing numbers of people and another kind of sustenance for millions in the population. A college that does not recognize this kind of sophistication will not hold the attention of students who arrive with the desire to discover and to create burgeoning within them. Too often in the past students have found in the college environment a kind of frustrating obstacle in the path toward discovery. Perhaps the curricular balance imposes restraints that impatient students cannot understand. Perhaps faculties display overt resistance to student inclinations toward specialization and immediate mastery of craft. Perhaps precollege concepts merge too easily into college-level activities. Or perhaps students may decide the department is more urgently concerned with reconstructing the road art *has* traveled than with affirming what art is and what it can become.

What kind of an art curriculum can the authorities hope to devise to satisfy the objectives of general education as well as the urgent and complex needs of students? It becomes a problem of balance, of course, with history of art an established ingredient, varying in depth and intensity with the variations in library and visual resources from one campus to another. The supporting ingredient of studio work cannot be added to the mix in offhand fashion. The principle at work has complex elements derived from human attitudes, teaching aptitudes, physical resources, pre-college opportunities, and other variants, all of which make generalizations of no particular value. It is certainly true, however, that if a college commits itself so far as to permit the existence of a place where students and faculty meet as practitioners rather than as theorists or historians, it has introduced on its campus a mode of learning that will not be governed by ordinary academic patterns. The process may involve an artist-teacher, whose presence in itself may induce new kinds of academic response. The step is best not taken if administrative and faculty convictions about the arts are insecure.

It is entirely understandable that a college that has as its pronounced objective the desire to train students for broad responsibilities in our culture may have doubts about introducing the kind of specialization represented by a teacher whose principal concern is with professional accomplishment. The assignment of a first-rate artist to a teaching role in college is something more than bringing Robert Frost to a campus to discuss poetry. It is not quite the same as adding a physicist or a historian to the faculty, though these are professionals with specialties, too. Perhaps we should examine the particular problems involved when studio practice is given the momentum of acceptance.

The first thing to notice is that the visual arts have a manipulative appeal, which is highly attractive. The very multiplicity of means through which the artist in our present day expresses his ideas also has its fascination. Students are aware of ways art can employ electronic devices, lights, sound, movement, and the

use of many media in combination, for these are manifestations that lie in the public domain. It is a dull student who is not aware to some degree of the ways in which professionals are experimenting to multiply or intensify artistic effect. Participation by the artist in liberal education, moreover, can never be an act of judicial but distant appraisal. It is characterized by an involvement on his part; it means the awareness of the artist pedagogue of any sign from the student that might lead to his development and fulfillment as an *artist*. It is the colleges, not the artists, who have opened the door to this particular subversion.

However happy the outcome for many students (and for many faculty members as well), risk is always present. The artist may indeed try to change the situation around him rather than tolerate the discomfort it causes. To say that this condition may make for a livelier campus and a more vital student experience does not obscure the fact that administrators will be discomfited, and it may even lead to the upset of academic procedures that have long been considered the foundation of the intellectual experience. For example, it is difficult to protect the sanctity of the doctorate if professorships are given to those who have no pretensions toward this kind of academic award or any intention of qualifying for it through long academic processes. Artists have little use for a document that many of their colleagues in other departments rightly consider a valid credential in academic advancement.

For a student entering college with the idea of pursuing art as a humanistic discipline, or even for one who comes to college with no idea about art at all, there are several other factors to be reckoned with. One is the pressure toward vocational specialization that he may have encountered in his high school career but which he may meet in a more insistent form on the college campus. Perhaps he will approach this new confrontation with more maturity than he possessed at preceding educational levels, but the change in degree of maturity from secondary school to college is not a great one, and it may in fact be almost imperceptible. The student's confrontation with

vigorous studio teaching is complicated by an admixture of totally new decision-making; new problems arise from his change of environment, his change of associates, the academic mixtures prescribed by the colleges for his growing enlightenment, the juxtaposition of different methods of inquiry, for he will find that the methods of science, literature, of history, and of the studio all use in a confused way the same terminology but assign different meanings to both the terms used and the outcomes achieved. On top of this there may be the complication of a move from a small community to an urban center, where abundant resources of library and museum materials may awaken new desires and even change educational goals. Or it may be a reverse move from an urban community with its vast resources of gallery and museum collections to a small campus situated so far away from the kinds of things he has grown to know that the whole college enterprise may take on a quality of removal and unreality, conducive perhaps to scholarly effort but remote from the vigorous and expressive condition of the arts as he has known them. To meet this kind of situation, many colleges located away from urban areas have developed rich museum resources of their own, and many larger schools have collections that would be a credit to any metropolitan museum. Each college, of course, has an obligation to survey its resources and to make its program consistent with the environment in which it attempts to teach. Its program should be capable of expanding into precincts beyond those of the campus itself. It has a basic obligation to sustain its academic intentions through scholarly work and with adequate library support. When it attempts a studio enterprise of any kind, it becomes vulnerable to the problems that inevitably accompany any deep penetration into student consciousness. It must be prepared for the changing sense of values in the student himself, for his increase in total awareness, and for his gain in independence of thought and action.

In all this the student may be searching for a stabilizing hand. He may not find his way easily through

the maze of counseling opportunities that are available to him, and thus he will fail to obtain guidance in making his decisions unless the guidance process is more enlightened than usual. For the most part students proceed in the arts through a kind of trial-and-error sequence until they have discovered for themselves the depth of their concern for the artistic experience. Counseling agencies in many campus precincts are using judgments based on nineteenth-century patterns of thinking about the arts. The influence to which a student is more likely to react is that of some teacher who is accessible during the long hours of a studio class. The nature of studio teaching permits the lines of communication to remain open. If the colleges are uncomfortable about the growth of an artist-teacher's influence on certain students, they must be reminded that in spite of the façade that has been carefully reared by a new generation of students to exclude the influence of their elders, students *will* seek guidance of some sort, and their most likely source will be those with empathy for human needs, those who respond affirmatively in a world that appears to many young people as capable of giving only negative answers.

For the general college student, the studio experience, however meager it may be in a particular place, provides perhaps his only opportunity to participate significantly in the creative enterprise at levels below graduate school. The balancing of an energizing experience like this against the other disciplines of academic life may enlarge the educational experience if it is properly handled; it may intensify a student's concern for new and personally achieved solutions in other academic areas. However, if an artist-teacher has only his own product and the professional development of students at heart, he will probably fail to make such relationships vivid. Educational insight is not an automatic ingredient in the artistic nature. Elements that may make an exceptional artist, in fact, may work against an artist's capability as a teacher and—to narrow the case still further—may vitiate his usefulness in a liberal arts environment by turning

his main attention to those students who show some likelihood of sharing the intensity of his own artistic drives.

It is probably true that the college years provide a last opportunity for many students to have any direct contact with the meanings of art or to explore the range of visual experience. Failing this opportunity, discovery of the arts or awareness of their implications in the life of any individual may be a long time in coming or may never arrive at all. The consequence of cumulative indifference to art and its implications (out of which with great pain our society may be slowly emerging) is, as we have seen, to make us singularly blind to the visual opportunities around us—in the design of objects in daily use, of the vehicles we ride in, the homes we live in, and the schools and other architectural works we tolerate. If one of the aims of general education is indeed to make us sensitive to our environmental condition, then the arts do have a key role to play at this point. The discovery of relevance in the arts to the daily lives of people is well within the capacity of the average college student. He will easily understand, too, that the degradation of environment, or the tolerance of threadbare visual systems, is part of a general adulteration of value which society carries as its burden from one generation to the next; if general education has a point at all, it must include resistance to this kind of cultural deterioration. While it would be optimistic to believe that a few additions to the curriculum in any subject could offset these massive tendencies, it is not too much to hope that in certain individuals, who may some day have key roles to play in their own environment, a sensitivity to the aesthetic qualities of life will have an effect. If some direct experience in one of the arts that is deep enough to have meaning is supported by intellectual studies of the kind that will transmute personal experience into philosophical idea, then education will have performed a significant task, and the arts will have more than a peripheral value.

A student is unlikely to arrive at any semblance of cosmic concern during his college years without being

guided by some of the insights preserved from the generations before him. Concept is, of course, only a first step. The next is significant action, and here again his educational background will either limit him or guide him to a successful outcome. The person for whom an education in the arts is one ingredient in a broad mix of humane experiences gains little from submitting to the orthodoxies of a studio education devised for the guidance of those who hope to become practicing artists. Yet for nonspecialists as well as for specialists, an understanding of the *elements*—of order in design, of structural principle, of the formal ingredients of line, space, shape, color, materials, and all the interrelationships that result from these—such an understanding, achieved through manipulation rather than through passive observation, may have singular significance. Ultimately the goal is communication and meaning. The complexities of setting this up for a nonprofessional student, however, are not to be underestimated. One must go far enough to assure his *understanding* but not his mastery of his materials. The projection of visible design considerations into the range of philosophical concept, moreover, does not take place automatically. It is a process that calls for intelligence, sensitivity, and restraint on the part of teacher and student alike. As concept begins to take precedence over personal values, these values, which earlier educational experience may have established, may be overshadowed by new problems that depend little on personal expression for their solution. For many students the transition from art as an activity to art as an attitude will never be made, but most students will emerge from any valid art experience with a developed sense of values.

[6]3
History
of Art

History, including the history of any art, has a firm place among the established academic disciplines. The range of method in projecting historical ideas is wide. History of art, because the evidence of man's drive for expression can be precisely observed, would appear to provide opportunities for the projection of ideas from the past that have continuing relevance in

our own time. As art history is taught, however, relevancies that might illuminate our present problems for the guidance of general students may be so overlaid with the methodology of scholarship that any relationship between history and art as a living source of energy in our own times is completely obscured. For the committed scholar, of course, search and analysis of the artistic residue of past periods has its own internal significance. Just as the emphasis in a studio classroom may shift from general to professional objectives, so the history-of-art student may be moved from general to particular concerns. A scholar's job is to generate scholarship, as a product and as a human resource. He will encourage a competent student to find in the fascinating problems of history the satisfactions that others may find in direct experimentation with the forms of art. Such teaching has its important place, but it may leave some students unaware of urgent opportunities in the arts of their own time.

Faculties in art history, of course, are aware of this separation of history and practice. Many history teachers depend on studio experience to support their scholarly views. But art history may also be presented as something quite removed from the artistic event as it occurs within the student's environment, and when studio courses are offered under the aegis of art history departments, they are put in a kind of jeopardy that does not seem to occur when the positions of scholarship and practice are reversed. For a student who can sense the excitement in the arts around him, art history can appear to have all the dull attributes of any other historical study, constrained as it may be by tight investigation, close attention to footnotes, and removal in time and space from the realities of the present. Art history is surely one of the humanities, but if the humanities are conceived as a means of bringing students to a state of maturity in which they can make meaningful decisions of their own, then a conventional history-of-art course may easily fall short. It is only when studies in this field are carried

beyond the mastery of content into the area of philosophic consideration about content that they reach the heights to which the enunciated principles of liberal education lead.

The achievement of a position from which relationships can be judged intelligently, and the student's own capabilities put into some kind of sensible balance, is one that may be rapid or slow. The extent to which a particular college can expedite the process may vary from one individual to another. It all depends on the confluence of attributes in teacher and student—on the cumulative effects of education up to the point of entering college, on the sensitivity of each student to his environment and his capacity for reacting to new stimuli—and of course on the ambiance of the college itself, whether it encourages this kind of rapid maturity or whether it maintains a control so rigid as to be inhibiting.

[6]4
Curricular
Balance

Having described the problems of organizing courses and having touched on the relationships between scholars, artists, students, and the college itself, it remains for us to suggest a balanced role for art in the curriculum. We may begin with certain assumptions —that the arts are an ingredient in the total curriculum, not its main thrust; that the problem of numbers in studio classes can be solved by new teaching techniques and devices; that administrative controls are benevolent (that is, sympathetic to the inclusion of the arts and respectful of them as a channel through which education can be pursued); that the balance between studio work and art history and theory and criticism is maintained in such a way that each is a support to the rest. What are the other problems that confront the curriculum makers in the colleges?

First, as we have said, there must be enough intensity in the studio experience to justify its purposes. But there must be continuity as well, so that the experience is not compressed into so brief a span as to evoke only transient response. Sequences in the arts must be developed systematically over a reason-

able period of time; perhaps the two-year span we have been assuming is not enough. The relevance of personal experience in the studio needs to be extended and intensified by the history of art, which finds in the product of our own time not only the vigor of experimentation and discovery but a pertinence to our society when it is measured against the best of man's past accomplishment.

All of this means using the total resources of a particular campus—the libraries, the visual materials, museums, galleries, and the arts as a contemporary product—out of which elements the student environment is built. Ideally the campus itself would contribute a favorable setting. In the look of its new buildings, in the discriminating choice of all elements in the student's surroundings, it would meet the standards that it professes to expound in its classrooms. But the outward use of facilities is at best only a reflection of an inner planning. Surely the ultimate value of art to a student would be found in a period of appraisal, in which all of the significance of individual achievement and scholarly concern is brought to bear on the serious consideration of outcome. Nor must this be left to mere chance. Somehow the teacher must promote the development of a philosophic comprehension in a mature student that is so secure that it will serve as a base from which significant decisions can emerge. The problems of leisure and the place the arts have to occupy now and will occupy in the future—in concerns beyond those of necessary employment—are also the matters that must be laid on the table. To expect art to claim a good deal of leisure time is probably a foolish bit of optimism, since the arts are only one material that can be inserted into the leisure of men's lives. It is a corruption of their meaning in any case to think of them as a form of therapy or as a space-filler. If the arts, on the other hand, become meaningful to such a degree that students want to seek them at the expense of easier pursuits, then they will have made a real contribution to one of our most urgent issues. Their value in these terms will appear, no

doubt, in any properly balanced college program.

If in the whole curricular process the business of grade-seeking and grade-giving can be minimized to a point that reduces emphasis on professional competence as the sole criterion, or even a major one, if opportunities exist outside the classroom to explore the arts in productive ways or to extend one's insight into the artist's mode of thought and principle of action, then there may be some hope that the college can achieve and maintain the continuity we have been speaking about. It is important to the outcome that a constant inventory be kept of all resources in the community that might lend themselves to the progression of a student toward artistic understanding, and these include the resource of people, people who are themselves distinguished or who are profound in their understanding of the achievement of others. But principally, of course, they must include a basic faculty of persons who have more than parochial concerns in the arts and who can impart values to young persons without imposing their own preoccupations.

[6]5
New
Techniques

One evident phenomenon of our time is the projection of creative thought through new and widely varied media. To ignore the impact of technology, of science, of new materials and the adaptations that are being made of old materials in new combinations, to turn aside from the many possibilities revealed by the professional artist in his use of new forms, new combinations of elements, new attitudes toward meaning, new problems of relevance, to ignore, finally, his continuing investigation of all the new concepts that mingle the arts and the sciences inextricably, is to diminish the impact of the arts on student life.

The problem is always to have a diversity of outcome without indulging in superficial judgments or arbitrary effect. The purposes of general education are not served by establishing a new academy, however modish the product may appear to be. The student's urge may be constantly toward emulation of some current use of attractive technical devices or of

content that reflects his desire to identify his vision with that of a contemporary. The faculty must examine these impulses in terms of more extended value—value as experiments, value as expressive means, value as contributions to broad understanding.

In the front rank of their discussions they are likely to consider the extent to which cinema has moved onto the campus, as both a fascinating medium of revelation and a tool for personal expression. The motion picture, a true child of this century, has grown steadily in its fascination for the current generation of college students, and it is unlikely that this force will diminish in the future. The moving-picture camera has produced an avalanche of films from campuses across the country—films that range in technique from expert to amateur, in subject matter from documentation to perversion, in substance from excellence to banality. Perhaps this new interest may be accounted for as a revolt against nonfigurative expression, or perhaps it is merely an extension of the fascination with movement that has been growing since Duchamp's nude descended the staircase. For whatever reasons, the cinema is here as a creative tool. Its success as an expressive medium is subject to the same limits as those of any other medium. It depends on skillful operation and deep understanding to achieve its best results, but as an experimental medium it can support a wide variety of objectives and project creative ideas that cannot fit adequately into the limitations of other media.

For a longer time, of course, still photography has provided a medium that is manageable at almost any level of proficiency and one that permits significant exploration of artistic values. It is in fact the prevalence of photographic experience generally that has provided many of the cinema enthusiasts with confidence and pictorial imagination.

The double aspect of professional instruction in any of the new media, as any young student in a professional art program is made immediately aware, can be described as technical competence added to significant intent. It is true that the ranges of technical accept-

ance are broader now than they have been in other generations and that the artist's intention is not easy to define or adjudicate when art appears to reveal purposes that may be unique to an individual or esoteric in any social sense. For the young professional there is still an obligation to meet reasonably strict standards of performance as an accompaniment to his curiosity about new materials and new concepts. It would be a poor kind of instruction that would permit him to substitute careless techniques for precise knowledge of the tools and processes through which visual effect can be achieved, just as it would be limiting to permit a concentration on means to obscure the necessity of purpose.

For the general student, however, who has no purposeful drive toward professional accomplishment in the visual arts, a quite different balance can be maintained during his college years. We must return to the assumption that his purpose is to understand artistic means rather than to master them. It must also be recognized that to participate to any degree in the artist's revelation implies a capacity to understand, on as many levels as possible, the meanings that have been projected or the qualities of the result. In this connection the educational process, for either the professional school student or the humanities student, cannot neglect the interrelationships of the different arts. This surely means more than fumbling and spurious "translation" of one art into another—painting out of music, for example. It means discovery and projection of relevance in all the arts in a generic sense as well as systematic studies in structure, meaning, and purpose in the *forms* of art; these studies must lead toward a comprehension of value as each art establishes its own unities and reveals the tangencies and overlaps developing from experiments in superimposition of effect.

To extend the educational process in the humanities into precincts like these—which lie beyond those of simple "appreciation" of the arts—must surely mean to project, in some balanced way, those modes of action, techniques, and intention that for the professional are

a way of life. It is hardly likely that this balance will be the same for all types of students or that it will be similarly conveyed in all colleges. It will be modified in one direction or another by the teachers responsible for its preservation, but it will also depend on the adjustment of all the educational resources at hand—formal and informal, those easily accessible to students, and those that must be sought.

Given any ideal situation—one in which there are clearly benevolent administrative auspices, ample space and facilities, faculty enthusiasm, intellectually inclined students, and accessibility to works of art that have some power to stimulate the curiosity of young minds—to which particular concerns in the visual arts should a humanities program address itself? The studio provides opportunities to deal with basic materials and processes, the form-shaping, idea-projecting means that man has evolved through centuries of change. Simple elements, such things as paint, clay, wood, stone, fibers, and metal, are still materials that are necessary to the satisfaction of certain creative desires. Added to them will be synthetic materials, glass, plastics, plaster, and all the rest, together with the sophisticated processes of printmaking, stained glass, welding, casting, and illumination. There will be elementary considerations, too, of such things as movement, scale, structure, and use; the catalogue will be extended by any ingenious and enlightened teacher in the direction of his particular aptitudes and inclinations. It may be unrealistic to prescribe the absorption of all these ingredients into any introductory course, but students need *awareness* of them all; their number should be increased in the minds of the curriculum makers rather than shortened. The labyrinth of new combinations of materials will entice students. To what extent the combination of art forms, or the encouragement of experimentation in temporal systems, in ephemeral effect, in the controls suggested by electronic mechanisms and others, in all the resources of photography, and in the images generated by scientific inquiry into the structures of nature—to

what extent these may be investigated will be limited only by the resources at hand.[1]

A history-of-art course, to be sure, will play an important part in establishing the relevance of the arts to their own times or in generating understanding of what are sometimes called the "monuments." For a few people the historical-aesthetic inquiry can be more comfortably pursued through all the processes of scholarship, as we have noted, but these pursuits produce specialists of another kind, the next generation of art history teachers, of museum workers, of connoisseurs. The usual student, who seeks merely to widen the horizons of his world through art, will still gain his best confidence by confronting himself with the artist's problem and by the excitement of finding his own solution, no matter how primitive it may be. Having once tasted the experience, there is real likelihood that some will not be satisfied with less than a total immersion in the swift-flowing stream of art. For these no orthodox cautions will suffice. They can best be guided by sending them on to places where saturation is possible.

Along with a hope that colleges will accept the complexities of contemporary art processes and contemporary intention must come some warnings. While we joyously anticipate the twenty-first century, we cannot altogether escape from the nineteenth; it is the century that opened the gate to all the freedoms the arts now enjoy. We regained our confidence in personal vision there and discovered ways through which it could be extended and purified. We also learned how the arts can be reconfirmed in their ancient public purposes. Of course the world has moved briskly in many ways since those middle years of the last century when the arts began to stir in new directions, and the context in which the arts are projected now has a new look, too. Within this context, however, which is governed by new tempos, new social and personal habits, new flexibility of movement and ease of communication, even by new doors opening into all the mysterious regions of nature and the universe, many problems

still await the artist's participation, as they waited for it a hundred years ago.

One of the most urgent of these, as we have hinted, is surely the problem of our cities, which are now suffering from our past sins of neglect and need an unending flow of fresh insight into their complex problems of education, physical growth, spiritual health, transportation, ugliness, and waste. It contains problems of entertainment for a population that moves out of old patterns while youth asserts its majority and workers find new leisure; problems of political action affecting the arts—the encouragement of state arts councils, for example, and their responsive multiplication of activities in the arts; problems of economic survival for large numbers of the population, including artists; the reconciliation of the arts with the complex mechanisms that we have devised, which now appear to dominate our thoughts. These are surely not problems that artists alone are able to solve, but artists have an important part to play in these enterprises and others. If society can employ the discrimination or intuition, or the clear and practical vision that art and its practitioners can contribute, it stands a good chance of performing its tasks more quickly, more efficiently, and surely with greater consideration for human values.

Although it is important for young artists to be made aware of both their personal and their public opportunities *as artists*, it is equally important, and more germane to this discussion, to bring as many people as possible into peripheral or central involvement with the arts. From college programs now functioning will come the board members of museums, the decision-makers in government and industry, the teachers, the museum workers, the publishers, scientists, scholars, salesmen, merchandisers, importers, craftsmen—all those who consciously or unconsciously deal with the arts as a product or event. Their responses to the arts are being fashioned now in college programs. The public awareness of what the arts can be, of the forces they can exert and their capacity

to extend and intensify—not only pleasure but value as well—will determine the successes of the next generation as it searches for enlightenment in its new concerns.

Note

1. The purpose of a general course in art is assumed here to be the understanding of as many works and attitudes as possible; logic is therefore on the side of presenting as many activities and as many approaches as possible. The editor wishes this point of view to appear clearly; it can still be argued on the other side that no experience in education is real to the student unless it is pushed for a while in depth and unless a certain fluency is attained. The matter of distributing a limited amount of scheduled time must still be left to the individual teacher, although the next chapter and the fifth section of the supplement suggest some compromises.

Curricular Planning

7

While this study was being prepared, a few of the people concerned with it spent a winter's day in New York talking over the training of art teachers with Dr. James Bryant Conant. Most of them were private school teachers, and he gave the whole morning to questioning them on their preparation for teaching. At the end of it he remarked genially that nobody in the room could qualify for a state certificate. If he later decided that the state certificate was a poor thing to judge a teacher by, it may be attributable to the caliber of our group.

The group had hoped for a little more from him. Dr. Conant is often thought of as a humanist, and the idea had occurred to one of our members to bring along and read a quotation from an annual report written by Conant at Harvard in his early days as president.[1]

But even a good grounding in mathematics and the physical and biological sciences, combined with an ability to read and write several foreign languages, does not provide a sufficient educational background for citizens of a free nation. For such a program lacks contact with both man's emotional experience as an individual and his practical experience as a gregarious animal. It includes little of what was once known as "the wisdom of the ages," and might nowadays be described as "our cultural pattern." It includes no history, no art, no literature, no philosophy. Unless the educational process includes at each level of maturity some continuing contact with those fields in which value judgements are of prime importance, it must fall far short of the ideal.

The humanists at Harvard might have rallied behind this challenging statement, but there is no record that they did—or that the Fine Arts Department uttered a syllable. When his report on "General Education in a Free Society" came out in 1951, accordingly, he altered his position and from then on made no particular provision in his planning for the arts.

[7]1
Educational
Quality and
Dr. Conant

Dr. Conant has done a great deal to focus the attention of the country on education, but he made it clear at the beginning of his book on the high school that he would not be tampering with its philosophy. He would accept the educational system and its vocational objectives substantially as he found them, limiting himself to pinpointing weaknesses and recommending strength. There should be stronger language courses, stronger math courses, stronger science courses, strength presumably arising from a thoroughness of detail and a seriousness of purpose. On the means of strengthening art courses, which he recognized in a subordinate category, he ventured no opinion.

The omission of any references to the various *qualities* or flavors of education in the Conant books is very striking. The words "imagination" and "intuition" do not occur, even casually. He does not say much about individual needs. Students, for his purposes, are either "gifted" or "less gifted" and are in school to prepare for two eventualities, vocation and leisure. One is reminded of Ben Franklin's dichotomy of the "useful" and the "ornamental." If Dr. Conant hopes sincerely that students will take music and art and social science courses wherever they can, it is presumably to ornament their leisure. Like Franklin, he speaks in the tones of the born administrator, a keeper of the academic house par excellence.

One can admire his realism, his willingness to work within the system, without for a moment agreeing that he strikes at the root of the difficulty. The failure of education lies not only in poor teacher-training but also in what is taught. A thoroughly trained teacher can be and often is an evil influence in education, as Dr. Conant would probably admit. Failure is not attributable, either, to a skimpy offering of language. Shakespeare is reputed to have known "small Latin and less Greek," the two academic languages of his time. Failure cannot, finally, be blamed on a poor offering of science or an outmoded program of mathematics. An ambitious student can, if he chooses, supply all these

deficiencies by just working terribly hard. "The fault, dear Brutus" lies rather in a poor assortment of stimuli at school and in a poorly conceived notion of human resources. The student who has overcome all the shortcomings of one of Dr. Conant's marginal high schools, and emerged from it flushed with achievement, may discover that he has just not acquired the imaginative equipment that he needs for the job of living that lies ahead of him. At that time it may be too late to acquire it. The competition he faces and the demands of his family command his first attention.

[7]2
Proposals
for Art

The earlier chapters of this book have tried to pick out the ingredients needed in a balanced education and to show how some of them may be supplied by art courses. It is necessary now only to say how the curriculum should reflect this and to outline the courses in some particulars.

How much time should be given to art? The answer to this will usually depend on whether you ask an art teacher or an administrator. An art teacher normally believes that art should be a required subject and a continuous experience; an administrator, even a friendly one, will say the claims of other subjects preclude this. The two points of view seem irreconcilable and are actually the products of opposite theories of education, the administrator usually looking upon education as a kind of investment portfolio made up of wisely chosen units, which are taken a few at a time and then salted away, and the art teacher stoutly maintaining that education ought to be a balanced experience *while it is taking place.* An administrator might admit the value of art as a balancing unit in the portfolio, but this is not enough for the true believer. He wants his balance here and now, and he thinks the claims of his subject are too obvious to warrant discussion. Art is the only subject that trains the eyes, it supports the humanities in a curriculum heavily weighted toward science, and it gives a student a golden chance to be creative. That it incidentally frees him from verbalism and nourishes his imagination only serves to ridicule objection.

Whatever the merits of the two concepts of education, and there is merit in both, we must pay some attention to the mechanics of the subject itself, which as a means of communication requires a certain continuous use if it is ever to become fluent. It is peculiarly sensitive to interruption at adolescence, as we saw in an earlier chapter; it seemed there, indeed, to furnish a key to the psychological changes that took place at that period.

In spite of these reasons for continuity in art, we are not prepared to say that it should be required throughout a student's career in general education. The idea of keeping one's educational fare in constant balance is not yet generally accepted, nor have curricular planners given much attention to the special problems of adolescence. It is more appropriate for the art department to pull an oar for balance within the present system than to recommend something that cannot be carried out in the near future.

The proposal we make is that art be required for at least two periods a week through the ninth grade, as it already is in many schools, and that art courses be required or strongly favored in two of the remaining years before the halfway mark in college. One of these years would have a full-time studio course and the other a full-time course in the appraisal of art, a study of its role, that is, in history and in contemporary life.

[7]2.1
Course
Structure

We do not want to be specific about the structure of courses up to the tenth grade. The methods now in use are numerous and fairly familiar, and each method requires its own direction. It may be pertinent, however, to lay down a few simple ground rules about planning for this age, since experience proves that the obvious is easily forgotten. The first of these is that art through the ninth grade must be thoroughly coordinated from year to year. It seldom happens this way. Whatever the teaching plan, someone at the top should be considering how it can avoid repetition and maintain its forward thrust. Inside a particular year, moreover, one technical experience should lead to another, and when a radical shift of program is planned,

it should occur at some logical point in the work rather than at a convenient date on the calendar. All this is elementary.

A second rule invokes a basic tenet of education. The courses should be planned as primary visual *experiences* without any element of mere academic *practice*. The fluency a student gains must come from doing things that have meaning from the start, and all subject matter must tie in with things he knows about; he need never realize that a technical scheme is hidden in it. This, in fact, is one of the differences between art in the lower grades and the upper ones. The teacher of the younger group does not need to take his pupils into his planning, although he will often discuss particular projects with them. The secondary or college teacher enjoys no such detachment. He is dealing with pupils who are becoming aware of what they want in learning and who deserve an explanation of what lies ahead of them, as well as a chance to make at least some of their own choices.

A third rule is that the program must be geared to the age of the child, but here we must be careful of our meaning. The Britsch theory has made it seem doubtful that age has anything to do with some of the practices in drawing that we have hitherto associated with children of certain ages. According to this view such phenomena as "base line" and schematic perspective are evidence of a natural learning process that also occurs among adults who are trying to represent nature. Any planning that allows for these phenomena must therefore recognize them merely as signs of an experience level and not of a childish outlook. We have discussed the Britsch theory at some length elsewhere.

An actual symptom of age is discernible in a child's intensity and in his willingness to tackle anything. A young child often puts a professional artist to shame by the sheer power of his color and the directness of his intention. This is why it is a mistake to coddle children at the beginning of their careers and simply invite them to splash away aimlessly with paint or indulge their sense of pattern in finger paint-

ing. An *idea*, whether it is representational or abstract, is far more appealing to them at this age, and they are perfectly willing to depict the fall of Jericho, or the splitting of the atom, and turn out a fine piece of color or pattern in the bargain.

A child's work will change gradually in natural scope as he grows older as a result of his expanding mind and his gain in worldly experience, and some of his intensity will give way to other qualities. Where his work was simple, it becomes complex, enriched in detail by his curiosity. It reveals more, too, about his tendencies as an individual, whether he is a fanciful person or a factual one, an emotional, a reflective, or an inventive one. This kind of growing up *can* be planned for at the top and must be carefully checked in the classroom, for while a wise plan stimulates a class, the results are fortunately still full of surprises. No beings mature in precisely the same way at the same age, and no one knows why the work of an awkward child will often pull itself together or even outstrip his age. It may be a sign, however, that something is right about his training.

[7]2.2
Courses for
Upper Grades

The courses for older children are worth a little more attention here, for while the possibilities in teaching are still unlimited, there is less experience to guide the organization of any such comprehensive courses as we have called for. We have gone to the trouble, therefore, of putting together a full outline of a sample studio course as well as a shorter description of a historical and critical one. They illustrate only one way of teaching art at this level, but they may give leverage on the problem and illustrate what we mean by "comprehensive." Ideally, the studio course should come first, possibly at the eleventh grade, and the critical course in perhaps the freshman year of college. There would be no difference in the general plan of either course whether it occurred early or late.

[7]2.2.1
The Studio
Course

The studio course would have at least four periods a week, *prepared*, that is, eight periods of total work. Its objectives would be to
1. Train the eyes, and the *mind through the eyes.*

2. Give the students a creative experience.

3. Give them the means of enlarging and contributing to their own visual environment.

The thirty weeks of the year would be divided into three parts dealing with personal art, design, and individual programs. Each week is assumed to have four periods, as the numbers before the headings indicate.

I. Personal Art

First Week

1. Discussion, with slides, of the role of art in contemporary life. This will be found to include

a. Art in personal experience.

b. What in the total environment is close to art, and why?

2. Discussion, in section meetings, of the stake held by the general public in art and of the plan of the course to provide for it.

Demonstration of how personal choice and sense of pattern can start operating at once through a variety of easy techniques.

3. Participation, with heavy black chalk squares and padded newsprint; exploring, first, the resources of the chalk, the quality of its strokes, broad, thin, or modulated (Figure 35); and, second, the nature of visual shapes, including the possibilities of representing nature (Figure 36).

Assignment (one period): Drawing on the subjects, "Shapes I Like" or "Waves and Cloud."

4. Beginning of a weekly program in *photography* that will continue for nine weeks and echo the projects of the week in a searching observation of nature. (The first week will be devoted to explaining the use of the camera and the darkroom.)

Second Week

1. Drawing. Black chalk held broadside so as to produce rounded forms when the weight is put on one side of the chalk.

Topic: Gesture. Living creatures make gestures with their limbs. Human beings see gestures in objects that do not actually move, as when a cliff "rears its face" or the road "meanders" over the plain. In a

similar way lines and abstract forms in a picture may appear to make a gesture.

Project: Explore the resources of the chalk in producing forms that "move" (a) in a straight line, (b) in a curve, (c) in a spiral. Note that accentuation is related to motion and that "moving" strokes, particularly the spiral, may suggest a three-dimensional form.

Assignment: Make a drawing of gesturing forms that co-operate or oppose one another. Note that the gesture of a form continues when it disappears behind another form and emerges on the other side.

2. Demonstration of how spiral strokes may suggest a solid object and give it a movement—a gesture. Application of this to a human figure.

Drawing of a figure by the spiral method. (Volunteer models from the class.)

Assignment: Imaginary drawing of figures in action. Figures may be reduced to abstract approximations but not to "stick" figures. All of them should have a spirally achieved volume. (See Figure 36.) (Note: This project and some of the following ones present two alternatives: a simple abstract assignment within the manual powers of an awkward student and a somewhat harder assignment in representation that will stretch his powers. The question of which is best for the morale of the class is left to the teacher.)

3. Gestures made by inanimate objects in nature or in abstraction.

Demonstration that a gesture may convey a dramatic quality, an *expression*. It may threaten, protest, resist, defy, abandon, plead, etc. (Figure 37).

Drawing, in chalk, of natural objects or abstract forms on the theme "Defiance." Continue this into the assignment period. Observe that spiral strokes are not always the best for expression. Straight strokes, jagged strokes, curved strokes contribute in a different way to the character and movement of a form.

4. Photography. Search for expressive forms in nature (Figure 38), particularly in close-ups of objects and materials commonly ignored such as weeds, fence posts, water patterns on the sidewalk. Pupils not used to

35.
Resources of chalk.

36.
Spiral strokes and
their ability to
represent moving
forms.

37.
Gesture and
expression.

38.
Dialogue. Phillips
Academy, Andover,
Grade 11.

Art, even for a professional, is full of new beginnings. The illustrations on these pages and the following ones take the student, experienced or otherwise, from the first handling of a tool through a series of projects that become progressively harder. None of them are to be looked upon as mere exercises. They are valuable to the student only if they are interesting and offer him real choices.

looking at natural objects closely usually need their attention directed. The Andover program (see p. 80) called attention to such variegated phenomena in nature as "Strong Shape" and "Sensuous Surface."[2] (See Figures 21, 20.) Some of them were expressive phenomena, others mainly decorative. Beginners here might look for visual illustrations of descriptive words like "threatening," "pliable," "abundant," "strident," and so forth.

Third Week

1, 2. Expression. Poster paint (limited to black, white, yellow, and brown) or, alternatively, collage, if the class appears to be falling behind in its representational assignments. Poster paint is an easy medium in which to gain a measure of manual control.

Demonstration of the quality of paint and brush strokes. There are obviously many ways of using a brush. Some of these must be explained in advance, and the possibilities of an opaque water medium should be made clear.

Painting—or collage. Use actual children's toys as models or suggestions for a painting entitled "Abandoned Toys" and force the *brush strokes themselves* to take on the expressive look desired. If collage is selected as a medium, cut gesturing shapes (but not human figures) out of old magazines to produce a composition entitled "Neglect." The student must control the shape of the gesture himself. Either a white or a colored background may be used. Brush strokes may be added to reinforce the gesture. Note the effect of color on expression.

3. Expression, full power. (a) Poster paint or (b) collage. In poster paint illustrate a macabre subject like "Witch Dance." In collage illustrate an emotional topic like "Nightmare" (Figure 39) against a suitably colored background. (In this week and the following weeks, projects will automatically extend into the assignment periods unless otherwise stated.)

4. Photography. Look for a pair or a small group of contrasting objects in nature (Figure 40); look for cases where the signal differences between qualities of objects make an expressive or a dramatic *situation*.

Fourth Week

1, 2. <u>Three-dimensional construction</u>. Pursue the camera quest for particular qualities and for expression by examining actual objects and materials in the studio. These will include wire, bent or twisted sheet metal, paper, cloth, wood, and also processed articles in metal, glass, and wood, like bolts, parts of machinery, household articles, etc. The gesture potential of these objects will be found qualified by their *texture.*

<u>Construct</u> a composition setting off the character of these materials, supporting them on a plywood base in whatever manner you can devise.

3. <u>Relate the materials more closely</u> in an action composition with some such abstract title as "Domination." The class will choose these titles, within pertinent limits.

4. <u>Photography</u>. Search for natural objects illustrating, say, the term "Dialogue." (See Figure 38.)

Fifth Week

1, 2, 3. <u>Space. Demonstration</u> of how spacing adds to the quality of articles grouped together (Figure 41) or, rather, helps them to come into their own. Make a composition that facilitates a study of enclosed or semienclosed spaces. Use stiff paper, balsa wood, heavy wire, etc., cut and glued or otherwise fastened together and fixed to a plywood base. A topic like "Protection" or "Entanglement" would give the study a direction.

4. <u>Photography</u>. Continue the study of shapes and spaces by looking for clear-cut and definite objects *outside* the studio and arranging them for the camera *inside.*

Sixth Week

1. <u>Three dimensions in two</u>. Point out that an artist can deal with articles too large for the studio simply by picturing them on a smaller scale. This may or may not involve the use of conventional perspective. Since an arbitrary study of perspective is a stumbling block to certain students, it is best to let all students discover ways of representing depth themselves—but offering the following suggestions:

a. Try putting articles one behind another in a picture,

39.
The expressive
quality of flat tones.
Collage on the topic
"Nightmare."

40.
Expressive figures.
Space enters into
the arrangement.

41.
A deliberate study of spacing. Student exhibition, Phillips Academy, Andover.

42.
Three dimensions in two. Realistic study of outdoor space and the perspective of large forms.

causing them to *overlap*—as a means of getting *more* objects into the picture.

b. Notice that articles in nature vary in appearance according to where you stand. If you are above or below or to one side of an object, you may see more than one side of it. (This may help you when you try to consider the shape of the space between one object and another.)

c. Articles *appear* smaller at a distance, without changing your conviction about the actual size of them. If you are willing to limit your picture to mere appearances, you can show a lot of objects, and great distance.

The first project should be a drawing in colored chalk of a group of semigeometrical objects arranged to overlap one another when viewed by the class. They should not be mere cubes, spheres, and cylinders, but articles interesting for their differences in size, shape, and color. The first efforts of the class will tell the instructor which members to help in conventional perspective and which to leave to their own expedients. Assignment: Make a sketch in black chalk of the classroom with figures, tables, and easels one behind another.

2, 3. Careful representation—on gray paper in black and white chalk, with two or three other colors added later—of some topic like "Buildings of the World's Fair" or "City of the Future", seen from the roof of some building. (See Figure 42.) Members of the class interested in conventional perspective can be told that a skyline is an interesting part of the picture and that it represents the eye level of the viewer. You can therefore see the *topside* of any object below the skyline and the *under side* of any object above it.

4. Photographic study of a subject where distance and diminution play a clear part, as when factory chimneys appear over the top of a fence and clouds appear behind them.

Seventh Week

1. Light and shade, as a means of revealing form. Brief demonstration of (a) how illumination varies between different planes turned toward or away from

the light, (b) how curved surfaces darken gradually, and (c) how objects cast shadows on one another (Figure 43).

Painting in poster paint of a still life set up in a position where the side light is strong.

2. Light and shadow as elements of pattern. Illustration, with slides, of the fact that artists since the Renaissance have been interested in the patterns made by illuminated objects against shadow and by shadowy objects against light. Examples from Tintoretto, Rembrandt, El Greco, Daumier, Degas, etc. (Figure 45)

3. Imaginative search—with sketches—by the class for situations in contemporary life where these effects occur.

4. Photography. Discovery by the class that chiaroscuro material in nature is abundant and interesting (Figures 44, 46). The instructor will explain that there are four principal kinds of illumination—front, back, side, and top—and that each carries its own decorative effect.

Eighth Week

1, 2. Illumination as dramatic expression. Shadow is associated with depth, mystery, and evil; it is a leading device on the stage, as is illumination.

Using gray paper and two premixed colors of your own, one light and one dark, paint an imaginary picture illustrating the drama of light and shade on such a topic as "Firefighters" or "Night Attack;" or, if this seems too hard for the class, paint an abstraction of dramatic illuminated forms.

3. Light as an independent objective. Light for its own sake, without any dependence on a contrasting dark is a comparatively recent phenomenon in art history. Studied experimentally by Corot and Turner, it became the main concern of the Impressionists.

Brief demonstration of the theory of Impressionism, and experiment on the part of the class with the vibration of "spectrum" colors to produce an effect of light. This will serve as an introduction to the use of oil colors.

4. Photography: Search for material involving the play of light patterns, as, for example, light falling through leaves to the sidewalk.

43.
Illumination in its simplest terms.

44.
Illumination more subtly realized by the camera. *Portrait.* Phillips Academy, Andover, Grade 11 or 12.

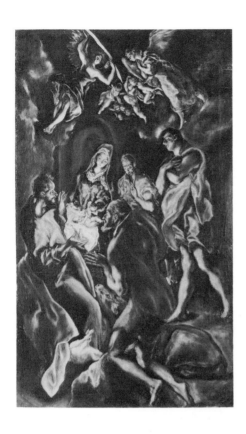

45.
Light and dark in dramatic composition. *Adoration of the Shepherds* by El Greco. The Metropolitan Museum of Art, Bequest of George Blumenthal, 1941.

46.
Light and dark as pattern. *Classmate.* Phillips Academy, Andover, Grade 11 or 12.

Ninth Week

1, 2. <u>Color</u>. Using an oil palette with a full set of tube colors, and mixing tints with a palette knife, experiment with color harmonies on the palette. Systematic ways of doing this are described on pp. 199 and 200 of the Teaching Supplement.

<u>Paint</u> a picture of "Beach Umbrellas" or "Cars in a Parking Lot" as though the observer were looking down on the objects from a height. Try to find seven totally different but harmonious colors for the umbrellas or the cars.

3. <u>Color and expression</u>. Draw, in charcoal, a composition of opposing forms with an expressive topic such as "Speed," "Humor," or "Precision." Mix pats of a few colors that you think might be appropriate and, painting directly from these, try to make the colors accentuate the relation between the forms. Leave the background unpainted.

4. <u>Photography</u> (still black and white): This meeting and the next will be devoted to a study of how illumination reveals expression in human faces and figures.

Tenth Week

1, 2, 3. <u>Color and chiaroscuro</u>. <u>Demonstration</u> of the changes in color that occur in nature between the light and the dark side of an object. <u>Full-color study</u> of objects strongly colored in themselves and strongly illuminated from the side, like fruit arranged on a window sill.

4. <u>Photography</u>: (outlined in program for ninth week)

II. Design
Eleventh Week

1. <u>Discussion</u> of the nature of industrial design, of the role of the designer and the role of the machine. Design in industry is governed by four conditions: (1) the function of the article, (2) the material, (3) the way it is made, and (4) the final appearance. Our aim here is not to anticipate the situations of industry but to allow the student an opportunity that a commercial designer seldom has, of experimenting with materials under guidance, without any restraint placed on his imagination. In this way he may discover some of the resources of materials for himself and make them yield beauty within a concept of utility.

2. Demonstration of the qualities of stiff paper as a material: how it may be folded, cut, scored, or otherwise manipulated to produce crisp forms of unexpected strength.

3. Student projects in paper construction, continued through the week.

Twelfth Week

Construction with small forms: balsa wood, toothpicks, drinking straws, and so forth, with the object of discovering how they can build larger forms of structural strength and beauty of pattern (Figures 47 and 49), using such principles as the arch, spiral, and cantilever.

Thirteenth Week

Study of the qualities of metal in common small forms: sheets, rods, and wires, and of ways in which they may be worked (Figure 48). Study of suspended forms, of the relationship and difference between tension and pressure.

Fourteenth and Fifteenth Weeks

Design to meet a need. Using the materials studied, design a mechanically simple article of use, such as a paperweight, a wastebasket, or a coffee table.

Sixteenth Week

Consideration of architecture as a human need. Discuss a hypothetical case in which you and a small ship's company are marooned on an uninhabited island and have to improvise shelter—with simple tools and local materials—from a northern winter. Illustrate your solution in its setting or build a rough model of it.

Seventeenth and Eighteenth Weeks

Suppose the island is later civilized and you go there by choice. How would you elaborate on your original house? Plan this house on a drawing board and build a scale model in cardboard and balsa wood, time permitting.

Nineteenth and Twentieth Weeks

After a brief discussion of styles in different periods, *design*, on paper, a small building like a roadside refreshment stand where the premium is on fantastic appearance, novel construction and use of materials, and novel facilities.

48.
An adventure in
metal. Phillips
Academy, Andover,
Grade 11.

47.
The quality of wood
and of the construc-
tive methods that
can be applied to it.
Phillips Academy,
Andover, Grade 11.

49.
Paper straw con-
struction. Phillips
Academy, Andover,
Grade 11.

III. Individual
Programs
Twenty-first
to Thirtieth Weeks
Inclusive

Individual programs are chosen by the students with the consent of the instructor, who will supervise their execution. The range of these will depend on the size of the course and the facilities offered by the school or college. At a minimum, a student should be allowed to specialize in paint, three-dimensional materials, including clay and plaster, photography, or architecture. Students with a strong experimental urge, however, should be allowed to plan work in new media and techniques, provided the instructor is convinced that these lie within the facilities available and serve a creative end. The new media might include abstract movies, slide tapes, moving forms, and so forth. The challenge of a project peculiarly one's own is to be thought of as a principal means of learning. Students equally bright, of course, may wish to plan their projects within the techniques they know.

An art teacher used to teaching in an extremely personal way may find this variety of planned activity a little staggering; to him we could reply that a constant element runs through it all—the imagination of the student, which does not balk at new opportunities once it is aroused. Actually a simpler course would take care of the essential requirement—his participation in art. What we have outlined merely adds to his vocabulary. Of course, the added material could be arranged in many different patterns, and it occurs to us to suggest a natural variation in Part I, putting the three-dimensional work first instead of waiting until the fourth week. The reason for studying gesture earlier is that action is more closely related to the motor instincts of a manually awkward student, and the manual side of art may still be considered important.

[7]2.2.2
The Historical
and Critical
Course

The historical and critical course includes three lectures and one section meeting a week, *prepared*. Its purpose is to broaden a student's visual education through examining the works of others and to give his knowledge of Western culture a new dimension.

The area of art included is the architecture, sculpture, and painting of the West, from the present to Ancient Egypt.

The means of study include

1. Lectures designed to present material, anticipate ideas, and provoke inquiry.
2. Section meetings designed to allow each student a chance to present and defend ideas of his own.
3. Outside study: looking at original works wherever possible, constant comparison of slides and reproductions, assigned reading in texts related to the works studied, original and assigned papers.

Plan

1. The best hope of giving a student real contact with works of art is to explain them in terms of his own experience, in his own language. The course starts with a discussion of ordinary twentieth-century environment and of material that challenges his normal likes and dislikes—movies, advertising, motorcars. The fact that these are products of "design" connects them with more personal forms of art. If the student can make the connection, he is ready to form opinions about the art of his time; for two weeks, therefore, the course studies both kinds of recent American and European works—architecture, appliances, clothing, etc., on the one hand, and personal works of painting and sculpture, on the other—and speculates on the reasons for doing them. At the end of this time the class will be asked to make inferences about the state of contemporary culture. The difficulty of generalizing about matters so close at hand will provide an instant reason for making historical comparisons.

2. Comparison is forced by an abrupt plunge into the past. The life and art of ancient Egypt is presented in a brief survey. With no more than this, and an extra look at the works themselves to go by, the student is asked three questions: What seemed important to the Egyptians? How did they use art to convey their scale of values? What was the quality of the art itself? A few salient attitudes toward death and toward kingly authority are easily recognized in Egypt and put down as themes very opposite to ours,

but the high purposes of the works is plain enough, and their effectiveness is plain as well when they are contrasted with anything produced today.

3. Somewhat the same procedure will be followed in all the periods studied. The Greek motivation is harder to determine than the Egyptian because of a larger mass of evidence and because the Greeks were a mercurial people, moving rapidly through history and living without any dominant center of culture. In their best moments they appeared to idealize man and to build a religion around manly qualities. They had an unlimited capacity for speculation, however, and were open to mystical influences from the East. Art performed a wide range of functions for them, giving the city-states a symbol of authority in the temple, supplying the people with an outlet for piety and sentiment in their monuments, and providing grace and ornament in ordinary living. A very large proportion of the people were reached by some form of art, and they insisted on high standards. How does the quality of Greek art compare with that of Egyptian? How does the Parthenon compare with, say, the Guggenheim Museum? Examine the World's Fairs of 1851, 1876, 1893, and Expo '67 and make some surmises about Greek influences in our time.

4. Roman life at its prime provides a different array of motives. Dominantly urban in its civilization, it is interested in such material things as organization, the dignity of public institutions, and the amenities of an affluent society. Its artists use a Greek technique but with a less subtle result. Public taste is less demanding, and the population behind it is far more heterogeneous. Roman social situations and cultural attitudes are often startlingly like American ones and can become the object of keen comparison by the class.

5. An interesting feature of Roman art was its change of character during its rise and decline. After attaining an extraordinary uniformity in the heyday of the empire, it responded to various oriental influences in its later days, reflecting among other things a different attitude toward authority. Christianity and a strong mystical trend finally gave it the Byzantine stamp,

and its materialism vanished into abstraction. Byzantine culture, the culture of the great city of Constantinople, seems very remote from ours today, but the passage of Roman art into abstraction is often compared with a similar transformation at the beginning of the twentieth century.

6. Medieval art is a record of dispersal. Protection—security—dominated the early medieval mind, and feudalism, rising among the ruins of the Empire, became the political means of attaining it, just as the medieval Church was the spiritual means. For all the local differences of early medieval life, these facts produced a certain uniformity of outlook. Art responded to the needs of small communities, monasteries, parishes, courts—everywhere. In human terms art supplied the need for religious expression and instruction. The student of today will have a good deal of trouble in understanding the mood of medieval Christianity unless he takes time to examine his own beliefs and decide which, if any of them, might be worth affirming in a work of art. In the light of this decision the Romanesque and Gothic sculptors may possibly appear more valid, particularly when the student's information is reinforced by historical reading.

7. Late medieval life—after the Crusades—enjoyed a better system of communications, a greater prosperity, and a growth in town life. These changes combined to produce a revolution in intellectual values, one that present-day Americans can sympathize with. Intelligent men were suddenly less ready to surrender their individuality to divine authority. Learning was released from church custody. Art and literature became attractive careers. In due course religious reform swept the continent, and science produced its first great figures since the Greeks.

This course from now on is bound up in the careers of individuals who worked for recognition of their personal powers, sometimes in the service of local religious or governmental bodies but more and more often under private patronage. While the Renaissance

is in one sense a general European phenomenon and produced a free exchange of ideas and styles, we are forced to notice the activities of particular groups, and the influence of a new political factor—nationality. This will take us in an arbitrary pattern through Italy, Spain, Flanders, Germany, Holland, and France.

The study commences in Florence, where the conditions of community life and public opinion are often compared with those of Athens in the fifth century before Christ. It proceeds to Rome and Venice, then across to Spain, and from there to the other countries in sequence, with a side excursion into England. The motives of individual artists cannot be adequately studied without learning something about their personalities as well as about the conditions under which they worked: the guild system, the rivalries in technique, the shifting patronage with the decline in feudalism, the growth of capitalism. If this is undertaken, the number of individual artists studied will be somewhat limited, and we must be careful to explain the importance of the groups they represent.

8. The baroque and rococo periods will be discussed as extensions of the Renaissance, extensions by natural growth as well as products of social change. A more sumptuous scale of living at the top of the social order favored a development of architecture and music. Painting became dependent in some degree on architecture but in certain places escaped into more personal forms and into greater realism. This was particularly true in Holland in the seventeenth century, where middle-class taste set the pace for it. Portraiture and a new interest in landscape painting kept the attention of a few artists on the particular in nature throughout the seventeenth and eighteenth centuries and prepared the way for the realism of the nineteenth century, helped by the discoveries in chiaroscuro of the baroque painters and by the increased use of oil paint.

The generalities of the baroque and rococo, the wholesale exchange of styles between different areas which was so unlike the localisms of medieval times,

are appropriate topics for a lecture or two, but the particular artists of the two periods are best discussed in one of the "national" sequences previously proposed.

9. The French Revolution marks an abrupt change in the intellectual climate of Europe and in the patronage of art. Even in countries where the class system remained outwardly the same, the growth of popular education threatened the foundations of privilege. Privilege, however, received new support during the Industrial Revolution from an entrenched capitalism, and class struggle passed into a doctrine. All this produced a divided patronage for art in the nineteenth century. The museum, a symbol of democracy, became the ultimate repository for the best in art, taking the place of the princely collections of the past three centuries, while an immense public sale of works of art through dealers and public exhibitions kept a large body of artists, good and bad, alive and hopeful of attaining the museum.

Centering in Paris, the home of the revolution, art and particularly painting became a battleground, with mounting waves of rebellion against the government-supported academic art. Romanticism, Realism, Impressionism, Postimpressionism—each less inhibited than the last in its pursuit of realism—produced a remarkable array of original figures passionately exploring their relations with nature.

Whether photography turned the tide against this, whether realism as a motive had spent itself, or whether there were deeper reasons in the social turmoil of the times, as there were in Rome in the fourth century, a spontaneous wave of abstract art arose early in the twentieth century, and we now see the development of some of the forms that came into the beginning of the course.

10. The leverage we may have acquired on our own time in this historical circuit is, we hope, one of sympathy. In such an immense context the achievement of contemporary art is not belittled. It tends, rather, to become more important. A bronze of Lipschitz is not less interesting when it is revealed as a member of

a family of bronzes that began before the Greeks. A building of steel and glass may lack the refinements in shaping found in the Parthenon, but its very real qualities improve when we discover a structural relationship with the Greek building and with the Roman Pantheon as well. A new intimacy, in any case, with familiar art is one of the goals of the comparative study suggested in this outline, and it is hoped that a successful student might be equipped by it to engage in mature criticism—criticism and *enjoyment* of art.

[7]2.3
Art Courses
in the Curriculum

It would be even easier to propose alternatives to the historical plan so briefly outlined than to the scheme of the studio course. There are many possible courses like this—and people, no doubt, to speak for all of them. These people, however, will understand that what we have written is intended to be suggestive, not limiting. Two things in our view outweigh all other considerations for the general student: the human message that may come to him across the ages and the elusive experience of beauty, which we seldom mention but which we always hope he will come by in the right context. To these objectives we might add a third, the sense of civilized history we have spoken of, the understanding in plain terms that art is not only his heritage but also his future.

The two courses described here are the result of carefully considered experience and of experience, too, that was aware of other courses in the curriculum. Some of the approaches of the studio course, in fact, have been used in experimental work among teachers of other subjects who wished for the sake of their own teaching to know more about the visual aspect of learning. They came to realize, as many people realize, that an instantaneous meaning appears when something is well presented to the eye and that ideas requiring many pages of written explanation can be compared in diagrams in very much the same way as forms were compared in our projects.

The English teachers of the group, we might remark parenthetically, found on their return to school that pupils of theirs used language more vividly when

they had discovered the meanings of descriptive words in a studio; and they found, too, that general fluency in English increased when pupils had attained a little fluency in another medium.

An example of this is to be found in a series of experiments recently conducted with underprivileged children by Miss Grace Whittaker while she was serving as head of the English Department at the Dorchester (Mass.) High School. Miss Whittaker took her pupils into "sensory learning" as a part of her program to teach them to read and write. An almost inarticulate pupil wrote the following lines after five months' exposure to visual training. Note the use of adjectives dependent on visual awareness:

The Train
I sat down in the silver snake,
And luminous eyes stared at me.
I sat down in the silver snake,
And shining arms hung over me.
I sat down in the silver snake,
And the hum of its heart throbbed under me.
I sat down in the silver snake,
Its jaws snapped,
And the silver snake ate me.

No less than English, mathematics, science, and history are thought of as relatives of these courses. None of them has the communicative side of English, but mathematics almost by definition is concerned with pattern, and a science laboratory is very much like a studio. And the kinship with history is even closer; the second course is an actual history course, dependent on other history courses and furnishing them with a new meaning. There is no reason, at any rate, why a student should not pass easily from any of these departments to the art department or vice versa and take his ideas with him.

We have been guided in all our speculations by considerations broader than those of art. Opening the eyes to the visible world is only a part of opening a person's eyes to his own capacities and putting his imagination to work. This, in turn, is an essential part of general education, which too many people have

thought of as simply a matter of touching a few extra bases.

Sadly enough, the purposes of vocational training, which dominate our schools, have very little to do with a kind of education that merely strengthens a person's resources as a human being. His power of reflection, his ability to distinguish values, his imaginative initiative, his ability to accept responsibility all lie outside the purview of his training for a job. If anything in the formal program develops these capacities, it will be the efforts of a particular teacher, or a stray course in the humanities, unless someone in authority steps forward and plans courses to fill the immense gap.

Art courses have their shortcomings, but they do fall into line with this kind of planning. They are on the side of precise meanings, of discriminating experience in the visible world—which must appear by now to be a large part of the human world; they open up sensibilities; they recognize feelings. They depend on discipline in the same manner as other courses, but rather more than other courses they arouse daring. They are, finally, on the side of fine ideas, for no one hesitates to put his best beliefs into a piece of handiwork that gives him a way of trying out his wings or, more prosaically, of looking at himself in a mirror.

It is this power of affirmation, on the whole, that gives art its principal importance in education, and such an ability often makes the difference between an effective person and an ineffectual one. We won't go so far as to say that an art course automatically takes care of a person's confidence as a human being or shows him what he wants to do in life, but it often carries him over a psychological hump—when it is applied with the right mixture of freedom and expert guidance. What is the mixture? Few art teachers can resist the temptation of prescribing their own.

Notes

1. Report of the President, Harvard College, 1946.
2. The complete list included "Strong Shape," "Similar Set," "Syncopated Series," "Sensuous Surface," "Super Subtle," "Stage Set," "Strolling Spot," and "Simple Smacker."

The Whole Man and the Citizen

8

If the educational principles implied in the foregoing discussions were followed, the truly educated man or woman would be very different in outlook and behavior from the present product of our schools. As we now observe him, he is a reasonably intelligent person who has gained a knowledge that will help him to earn his living in our society and to advance himself in a competitive world where the ignorant and the untrained are at an economic disadvantage. He has a wholesome respect for education itself but no deep comprehension of its implications and possibilities. As an efficient workman in his chosen occupation, he knows that he can look forward to an increase in his leisure time. With automation, and the consequent shortening of his work hours, this will often be an enforced leisure that will find him with no adequate resources for the creative use of this time. It will be a kind of vacuum in which he tends to be lost and listless, the passive recipient of highly commercialized and sterile forms, of what Malraux has called "mass delectation." He has not been made to understand that "the purpose of a liberal education is to make one's mind a pleasant place to spend one's leisure."[1] His attitude toward the arts is one of cheerful inadequacy, and he regards them as the preoccupation of a special few but not of himself. Since he has never been shown the importance of a beautiful and intelligently ordered environment to himself and to his community, he feels no personal responsibility for it. Content to leave the shaping of it to others, he never asks himself why the richest country in the world is visually the ugliest. He is, in sum, a proficient but essentially lopsided and ill-balanced person deprived of many of the solid satisfactions to which each of us is entitled.

With the humanities restored to their essential place in his schooling, our hypothetical American would have a very different attitude toward education itself

because he would know that a man's true vocation is to make himself as complete and resourceful a human being as possible.

He would come to see the arts—architecture, painting, sculpture, music, literature—as a mighty language in which some of man's finest thoughts, most compelling visions, and most exquisite perceptions have been offered for the benefit and pleasure of all; and he would not wish to be deprived of this great heritage.

He would be curious to know something of the art created by civilizations of the past, not only for their own sake but for the witness they bear to the character of other peoples, a need that is imperative today when our ability to understand other nations is essential to our own survival and to the assumption of our world-wide responsibilities.

Armed with some solid knowledge of what makes for excellence in the arts and with a sharpened sensibility to design, color, pattern, and form, he could achieve a modest confidence in his own ability to comprehend and judge the art that his own modern world offers to him, measuring present accomplishment against the best creative work of the past. He would neither reject out of hand the baffling shapes of modern work nor inertly accept them because they are the latest and most publicized manifestation. In short, he would become a part of that alert and informed audience without which the arts can never play their full part in any community.

He would derive benefit from seeing art in reproductions but would recognize that these are often inferior and misleading. No longer content to experience art in this way merely at second hand, he would seek out originals, discovering that only in the presence of the painting or sculpture itself can one really know the artist who made it, sense the full meaning of his effort, feel its full impact on the senses and the mind.

His broad conception of art would tell him that it is not confined to masterworks but can take more modest form in prints, drawings, watercolors, small pieces of sculpture, fabrics, and other useful materials

and objects. Having come to know that such works are not too expensive for him to possess, contrary to the general public's impression, he would consider it his privilege and his responsibility to support and encourage the arts in this most tangible and constructive way, by becoming a patron.

With the right kind of stimulation and guidance, he might develop whatever creative powers he possessed through his own efforts at drawing, painting, or the fashioning of useful objects. The pursuit of hobbies is at least a more creative activity than submission to the more stultifying forms of canned entertainment, provided that one's hobby becomes something more than a killer of spare time or a wishful effort to join the ranks of the professionals without either the time or the developed skill and the inspiration to do so. A surprisingly large number of Americans engage in hobbies of an artistic sort, some of whom have been misled by the hucksters of do-it-yourself kits or of art-by-correspondence to believe that there are recipes and short cuts to excellence. Others work independently and thus derive a greater personal satisfaction from what they do, but the results indicate how much more satisfactory this hobby would have been, had it been informed by a knowledge of the principles of design, the behavior of color, the relation between use and form. Some greater familiarity with the best in the pictorial and the three-dimensional arts would give direction, quality, and a truly creative character to these part-time enterprises. The amateur craftsman who joins taste to skill can make objects of use and decoration that will have special meaning for him because they are an expression of himself. In the long run perhaps the best contribution of these activities to the life of the individual will be the indirect way in which they enhance his respect for the work of men who have devoted their lives to the making of art.

An artistically enlightened citizen would no longer wish to leave the designing of his environment to others. He would recognize the existence of many designers of proved creative power and integrity, who,

Plate I. Representation does not spoil an interest in mere color and paint. *Abstraction.* Newton Public Schools, Grade 1.

Plate II. *Frog's World.* Milton Academy, Grade 8.
Plate III. *The Wise Men.* Milton Academy, Grade 8.

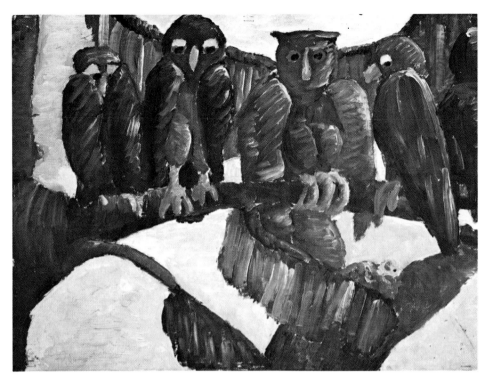

Plate IV. That there are other types of creative personality more elusive than the four pairs mentioned (pp. 167–181) is suggested here. *Owls.* Milton Academy, Grade 9.
Plate V. *Outer Planet.* Milton Academy, Grade 8.

Plate VI. *Storm and an Open Boat.* Francis Perry, Milton Academy, Grade 10.

given the opportunity, could transform that environment, from the planning of whole communities down to designing appliances for the American home. By his own efforts or by the exercise of his civic right to choose men of sound taste and a respect for the arts to serve on local boards and committees, he could do much to prevent that vandalism which now destroys areas of beauty in city and country, a procedure as economically unsound as it is aesthetically disastrous. With some measure of respect for the visual reminders of the historic past, he would resist the sacrifice of areas and structures which preserve a continuity with that past. He would make sure that those who represent him in legislative bodies were men who did not look upon the arts as a relatively useless appendage to life. He would insist that the growth and replanning of his own community be in the hands of experts with cultural qualifications, not of opportunists preoccupied with the gainful manipulation of real estate. Aware of the emptiness and vulgarity of the mass media, he would also realize that his failure to complain effectively was, in the last analysis, responsible for the low state of films, radio, and television; and he would exercise the consumer's right to protest, no longer leaving such matters under the control of powerful lobbies with a vested interest in mediocrity.

Finally, the result most to be hoped for and yet most difficult to formulate in words would be the American's attainment of a more fully humanized attitude toward himself, toward those in his immediate circle, to his community, nation, and world. In contrast to those artists of today who shun contact with the ordinary citizen and draw their inspiration from the depths of their own psyches, there are artists like Ben Shahn who consider the present age a particularly bleak one for the human spirit and who are determined in their art to present a more hopeful and confident image of man, tragic though that image may sometimes be. But the work of the artist who calls himself a humanist will not convey its meaning to laymen who are not themselves humanized. Through

a knowledge and a love of creative art, an experience firsthand or by proxy, so to speak, of the imaginative side of human activity, the educated citizen would acquire powers of observation, discrimination, and judgment that would inform his approach to all the problems of life. As August Heckscher says,[2] "The student and the citizen who has ventured forth to the edge of creativity will never be quite the same person thereafter."

Notes

1. L. P. Jacks, The Education of the Whole Man, University of London Press, London, 1931, p. 110.
2. August Heckscher, "Of Art, Life and Learning," an address delivered at Pratt Institute, Brooklyn, N.Y., 1963, p. 8 of the printed version.

Teaching Supplement

On the theory that art is a harder subject to understand than, say, mathematics, the authors of the preceding chapters have tried to streamline their exposition and avoid issues that seem to threaten a precious thread of continuity. Anyone who is familiar with the subject, however, may want to see these issues at least acknowledged, and all readers are entitled to a fuller discussion of alternatives in teaching method. To cover these items more completely, material is being added under the following headings:
1. The Philosophy of Medium
2. Patterns of Learning and Gustaf Britsch
3. Art and Personality
4. Alternatives at the Elementary Level
5. Alternatives at the Secondary Level
6. Alternatives in College
7. Color Harmony and the Theory of Percival Tudor-Hart

Supplement 1
The Philosophy of Medium

Niels Bohr is not usually a disturber of the artistic peace, but a chance quotation from the *Dialectica* fell into the middle of the speculations surrounding this essay and has lain there ticking away ever since, like a lost nuclear device: "The properties of the instruments or apparatus employed enter into . . . belong with, and confine the scope of the investigation."

Medium, before this disquieting statement, had always seemed a buoyant topic. The tools and materials of art had diffused their joyous contagion without interference from the intellectual world. Delacroix, the most articulate of artists, had declared that a full palette always aroused his full audacity and reminded us that Rembrandt, with equal boyishness, had found nothing more inspiriting than the sight of his color grinders. But now the shadow of a great mind had fallen across it all—across the happy domestic triangle between the artist, his medium, and his Muse. It suddenly appeared a futile thing to probe a subject with a medium that could produce nothing but an image

of itself. Our flights of imagination were illusory; the Muse was false and must be turned out of the studio. Nothing was left for the artist but to stare at her empty pedestal, and from there to glance ruefully at the soiled equipment that had once seemed a source of beauty.

We may talk of it lightly, but the Bohr remark has all the earmarks of a truth that has uttered itself. It is not precisely an unfamiliar one, but nobody had ever planted it across our path before Professor I. A. Richards[1] lifted it out of its context and made it the subject of a poem. In the verses known as "Complementary Complementarities," the *instruments* are the thoughts by which we seek to know a friend. In our thoughts we form an image of him, many images, but these are actually reflections of our own thinking powers, of instruments. The true character of the person eludes us.

All this is said in the poem with a lyric simplicity. There is nothing wrong with these verses as a vehicle of poetic fancy. They fail us and fail themselves only as a means of discovering truth. But wait a moment. What kind of truth are they seeking? The truth about a friend, to be sure, but isn't the poem looking for another truth, a truth about human fallibility?

The picture I take
Is the camera's view
Not mine; not you.

Change the instrument
Change the film or screen
And you're seen

Otherwise. So
—You will find—
With my camera mind;

Film varies there
Minute by minute
And you as fast in it.

Where are you then?
Which infra-thought you
Am I now talking to . . .

Ultra-sentiment you?
Among such how to see
How any you can be?

This kind of truth is well discovered; the crisp poetic medium has revealed it neatly. And so the Muse, it seems, has a role to play after all for a medium has measured something within its powers. The other truth, the truth about a human being is in the nature of a scientific truth, as elusive as any looked for in outer space by Niels Bohr. Science will go on whittling away at such truths, and the arts will continue to capture their own kind, giving them permanent shape in a medium. The happy ménage is reestablished. Neither Bohr nor Richards was ever really scandalized by it.

With her passport—or maybe her union card—once more in order, Medium, like a good twentieth-century girl, is ready for a session with the analyst. How shall her talents be utilized in the visual arts under present conditions of working and teaching?

At an earlier point in this compendium we defined medium as first a material and next an appropriate use of tools; the union of the two gave an artist a means of stating his ideas. This limited concept of medium will suffice for most of our purposes, although obviously there is a lot more to it than that. "Material" and "tools" can be figurative. Meter and verse form are part of the poet's material, and so is a traditional literary style. The medium of cubist painting was less a matter of painted cubic shapes than a certain experimental rapport between the leading cubists. They shared an attitude, and this became their natural vehicle of expression. Attitude plays a considerable part in medium, and so do habits and the things learned in school. A Japanese schoolboy works in a medium different from that of an American schoolboy using a Japanese brush.

An art teacher, though, is neither a dealer in styles nor a salesman of cultural attitudes. He has to be careful about imposing or even suggesting any kind of technique, although he ought to be sharp enough to recognize and encourage techniques once they develop on their own. His main concern with medium is that his students get something out of the stuff they use. In doing this he can adopt three approaches:

(1) he can think of medium as an end in itself; (2) he can allow medium to suggest a line of visual experience; and (3) he can start with an experience he wants to record, which may not even be a visual experience, and then search for images and a medium appropriate to it.

[S]1.1
Medium as an
End in Itself

We happen to be on record as saying that elementary students should be allowed to *represent* the happenings of their daily lives, and this would seem to mean that any discussion of the first approach, medium for its own sake, will begin under a cloud. We are not concerned with the work of children alone, however, but with a current attitude among artists as well. It would be hard in any case to understand the nature of medium at all if we could not isolate it for a moment.

Let us look at a simple form of it. Suppose we take a tube of blue paint and squeeze a bit of it on a white sheet of paper. If we give it a few spiral rubs with the thumb, the paper will show through the spirals in a beautiful transparent effect. We may feel inclined to add a few isolated thumbmarks for balance, and this suggests a further idea. We slice a potato in half and make dabs of blue paint here and there with the flat side of it, obtaining a pleasant contrast between the flat discs and the spirals.

Arrange spots like these in a pattern (Figure 50), add a color or two, and we can make something very pleasant to the eye, depending on our skill. The pattern of course is the important thing, but it is a pattern related to the quality of paint and white paper and a certain motion of the thumb and the potato.

Experiments like this can be multiplied ad infinitum. We can start with any materials so long as they can be made to stick together. We can glue them to a flat surface, suspend them from a hook by wire, or build them up from the ground in a pile; we can mold them, hammer them, perforate them, weld them, burnish them, all of which involves skill and taste and a sense of design. The process may become highly technical, although in the simpler forms skill and experience are *not* very much needed. This is

why it is so very tempting to give simple abstract problems in design to children. Taste and design are natural possessions in children and can be brought into play at once if children are freed from the need of representing anything. The results, moreover, appear highly plausible. Children do produce interesting and sensitive collages and beautiful constructions in wire and wood. "Interesting," "sensitive," and "free" are stock words among teachers who look upon art as an interlude in school life rather than as part of the process of learning.

[S]1.2
Medium
Suggesting a Line
of Experience

We have not been able to, we cannot expect to illustrate the resources of visual medium in mere words; the transparencies, the sparkle, the somber depths, the contrasts, flamboyant or subtle, are best explored in the works of contemporary artists. It is comparatively rare, however, for medium to take over quite as completely as in the process we have just described. Design comes into it, as we saw, and other motives take a hand also. While the thumb was making blue spirals a moment ago, its owner realized that he could make more *willful* strokes here and there, and this may have led him to experiment with other instruments of will—with brushes and knives, for example—producing bristling and slashing strokes. The ability to put *feeling* into the use of medium, and feeling into the design, multiplies their resources by ten; the range of sensuous qualities we were first speaking of is now reinforced by a scale of intensity. The medium—which we hope is under skillful control —is responding directly to the mood of the artist. One need not even look to abstract art for an illustration of this. Vincent Van Gogh's pictures of the sunny landscape of France were sometimes turned into a fury of willful twisting strokes that corresponded to the throbbing of his turbulent spirit (Figure 51).

Is this all? By no means; the most suggestive use of medium in this category is yet another. Let us suppose that a novice is making a collage, snipping or tearing pieces of colored paper and overlapping them at random against a gray background. As he does this, he may discover that some of them com-

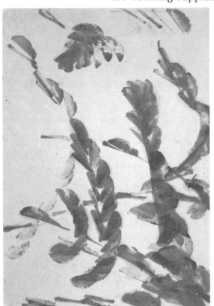

50.
Medium at its
simplest. A potato
print.

51.
"Willful" use of a
medium. *Houses at
Auvers* by Van
Gogh. Courtesy of
the Museum of Fine
Arts, Boston.

52.
Coarse brush
strokes become the
language of com-
passion. *Christ
Mocked.* Courtesy
of the Museum of
Modern Art, New
York.

bine to assume the forms of objects vaguely remembered: buildings shouldering one another against a gray sky, a child's blocks abandoned on a nursery floor, a group of figures in a shadowy and cavernous place. He projects his past experience into these paper shapes and is finally drawn to the idea of seated human figures elbowing one another in the gloom; he adds painted forms and modulations to bolster the impression.

What eventually emerges from the abrupt and rigid forms of the cut paper and the implacable overlapping may, with the help of a painted musical instrument or two, turn into a group of jazz musicians at a night club. The novice making it may be forgiven if his experience included a glance at Picasso.

This is one of the commonest uses of medium, for although the illustration just given is a simple one, the process is essentially the same as when a representational artist, say Renoir, discovers that a certain group of brush strokes will convey the experience of seeing a tree, will give the sensation of its mass, its softness, its movement, and its color. The strokes may have a willfulness about them as well; they may be done with feeling, but the main point here is their aptness, and that is something that the artist has discovered by sheer experiment in the medium.

A footnote should be added to this; while it is the mark of professionalism to work with aptness, aptness can just as surely carry its abuses. Persons who become fascinated by brush strokes sometimes forget to look for meaning in them and become satisfied with mannerism. We seldom have to complain of this in children who are usually but not invariably less precise in their handling of medium, but it may become an obsession among older students and involve plagiarism of a style. The teacher has to decide when technique passes into mannerism and bring about a return to meaning if he can.

[S]1.3
Medium
Deliberately
Chosen

Twentieth-century art abounds in work of the kind we have just described, work in which the artist's personal discoveries in medium direct the destinies of his work. Rouault's paintings are a good example.

His coarse black outlines, reminiscent of his employment as a stained-glass factory worker, have influenced both his choice of subjects and his reflections about them. Their stark quality is part and parcel of his religious and humanitarian attitudes (Figure 52). So personal is the approach to medium nowadays that we commonly ask "what an artist works in" when we want to identify him. Up to the end of the nineteenth century this was less true. Artists varied in their uses of medium, to be sure, but the differences were less formidable. Clearly, too, the nineteenth-century artists were more aware of their subject matter than of their means. To most of the landscape painters the landscape itself was all-important. Cézanne was totally helpless unless he had his subject before his eyes, and Monet thought at one time the particular illumination of a certain hour of the day was so important that he had canvases lined up for every hour between two and six.

These artists illustrate the third and last approach to medium; it differs from the second mainly in timing. The artist is still obliged to discover the resources—and the limitations—of his medium by experiment, but he experiments with an objective already in view and looks for the brush strokes, or whatever, that will answer his purpose. Often enough the *medium* in the narrow sense is an obstacle to him. Stone is an immobile medium, yet the baroque sculptors and architects were interested in movement (Figure 53). Painting is a flat medium, yet the realistic painter deals in depth (Figure 54). Often too, the artist, even a great artist, is indifferent to physical aspects of his medium. Goya was habitually impatient with the tools he was using and was frequently a careless workman. Cézanne was manually clumsy. Both of them were eager to get on with an aspect of their work that had little to do with either brush or paint: a kind of life pulsation, in the case of Goya, and a play of light over elemental form in the case of Cézanne. In a sense they were trying to paint the impossible, and they were often disappointed in their results. However, because they were men of genius,

53.
Medium against the artist. Movement translated into stone. *Apollo and Daphne* by Bernini. Villa Borghese, Rome. Photograph by Alinari.

54.
Depth in a flat medium. *Presentation of the Virgin.* Courtesy of the Museum of Fine Arts, Boston.

they discovered fluencies larger than mere manual ones, and their example, though seemingly outmoded, is not entirely lost.

It is highly pertinent for the teacher and the art critic to know the three approaches, particularly the last one, since the first two have become in a sense familiar. The last approach has a significant bearing on students' work at the upper levels where they are normally inclined to attempt the impossible. Current teaching methods often lift the student forcibly out of this and make him pay attention to the art of the possible. Although this method has produced defensible results, there is still argument in favor of the soaring inadequacies of the other, the ideas never quite realized in the technique, the dramas grandly conceived but awkwardly carried out.

Note

1. The poem by I. A. Richards quoted at the beginning of this section is number I in "Complementary Complementarities" and is taken from *The Screens and Other Poems*, London, Routledge & Kegan Paul, Ltd., 1960. It was also printed in this country by I. A. Richards and is reproduced here with the author's permission.

**Supplement 2
Patterns of
Learning and
Gustaf Britsch**

A note in Chapter Four made a brief reference to the educational theories of Gustaf Britsch, a Swiss art teacher, who died in 1923 before he had made any adequate statement of them. What little we know of him comes from his disciples who loyally wrote down what they remembered. They never succeeded in making his teaching popular among art teachers, but his main tenets have received a good deal of support from contemporary psychologists and, in any event, cannot be ignored. Our purpose here is to give them a needed airing and to consider changes and extensions suggested by current teaching practices.

As an art teacher, Britsch thought he had found the sequence of steps by which people normally approached the problem of representing nature. If the teacher violated this, he believed, the pupil would wind up with a distorted knowledge and maybe in a state of creative paralysis. The theory was applied by Britsch solely to the manual and conceptual problems of art, but once a psychologist accepted it, he

could scarcely let it go at that; it might provide a key to other creative processes. That is doubtless what attracted Dewey to it, for it was Dewey who wrote a foreword to the American statement of it by a Britsch pupil, Henry Schaefer-Simmern, *The Unfolding of Artistic Activity*.

In this account of the theory, representation is taken for a basic urge among people who wish to communicate, be they adults or children. Learning to represent is a matter of isolating one truth about nature at a time and putting it into whatever manual terms are required by a medium. Thus a beginner in drawing will seek first to detach a form from its background and finds it can handily be represented by a circle—a circle for everything: for a house, a person, a tree, or the sun. To give an object a shape of its own at that moment is less important than to separate it from its environment.

Once he has isolated forms in this way, he is ready to consider something else, direction, the easiest directions a form can take being the vertical and the horizontal. We are as familiar with that phenomenon as we are with the circles; children's drawings from all over the world are populated with figures possessing strictly vertical legs and horizontal arms. But there is something wrong with these figures from the child's point of view: they can't move. And so the next step is toward obliquity and motion, a diagonal leg having obviously taken a step forward. About this time, too, the child, or the "primitive" adult, will want to be consistent about the directions in which the different objects in his pictures lie. If he is drawing a village, for example, he will want all the houses vertical, even if this involves placing one above another. If he happens to be drawing a village square, however, he is perfectly willing to make the houses lie in four directions at once to show their perpendicularity to the four sides of the square.

The last steps in realism taken by a child come when he diminishes forms in size to indicate distance and, finally, causes one form to overlap another. Any real grasp of conventional perspective, though, is sup-

posed to be beyond the reach of the stages of development covered by the theory, and it is not indicated how anyone is to make a transition to this evidently suspect form of knowledge.

In spite of this omission the theory establishes a long chain of fairly verifiable phenomena, art teachers usually being willing to admit that they have noticed facts like these and that the experiments described by Schaefer-Simmern are completely authentic. Teachers are seldom in a position, of course, to verify the exact sequences of development over the years in any group of children or to separate the phenomena strictly associated with learning from a welter of other phenomena caused by Heaven knows what. It is still a little hard to swallow the doctrine that age and maturity have nothing to do with the process, but most of us would pigeonhole this item after a few grumblings and concede that since human equipment has a rough similarity in structure, it might also have a similarity in function.

Four main objections will be raised against the theory as it is stated, objections that do not seriously impair it but suggest, rather, the need for extending it and possibly softening its application. First of all it is too dogmatic in asserting that all imagination stops when it is violated, and second, it goes too far when it holds that direct observation can never have any effect on a child's developing work. A third objection would be that it conflicts with some of the contemporary approaches to medium, and a fourth would be that personality does in fact have some influence on the mechanism.

Taking them up one at a time, we can say in support of the first that art has undoubtedly developed in many cultures under conditions that would not receive the support of Schaefer-Simmern. Apprenticeship began early during the Renaissance, and probably also in Greece, and was nothing but a tough school of outright imitation. The Britsch theory, to be sure, is primarily concerned with education, and a system of education is not discredited when someone succeeds without it, but it is clearly unsafe to say that

originality dies when art is forced into narrov

The second objection is probably a lit serious from the teacher's point of view. The as it comes to us does not recognize the insistei of nature. It is hard to believe that children d, ⌐ notice nature or notice the way that popular art and photography deal with it. Signs of fairly close observation do after all appear in children's drawings, and in early ones at that. Children are always putting in little details that are familiar to them, usually without any concern for their relative size, in the clear expectation that they will be recognized. The box of corn flakes on the table has to be Kellogg's; the dog next door with the ragged ear has to have a ragged ear in the drawing. The time arrives, moreover, when some of the class—only some of them, of course—will demand to know how to make things "real," and there are even a few who will catch the trick without asking. Nor is this always an indication of a sterile precocity when it happens. Toulouse-Lautrec drew with great realism and with great charm before he was ten.

A good teacher who accepts representation as a part of his objective is hard put to it to decide how to handle such "realities" as perspective and illumination when he is working with a class of thirteen-year-olds under a plan of common assignments. Can he risk a project involving perspective when he knows that it will upset at least a few of them? Can he afford to demonstrate a technique or encourage a skill in rendering a natural effect at all—this being the age when skills appear. In showing a pupil a bit of manipulation, is he not really telling him what he ought to look for?

If the theory runs into difficulties with the realists, it will also fail to satisfy the abstractionists whose main approach to teaching at the lower levels is through the quality of a medium. The Britsch theory, to be sure, recognizes medium and makes provision for media other than drawing and painting, which are used as illustrations here, but it always assumes that medium will be used for representation. It will not forbid a little preliminary experiment in abstract

forms, as children experimented with clay in Chapter Four, but it has nothing to say about the child who may want to go on improvising.

If the Britsch ideas had been actively argued over the past forty years, it is conceivable that someone would have tried to extend them to cover some of the newer practices in teaching. Do we need now to take a new look at the philosophy behind them? If a pattern of development is merely a series of natural steps one takes in overcoming mechanical difficulties, why must we multiply these difficulties at the outset by forcing medium to connect with something outside itself? Why burden it with a concept when it can proliferate forms unaided? Or do forms take on a shallow and superficial quality when they are *not* governed by concepts? As far as children are concerned, we believe that this is precisely what happens when the scenes of their daily lives are not available to them; a good many of their motives are eliminated then, and art becomes a game of making pleasant contrivances.

We do not wish to ignore the "play" theory of education; children do like games and can discover games in almost anything. But in the last analysis communication is more important to them, and representation, for children at least, appears to have more resources in communication than abstraction. At any rate children seem to turn to representation, if they are left entirely alone, and Britsch is scarcely to be criticized for knowing it.

Supplement 3
Art
and Personality

The fourth criticism of the theory, that the pattern of learning is influenced by personality, is related to the question of types and cannot be answered until we know what kinds of types we mean. And it is not easy to specify our meaning; the vocabularies usually applied to personality are quite unrelated and range from casual inventories of traits supposed to have a bearing on a person's employment to batteries of scientific terms used by psychoanalists to diagnose a patient's mental condition. The purposes of these vocabularies are so various that they often seem to de-

scribe the classifier more accurately than the subject classified. By this token a group of art teachers interested in the social tendencies of their children will select such terms as "withdrawn," "co-operative," "antisocial," "adult-conscious," and so forth, while Herbert Read equates a list of personalities observed by him with Jung's eight types of psyche: "extrovert" and "introvert" multiplied by the four areas of awareness, sensing, feeling, thinking, and intuition. Read's attempts to put children and famous artists into one or another of these eight categories are often acrobatic and result in strange bedfellows among the artists. Rembrandt, who was dark and introspective during his later years, is called a "thinking extrovert" and is given a berth with Rubens, who might normally be thought of as suave and worldly.

Very little of this language seems useful in classifying phenomena of mental development as they appear in the art room; few terms we can think of will help a teacher who is not a psychologist to know his pupils better. Unless he is a pedant, a teacher is apt to be more interested in individuals than in classification in the first place. He will talk of underlying similarities between pupils only as a means of pursuing their fundamental differences.

He will still find it convenient, however, to lump a group of students together in certain categories of his own when he is about to plan a program and wants to allow for the various needs of its participants, and it is worth while here to follow him in his interests and see if they apply to the Britsch system or add to the store of our empirical knowledge about personality.

[S] 3.1
Personality
in Visual Terms

Suppose we are trying to classify a group of relatively mature pupils, thirteen-year-olds, and doing it purely by the look of what they produce without any preconceived notion of causes. We usually have no difficulty in recognizing *a few* of the characters described in Chapter Four as "visual" (optic) and "haptic." It is easy enough to see where a person operates as an onlooker at the scene he may be trying to represent and where he is involved in it. The contrast

illustrated by the two words is roughly the same as that between "objective" and "subjective," or even "extrovert" and "introvert." It would make our work a lot simpler if we could put everyone into one of the two categories as Lowenfeld does, but this, unhappily, would give us very little information about the majority. Most of the products before us seem to lie somewhere in between or to call for entirely new measurements.

We must be satisfied if we recognize a few clear cases of nonchalant detachment on the one hand, in which the objects of a picture are placed at a definite distance from the observer (Figure 18), and of emotional participation on the other, in which everything is brought up to the foreground where it hammers for attention (Figure 17). The use—or neglect—of perspective seems to play a significant part in the difference.

We could go on to speculate on the relative sensitivity of the two types; this is a matter of personal preference. Or we could say that the author of the subjective work is probably more dependent on his sense of touch and motion, on kinesthetic perception; this is a matter for the psychologist. Our business here is simply to note that the two types, detached and participating, do exist and respond to different incentives in teaching. Do they follow a different course of development? That is something we shall presently come to.

In a group of thirteen-year-olds—a large one—we can recognize a good many pairs of these differences. There is the student, for example, with a developed sense of movement and rhythm (Figure 58), and the pupil with no sense of movement at all, whose work at sixteen is frozen and static (Figure 57). The same difference exists in the work of the masters, so it is no mere question of an intermediate stage of development, of rigidity caused by a straining to learn. Teachers are not always in agreement over this pair of types, are not unanimous about which pupil belongs to one

type or the other; teachers are human, too, and fall into types themselves.

The personal differences between teachers do not obscure the fact that both types are *interesting*, each in its own way, and produce satisfying results. On the plane of genius a rhythmical artist would be Michelangelo or Rubens (Figure 56), while a static artist might be Giovanni Bellini or Piero della Francesca. There is an interesting variant of the static pupil whom a few teachers may recognize; he is the "architectural" type, who usually works on a large scale and shapes his objects and the spaces between them with a cool impersonality. Perhaps a good professional example of this would be Seurat in his monumental painting, "La Grande Jatte" (Figure 55).

We can proceed to another pair of opposites about which there will be still more argument. (We are in a highly controversial field where the semantics are obscure and all the evidence must be supplied by people of different susceptibilities.) This one includes the student with a temperamental tendency to *particularize* and the one with an opposite tendency to *generalize*. It can be argued, of course, that everyone has these two tendencies and that teaching has a lot to do with it. There are still some students, and some artists, who in the last analysis have a totally different preference. A certain child will give all his attention to realizing a particular sensitive relationship between the details of an object, a relationship that occurred once and once only in nature. He makes a portrait of the object, not a photographic replica but a sensitive *portrait*, where another child looking at the same object will see in it only an example of a *category* of objects and will try to represent what they have in common. The same thing occurs among the painters of the Renaissance, where one of them will lavish his most delicate attention on the particular sleeve worn by Eleonora Gonzaga (Figure 60), and another will merely bestow upon her the same opulent sleeve he has given fifty other women (Figure 59). This, we

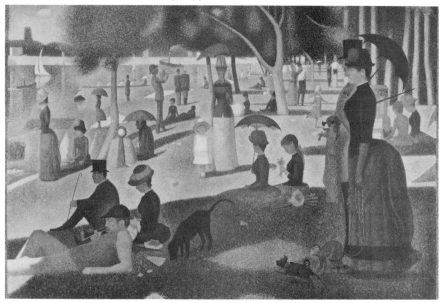

55.
Unaware of movement. *La Grande Jatte* by Seurat. Courtesy of the Art Institute, Chicago.

56.
Aware of movement. *St. Gregory of Nanzianus* by Rubens. Courtesy of the Albright-Knox Art Gallery, Buffalo, N.Y.

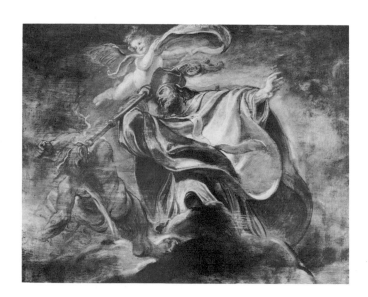

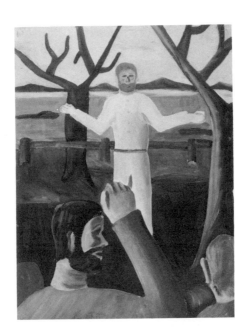

57.
Unaware of movement. *Surrender.*
Milton Academy,
Grade 9.

58.
Aware of movement. *Pursuit.*
Milton Academy,
Grade 9.

feel obliged to repeat, is not a matter of slavish reproduction versus a nobler ability to generalize. It is a question of two separate sensitivities pursuing opposite ends. Titian is not an automaton.

Only one more pair of opposites need be mentioned here, although we could go on at some length. This pair includes the student whose work is obviously organic, every detail growing out of an adjoining one, and who maintains a balanced effect from start to finish, and his opposite number who, in spite of all admonishments, insists on finishing one thing at a time. The curious thing about the latter is that his final result is often as strong and, in a sense, as unified as his rival's. His concentration on detail, moreover, has given his work a kind of permanent intensity, which this particular student cannot achieve in another way. (Compare Figures 61 and 62.) Like the others he has his professional counterpart (Figure 63).

With these four pairs of innate opposites we have not enlarged the vocabulary of the psychologist, who may be unable to explain any of them in terms of what he knows; it will still be necessary to use some such classification as this if we are to test the relevancy of personality to the Britsch pattern in a manner that will satisfy an art teacher. We must talk in terms of phenomena that are familiar to him.

[S]3.2
Variations in
the Learning
Pattern

How may the learning process have varied among our eight types? Without controlled experiments we are in the realm of conjecture, but the disparity between the things they produce is wide enough to suggest that they parted company at some point. Did this happen during the childhood pattern described by Britsch, which normally terminates around thirteen, or was it in the years between thirteen and sixteen, when you would perhaps expect the hardening of personality anyway?

There is strong reason to suspect that some variation commences quite early in the game. If the pattern of learning is supposed to be the result of the child's need to differentiate form, why isn't it equally reasonable to believe that the need will vary in individuals? We can see that in the first period of learning the

basic problems of using one's hand and eye might be somewhat uniform, but once a little fluency is gained, wouldn't it be normal for a child to turn immediately to the kind of work he is temperamentally attracted to? The child with the subjective approach—we are avoiding the word haptic—might easily do this before he had reached the "overlapping" stage of the Britsch pattern, which is a preliminary to perspective. For him, the differentiation of form would simply mean the ability to distinguish the "feel" of an object or to attach it to some intimate recollection. A sense of distance would not be necessary to this. The closer he got to the object in the painting, the better it would be.

For the objective type, on the contrary, differentiation of form would imply the ability to get away from it, to hold it at arm's length, so to speak, and compare it coolly with other forms. This child at almost any age would be seeking a vantage point on experience instead of gathering experience toward him.

This seems to be what happens in the work of children and particularly in the work of the objective type. Children of seven will sometimes work with a very complete sense of detachment, making competent, self-contained forms that leave you in no doubt about their location in space. This is already an intimation of perspective, and pupils with such an attitude advance rapidly toward a conventional understanding of perspective without any prodding from the teacher. The subjective pupils, as we saw, got stuck along the way somewhere and may never complete the pattern (Plate V).

With regard to the second pair of types, the children with or without a sense of motion, the question is complicated by a matter of mechanics. A child's effort to gain a manual control, especially in representing human forms, produces a kind of rigidity in itself or else a kind of explosive movement in a straight line. He may have the best sense of movement in the world, as a finger painting done at the same time will reveal, but he can't get any suppleness into the principal objects he is struggling with. The rigidity derived from effort and tension, however, is

59.
Concerned with generalities. *The Nativity* (detail) by Tintoretto. Courtesy of the Museum of Fine Arts, Boston.

60.
Concerned with the particular. *La Bella* by Titian. Pitti Gallery, Florence. Photograph by Anderson.

61.
Finishing one detail at a time. The author of this composition made no effort to keep his picture in balance as he went along but proceeded patiently from one detail to the next. *The Miraculous Draught of Fishes.* Milton Academy, Grade 9.

62.
A balanced effect from start to finish. This student was apparently incapable of working in any other way. *The Miraculous Draught of Fishes.* Milton Academy, Grade 9.

63.
Judith and Holophernes by Donatello (courtesy of the Kunsthistorisches Institut, Florence). The whole monument including the base, which is omitted from the above photograph but is an important part of the original, was clearly meant to be looked at *one level at a time.* Abrupt horizontal divisions mark it out for this kind of examination and contribute very greatly to its liveliness.

not really the same as the suspended animation of the other type. A true devotee of motion reveals himself by the general look of his pictures. If he has trouble making his people move, he makes up for it in the clouds and trees. The whole scene may be in a cataclysmic state of turbulence, and this may be true at the very beginning of his career. You have only to put his drawings alongside those of his static counterpart, and you will see the difference.

The sense of movement, in fact, is a point on which humanity at large is fairly clearly divided. People are "movers" or "nonmovers" more categorically than they are "objective" or "subjective." Britsch apparently thought that everyone became interested in motion at some point, but interest, for him, apparently meant a recognition that motion *could* take place. If arms and legs were shown in several positions, that was enough; it didn't matter if they appeared frozen in the new positions. A truly dynamic visual effect, however, is quite different from this. It depends on accents, curves, willful strokes, and many other intangibles of execution.

A very large number of humans never achieve movement or want to achieve it. They pursue artistic careers with a full repertory of other abilities, satisfied, as Britsch was, with a perfunctory recognition of the *results* of motion. A few contemporary artists seem not to have reached even the "diagonal" stage and go on planting vertical or horizontal forms across their works as long as they draw or paint.

The whole discussion of this subject, however, is limited by the fact that an uncertain number of people are constitutionally disqualified from taking part in it. A color-blind person will not understand a discussion of color harmony, even though he might prove more docile in an argument than a motion-blind one. The question of constitutional faculties or deficiencies like these is, of course, a battleground among psychologists. If it were settled, we might have a new approach to behavior.

We have discussed two of our four pairs of individuals so far and have found some deviation from

what is assumed to be a standard pattern of early learning. This does not appear to be as true of the other two pairs, although the evidence is difficult to appraise. The differences are well-defined at adolescence at least, and their mysterious appearance at that time is one more reason for attaching importance to the changes that take place during this critical period. With regard to one of them, the one in which the tendency to generalize is opposed to a tendency to particularize, we need the advice of a sympathetic psychologist. Particularity, in the rather delicate meaning we have assigned to the word, is a product of direct observation. When you focus on a particular situation in nature, you are able to see a meaning in it *as a whole*—or some people are. This unified effect, which seems to be a *Gestalt* concept, is made up of a balance of details of greater or less importance, and a sensitive drawing would emphasize them unequally, giving some of them a heavy black contour and others a pale gray one.

At what age is a particular kind of child able to observe nature in this unitary fashion? Our art courses tell us little about this because they are usually concerned with imaginary subjects and involve little work from nature. It would be interesting to learn more about it from a scientist if we could find one who accepted the phenomenon of observing these whole situations, of seeing nature in sizable units. It is clear that children begin their representation with just the opposite—with general rather than specific concepts of house and tree—and that many of them continue the habit into later life, as the work of professional artists proves. But a few individuals seem to break away from it and go in more and more for the particular house or tree. It is a ticklish problem for the teacher to know when to reinforce this tendency and when to oppose it.

The last pair of opposites, the child who works in a connected or balanced manner and the child who becomes absorbed in one subject at a time, offers us another case of an individual going against the grain. Children have a natural tendency to keep their work

in balance while it is in progress, as teachers are often delighted to remark; when balance is violated, it is usually the result of a self-conscious effort to make some detail look "real," and the child is scolded for being imitative. This makes it all the more curious, then, when balance is forsaken by a talented child of fourteen, and his work does not really appear to suffer for it at all. It is a proclivity calculated to try the patience of the teacher, who may look upon it as evidence of poor organization, but it is useless to oppose it, and it does have a parallel in professional art. Most of us can think of works of architecture, sculpture, or painting that are meant to be looked at one section at a time, and yet remain important works of art (Figure 63).

The person with the extreme opposite tendency, who comes out of childhood with a sure and connected manner of working, is apt to be a favorite of teachers because he needs comparatively little attention, but he is not necessarily more imaginative than the other. It will be argued by a behaviorist that he is not a separate personality but only a case of superior adjustment to conditions; there is no proof, however, that this ability to perceive obvious connection *is* a mark of superiority.

This pair of opposites, like the others, represents two extremes of a range of qualities shared in some degree by the rest of the class. In the middle of the range they are amenable to teaching, and the teacher can fortify or restrain them as he may think best. The main point is gained if he recognizes them.

[S]3.3
Classification
Versus
Descriptive
Vocabulary

We may very well discover a better list of personality tendencies than this. (See Plates IV and V.) If an art teacher knows of one, let him bring it forward at his next meeting. The majority of teachers, however, may find it more important to *describe* their pupils in accurate words than to place them in categories; they learn the value of this when they come to compose their reports. In doing this, they may become aware of a quaint truth in epistemology, that the language of the arts tends for once to be specific where the language of science is vague and general. It is more

useful, for example, to fasten the word "poetic" on a particular youngster than to place him successfully in a category of "intuitive introverts." Even if the scientific language were more accurate in its delimitations, its use in report-writing would not be a labor of love.

What a teacher really needs is a *larger* English vocabulary based on a knowledge of art and a thoughtful knowledge of children. Words actually stand for categories, to be sure, but with well-chosen words we can narrow the fit. The word "poetic" used here will become more specific if we can turn it into "lyrical," and more specific yet when we say that a child's drawing is like something out of *A Child's Garden of Verses*. A teacher—and not merely an art teacher—can cultivate his powers of perception by the habit of making finer and finer distinctions of terms.

We can approach vocabulary in terms of opposites, too. We can list the qualities of children's work as playful or sedate, fanciful or literal, whimsical or forthright, reliable or capricious, casual or involved, impulsive or deliberate, exuberant or restrained, thoughtful or mechanical, nonchalant or excited, sparkling or sober, romantic or prosaic. With a list like this in hand, it might be possible to notice entirely new qualities in the children's work at the next judging. But everyone must deal with vocabulary for himself.

[S]3.4
Conclusion

The weak part of our argument on the pattern of learning is of course that it is not based on careful testing; any surmises we have made come from experience remembered and from looking at files of drawings. Files of children's work, it is true, reveal some very astonishing things—and many that were not considered by Britsch—but they are not reliable; there is no telling what influences may have been at work on them. A good many things revealed in this scrutiny, however, have reminded us again that while representation is only one phase of art teaching, the Britsch mechanism seems at least an explanation of that. It could be extended, no doubt, to explain such things as how a child develops his use of color, which is one of the most striking things in childhood art for both its harmonies and its absolute force, and

it might provide a key to a theory of color harmony.[1] It would bear extending in many directions.

We criticized the theory in the first instance on four principal counts: we found it dogmatic, and we felt that it neglected observation, was open to question on medium, and denied a personality factor in the pattern of development. These criticisms stand as they have been amplified, but in their totality they tend to emphasize the actuality of the structure and the need for experiment before we shall know much more about it.

How does this theory help us in teaching? It removes one set of phenomena from an area of worry and speculation and places it in an area where there are normal expectations. It makes a teacher aware of growth, but prevents him from becoming impatient with the rate of growth. We wish, of course, that it could be squared with some of our notions about maturity and adolescence. Perhaps it will fall to the lot of another exceptional art teacher like Britsch to take this step forward.

Note

1. Tudor-Hart, whose color theory is mentioned on pp. 199–200, was interested in the color choices of children, although he never specified at what age a sense of color interval developed. It would be interesting to explore this by experiment and see whether children appear to prefer certain intervals earlier than others.

Supplement 4
Alternatives
at the Elementary
Level

So much has been said about the problems of childhood in various parts of this book that to add a lengthy supplement on elementary teaching would be to belabor the subject. Everybody's way of teaching the lower grades was certainly not covered in Chapter Four, but maybe the main approaches were at least pointed to.

The principal cleavage in attitude at this or any level seems to occur between the teachers who stress the aesthetic and sensory roles of art—the qualities that make it different from any other subject—and those who look at it as an ordinary means of communicating experience. Both of these groups teach exacting programs, but the aesthetic team will emphasize medium and the physical qualities of things and will perhaps get the children used to adult art from the

beginning, while the language team will emphasize the panorama of life and will expect a child to wrestle with representation, believing that it is a natural occupation for him and gives him a wider range of expression. The two attitudes may differ even more in practice than in theory, but of course they are seldom encountered in their pure state; most teachers have a little of each in their teaching. A general educationist tries to recognize both of them but will not, in any case, rule out the appeal of communication at this level.

Two more common estimates of art deserve mentioning, although neither has anything to do with strict educational theory. One is that art is a kind of universal therapy, good for the ailing spirits, and ailing education, and that the teacher is in consequence a custodian of the student's psychological welfare. The other considers art chiefly useful as a *détente*, a break in the school routine during which children forget their inhibitions and recruit their strength. Art may be both of these things, but it has no monopoly over therapy, and relief of tedium and tension is the happy by-product, not the objective, of good education.

An error of definition like these two may hurt an art program, however, whether it is committed by the teacher himself or by the authorities above him, and there are still more serious faults of attitude, some of them all too easy to slip into. Pre-eminent among them is the cult of charm and quaintness, which is not confined to the art room but which may eliminate the challenge from almost any subject. Symptoms of it in art can usually be spotted in the school exhibitions when naïveté rather than imagination is plainly the basis of selection or when a loose, informal way of handling the medium has obviously been suggested by the teacher. The same kind of cuteness is often tolerated in children's dramatic productions by coaches who are unaware of the dramatic powers of children.

The only fallacy we intend to dismantle now is an ancient one that keeps bobbing up in academic theory —and bobbing up more seriously in the mind of the

teacher—whenever representational problems arise. This idea holds that accurate observation and representation of nature may be achieved by a graduated series of exercises beginning with geometrical forms and ending with, say, the human body. Pestalozzi, who was ahead of his time in directing attention to visual education, was nevertheless the originator of a painfully analytical system like this. After what has been said about Britsch, it needs no comment here.

The survival powers of the idea, however, are apparently inexhaustible. *The Art of Seeing* by Woodbury and Perkins was a twentieth-century example of it. Appearing in 1925, this book set up an elaborate system of aids to drawing and memory, some of which have become familiar practice. The use of "stick figures" was one of these, and there were various devices to explain perspective, some of which, we have to admit, are almost unavoidable.

The most recent graduated approach to an accurately observed realism follows the novel path of abstraction. Children in some schools start, apparently, with very simple abstract patterns which continue through the early grades. So simple is the manual work in these that the teacher can insist on neat workmanship. The emphasis on workmanship is maintained throughout; the assignments become more and more difficult and less and less abstract until finally in the eleventh or twelfth grades pupils can do realistic figures with a measure of manual confidence. The whole thing is geared to the child's developing skill.

Why not consider skill in this way? No reason at all, provided it is not allowed to outweigh imagination. The techniques in question are probably limiting and remove art in any case from any consideration of environment. Skill is an asset, to be sure, but the child who battles out his problems in his own awkward way is likely to arrive in the twelfth grade with an original style and a wealth of experience. The look of competence is certainly not a substitute for these achievements.

Supplement 5
Alternatives
at the Secondary
Level

In spelling out a particular art course or pointing to the art program of a particular school, one always runs the risk of appearing to say that these are the best solutions. To minimize this, we are describing a course of another type to place alongside the illustrations of studio courses in Chapters Five and Seven, and after that we shall comment on a famous college program. The secondary plan does not originate in any sweeping proposal for general education. If it is able to contribute, it will be as a balancing unit in a student's personal plan, but this does not mean that it cannot be effective. However much we aspire to broad attitudes in our planning, it is well to remember that the balance of the scales is tipped by weight rather than by breadth. A strong specialty course, even when it is taught by a highly opinionated teacher, can weigh exactly as much as one in which the planning is seemingly more enlightened—if it is taught with fervor and conviction.

The first course is a simple one in structure, planned to lie within the scope of a teacher who is primarily a painter. It does not assume that art is a required subject in a school or that this will be a student's only chance to take art. It is designed for a school where art has gained a foothold as an elective and where several accredited courses are offered—a main course like this one and an extension or two, possibly in the direction of design. It is more easily taught to a small group than to a large one and offers at least one tangible advantage over the comprehensive course: its narrower range of techniques allows the cultivation of greater skill and fluency and takes advantage of any skill in painting that may have been acquired earlier.

The Alternative
Studio Course
(Secondary Level)
First Quarter:
Realism

Discussion with the teacher of what kinds of objects are worth putting into a picture *for their visual qualities alone.* The teacher will be prepared to argue with the class, producing slides and photographs of old and

new art and pointing to various objects kept in the studio. He will explain that he wants the class to begin with the simplest materials, but materials of its own choosing. He will then take the class on an excursion to pick up these materials in a promising area like a neighboring swamp, or perhaps even a dump. The pile of miscellaneous articles brought back to the studio will be arranged in *still lives* by individual students or by small groups, and these will form the basis for the first project.

Project 1

Demonstration of a medium, charcoal or black squares of chalk used broadside as well as lineally. Illustration of the resources of charcoal strokes in producing smooth forms, rough forms, blurred forms, and so forth.

Brief experiment in producing abstract forms by the different uses of the medium.

Application of these uses to a literal drawing of the still life (one period).

Project 2

Demonstration of apparent movement in inanimate forms. Use slides to illustrate.

Demonstration of the possibilities of rendering this apparent movement—which is intimately connected with the "expressive" quality or character of an object—in a medium. A medium more responsive than charcoal for these purposes is a flat bristle brush dipped in ink or black poster paint and wiped nearly dry, so that "feathering" or shading is possible (Figure 64). In addition to feathering, the brush can make a quick and responsive *line* when it is held sideways, and its use in emphasizing elements of character becomes interesting. It also provides a transition from drawing to painting.

Painting or drawing of the still life in these techniques, forcing every stroke to emphasize movement and character (Figure 65).

Project 3

"Comic" still life. Set up a still life in which bottles and potatoes take human postures and wear flowing robes of cloth. The element of caricature in this allows the student further leeway in exaggerating gestures and brush strokes in the dry-brush technique.

64.
Dry-brush drawing, a persuasive medium to a person with a feeling for movement. *Telephone.* John Hagerty, Milton Academy, Grade 10.

66.
Danse Macabre. Stephen Locke, Milton Academy, Grade 11.

65.
The transition to painting. *Boots.* Mac Dewart, Milton Academy, Grade 11.

67.
"Comic" self-
portrait. John
Hagerty, Milton
Academy, Grade 10.

68.
"Serious" self-
portrait. Mac
Dewart, Milton
Academy, Grade 11.

69.
Expressive triptych.
Atomic Destruction.
Peter Pappas,
Milton Academy,
Grade 11.

Project 4 The human skeleton. Make several careful drawings of the skeleton or parts of it, using either dry brush or charcoal.

Project 5 "Danse Macabre" (Figure 66). Medium: oil paint, greatly thinned with turpentine, to make a transition from the dry-brush technique, which is one of drawing, to painting.

Using the newly acquired knowledge of the skeleton, make a *full-scale painting* in which skeletons engage in human occupations: boxing, playing chess, performing surgery, and so forth.

Project 6 Self-portraiture. Make a mirror portrait (Figure 68), drawing it first in charcoal and then painting it in thin oil paint. Make sure again that the individual strokes of drawing and painting convey the movement and character desired.

Project 7 Fantastic self-portraiture. Make an imaginary portrait of one's self playing the part of some flamboyant character (Figure 67).

Normally these seven projects will occupy about a quarter of the year and will conclude this particular experience in realism.

Second Quarter:

Three Dimensions

Project 8 Demonstration of how simple geometrical solids placed at angles to one another can suggest movement and expression. Using a student model, a simple action pose, and clay as a medium, try to *convey the action* of the pose with just three solid shapes set at proper angles from one another.

Project 9 Clay portraits (Figures 70 and 71). Simplify the forms of nature into semiabstraction and make portraits of classmates.

Project 10 Three dimensions on paper. Experiment first with shading geometrical objects in charcoal and making them cast shadows. When the student has grasped this, he may proceed to drawings of small groups of his friends, shaded in a manner that suggests the abstract modeling of the clay portraits in the last project. The purposes remain the same: to show how simple forms, properly tilted, can be given movement and expression.

Project 11

Expressive painting. (Limited palette in oil. Black and white with one or two additional colors.)

One way to drive an expressive topic home is to repeat it in several versions that go together. A triptych, or composition in three panels (Figure 69), will do this, the first element in the expression of the painting being the division of the canvas (or paper) into large and small panels.

The project should start with a charcoal sketch of a common topic of campus life, like "Fall Sports" or "Academic Protest." It should then be drawn as a large composition and painted thinly, first in monochrome, all the forms being shaded in the same way as the drawings in the last project. The other colors will be added last to heighten the expressive quality.

Project 12

Paint another large composition, using full color, and selecting a topic of greater dramatic interest like "Segregation." Commence it in the same manner, however, with a drawing of simplified forms shaded with a brush in monochrome. Add the colors one at a time, noting the expressive value of each (Figure 72 and Plate VI).

Third Quarter:
Fantasy

Project 13

Discussion with the class of the images that occur in dreams. Are they shapes, colors, live people, familiar places? If they are shapes, do they convey any notion of third dimension?

Experiment with shapes suggested by music in the following manner: Play a record and ask the class to listen for recurrent rhythms, drawing forms suggested by them in charcoal while the music is playing. Ask them next to wet the paper front and back in the sink, washing off the surplus charcoal, and to wet the drawing board as well. Then, listening to the music again, ask them to put a thin wash of water color, suggested by the *mood* of the music, over the entire sheet, allowing the drawing to show through. The final stage of the painting will come when the forms themselves are painted in color, still to the accompaniment of the music.

Project 14

The beginner's vocabulary in imaginary shapes ac-

70, 71.
Simplified clay
portraits. Milton
Academy Girls'
School, Grade 11.
Photographs by
Bradford Herzog.

72.
Simplified forms
in a painted com-
position. *Hauling in
the Boats.* Colby
Hewitt, Milton
Academy, Grade 10.

quired in the preceding project can be extended by asking the class to consider shapes at three distances. They might first make a charcoal drawing on the theme "Conflict," then proceed to the subject "Battlefield," in which conflict occurs in the foreground, the middle distance, and the far distance. If the class needs a tip about perspective, it can be told to draw a skyline first and to remember that the skyline represents the artist's eye level; everything above the line will be above *him*, and everything below the line will be at least below his eye.

Ensuing
projects

Further projects can be brought into touch with nature, which is the source of any imaginary world a pupil may create for himself. He may be asked to explore the "gestures" of trees, clouds, buildings; to illustrate the moods of imaginary situations through the use of color and through the movement imparted to form by the medium used. He may finally return to the kinds of illuminated forms used in the second quarter and carry them further in full color (Plate VI).

Fourth Quarter:
Individual Programs

Pupils will select projects of their own on the basis of what has appealed to them earlier, and each one will undertake to carry through an ambitious work under the careful supervision of the instructor.

It will be clear to any teacher that the course outlined here is made up of known elements and procedures that are always being taken apart and put together in fresh ways by any eager experimenter. If a young teacher started out with a course like this, he would normally end up with a quite different one in a few years, by the mere process of extending one project and substituting another.

The bias in favor of painting is defensible on both sentimental and practical grounds—sentimentally because it ties in with a long tradition in teaching, practically because it is easier to find competent instruction and facilities for painting than for anything else. From the student's standpoint, moreover, there is a good deal to be said for the easily attained fluency

of painting as a means of developing young ideas. In a spirit of compromise it might be suggested that the bias could be mitigated by including three-dimensional work in the third and fourth quarters. The instructor would only have to demonstrate a line of imaginative exploration in wire, metal, wood, and plaster of Paris, in line with the procedures in Chapter Seven, and the sequence would be somewhat modernized—if that is in itself desirable.

**Supplement 6
Alternatives
in College**

Art is described in this book as an intimate experience, and part of its contribution to education is the support it gives to a student's personal notions of value. This is all very well for the secondary school, but when the dictum reaches college, it runs into new resistance among the people who teach it. A college art teacher, particularly a studio teacher, is not usually oriented toward general education; if he came into academic life as a professional artist, he may never have heard of it. Mass production in art is most likely anathema to him, but mass production with a theory of education behind it—and a moral one at that—is certainly something that he never bargained for.

If this is the way a teacher feels about general studies, we ought not to be surprised at a certain disaffection among the students. A student is usually readier to learn from a brilliant specialist, or to study in one of the exciting new fields of art that technology is always making possible, than to linger in the ruck and muddle of a general course. Offer him a chance to make an abstract movie or compositions in moving lights, and you will have a vacant locker in the art studio. There is nothing wrong about this. It would be disastrous to education if colleges were not able to assume a pioneering role in certain phases of cultural life, and disastrous, too, if they could not admit lively students to their experimental courses.

For purely practical reasons, however, a college must limit the enrollment in its specialties and hew to a line of general education if that becomes its policy. A broad course need not be a boring one. If

art teachers need re-educating on this point, they scarcely need it more than teachers in most other departments.

That colleges hire studio teachers directly from professional life, however, is a reminder that the university campus is becoming more and more a center of professional training in art, and this fact alone has a bearing on the character of any undergraduate course. With a professional program in full swing at the graduate level, the department is apt to consider any lower course a poor relation and to leave its organization and its philosophy to the teacher who happens to be in charge of it. If this teacher is not used to the optimism of academic planning, he may be cynical about helping people who do not intend to carry their studio work very far; he shoves what he can into the breach, and his expedients take on a motley variety of forms.

Some of the courses that develop in this manner are calculated to give the student just a taste of creative work, some are organized as design courses and actually lead up to architecture and industrial design; some of them are frankly personality courses and give the students a kind of aesthetic recipe bearing the name of the teacher. Most of them assume that art is a special rather than an ordinary experience and that the interests of the citizen are adequately served by treating him to a sample.

It is obviously useless to look for plausible alternatives in college art among random courses like these. Even general courses that have been carefully planned are usually experimental in their studio phases, although they have a longer record of experience in their critical and historical phases. If we wish to supplement our study of college methods in the studio, we are better advised to look at a well-organized college "major" in art, whose goals are not precisely the same as those of general education but which are not professionally slanted, either, and are well integrated into the undergraduate scheme. The Yale undergraduate courses have been selected for a brief discussion, not because they are typical but because they are care-

fully organized and influential and are based on a concept of education that is certainly unusual in art training.

From 1950 to 1958, the art program at Yale owed its character to the eminent German teacher, Josef Albers, who came to this country on the dissolution of the Bauhaus and finished his career in teaching as Chairman of the Art Department. Although the program is now in other hands and the printed information on which this discussion is based[1] is somewhat outdated, no radical change in plan has yet been announced by the Department, and the Albers ideas in any case are worth discussing on their own merits.

In common with many other German scholars, Albers believed that a long period of analytical experience was necessary before a student assumed the task of creating works of his own. This training he compared with the study of music before a composer writes music, which is a strong comparison, or the study periods required by poetry, philosophy, or history, which are weaker comparisons. A very fundamental basic design course is accordingly offered in the first year at Yale as well as a similar course in basic drawing. In the design course a student is asked to lay aside his notions of any single idiomatic technique and concentrate on the *process* of visual design, in a variety of media. In an equally impersonal manner the drawing student lays aside his idea of line as a boundary of form and studies the qualities of the line itself. The explorations of these two courses are mainly in abstraction, not because Albers "found any quarrel"[2] with representation as such but because he considered it irrelevant to the process involved.

The second year provides a more specific study of problems in painting, sculpture, graphics, or whatever specialty the student has chosen for his major. The program varies somewhat with the individual teacher, but the painting class, working as a unit, might be assigned a quick series of studies in organization, using a common problem, and trying to discover the greatest possible number of solutions around the class. A thorough discussion of these solutions is

an important part of the program. The sculpture student at the same time would be investigating the fundamentals of three-dimensional order, the graphics student the fundamentals of lettering, and so forth.

Up to this point the emphasis is on *analysis* and *process* and not on any finished product; in the third year, however, the student takes up problems of his own, hoping to apply the mechanical experience he has gained and knowing something at least about how art meets the eye. A portion of what he knows at this point might fall to the lot of a general student who has taken one or two of the courses as electives in order to "round out" his knowledge of the humanities.

It is hard to glean anything about the actual operation of a program from its formal announcement, but the point of view governing the work at Yale under Albers is illuminated by a striking and poetic statement at the head of the brochure. We cannot duplicate its form, but its meaning is preserved in the following abbreviation:

To design is to plan and organize, to order, to relate, and to control. . . . It embraces all means of opposing disorder and accident. . . . It signifies a human need, and qualifies men's thinking and doing. . . .
A school of design is not first an opportunity to express one's self. It is an educational area to teach systematically and to learn, step by step—through practical work and through experience, observation, and articulation.

It takes a good deal of temerity to oppose a defense of order like this, but it is reasonably safe to say that if Albers were a teacher of a verbal language instead of a visual one, a similar pronouncement would draw a withering cross fire from his colleagues. A language colleague would reject out of hand the notion that fluency of speech can be acquired by a protracted study of grammar. A language student nowadays is made to talk his language at once and study his grammar when the need of it has been proved to him. His first need of all is to have something to say.

Just what do we organize in an art course? Do we

keep a store of interesting visual experience lying around just waiting to be organized? We can hardly be expected to organize in a vacuum. Unlikely as it may appear, a good many students do arrive in an art class with such a store of ready material: objects and relationships in nature that are precious to them, some of them tangled, of course, with emotional experience and associations supposedly irrelevant to art. In an Albers class, however, this paraphernalia would apparently be laid aside for a year or two while the nature of medium, of color, of space, or of rhythm was explored. This would be rough going for some of them.

In trying to decide where their interests lie, we are forced to consider two opposite kinds of education, the education that amasses skills and the education that cultivates motives. The partisans of motive would say that you can acquire a solid skill only when you have something important to put it into, something important to you as an artist at the moment. They would add that the spark of motive is often extinguished by academic exercises. The partisans of skill would say that the skills needed nowadays are far too numerous to be picked up one at a time on a job and that, in any case, the fundamentals must be learned willy-nilly, as they are learned in music. If the student's motives are not strong enough to survive the learning process, which is a fascinating one under Albers, then he ought not to be in art. It is not clear where this leaves the *general* student.

Probably some combination of the two theories is inevitable in contemporary education. The apprentice system of learning is dead; the course system is evidently with us to stay. The latter need not be divorced from motive, from the student's developing beliefs, or from his creative urge. The two *can* be pursued together.

This does not prevent the battle lines from being drawn between the two camps with deadly precision, as the following anecdote will illustrate. A professional visitor was being shown around a leading art school—not Yale—by one of its administrative officers

who felt constrained to illustrate the point of view of the school. The students, he said, were drilled in the belief that their four-year course was pure practice; what mattered was the ability they acquired, not the product itself. No matter how intricate the job or how painstaking the effort, the value of the product evaporated when it was completed. With that he paused in the exhibition room and in a spirit of sudden bravado brushed an architectural model, put together by a student during weeks of meticulous care, from the top of a display counter to the floor, where it shattered in a thousand pieces. "You see!" he remarked triumphantly, "no one turned around when I did that! They are trained to think that it doesn't matter!" To be delighted at this destruction of effort as well as at his success in eliminating any pride of achievement in his school seemed a very shocking thing to his visitor.

To the partisans of motive there are never enough moments to cultivate the things one believes in and to learn to know them better. Design and order, to them, are dictated by the *quality* of what is being studied, and for some of them this means not the quality of strokes, or rhythms, or colors but of whole objects, real or abstract, that are known and studied separately.

A Japanese artist of this persuasion who places a stork on a dead tree against a moon and a profile of Fujiyama, in a vast and empty composition, is not just being sentimental; according to Albers, no doubt, he is displaying masterly organization. But the organization is actually made inevitable by the artist's understanding of the quality of the objects: the delicate beauty of the stork, the ruggedness of the tree, the mystery of the moon and mountain, and the vastness of the space between. If he succeeds in putting these qualities across at all, it will follow automatically that he organized them instinctively or they would contradict one another. He could scarcely have prepared for this by merely studying the effect of so much orange against so much gray and white and sepia.

The matter of his preparation, however, is one that

will never be settled in an argument. It is logical to believe that the vitality of any composition in two dimensions must be sought in two-dimensional things like lines and patches of color. It is illogical but entirely necessary to some people to seek it in the relationship between things experienced, whose reality and meaning were settled before the picture started. This is why artists occasionally study the parts of a picture separately and why a rigid course in figure drawing was always prescribed for beginning students—to provide a vocabulary of interesting detail.

What have we gained for the general student by presenting these conflicting views on art and education? We have done little but set the scene for him; but this is useful in itself, and perhaps we can remind his teachers what we want for him. The sweeping nature of our wishes may have a sobering effect on their choices of methods.

We want a student's experience in art to make him a reflective person, so far as his nature will permit. We want to put a range of artistic experience before him and let him see where it jibes with an inner experience of his own. We want him particularly to add the dimension of beauty to his thoughts and to know a few of the aspects that beauty wears.

We want him next to affirm the discovery of his resources by using them. This is an ordinary corollary in education. When a person is obliged to make his choices and state his sympathies in a work of his own, he becomes sure of them. We want a student to acquire the *habit* of choosing, in the hope that he will carry it into his later life and by his choices exert an influence on his surroundings. We consider this a part of his real education as we have been describing it.

We want him, naturally, to use his eyes discerningly, to "see things with his mind," but this should have come to him as a habit earlier in the game. The real thing we'd like from a college course, and this might include all the rest, is simply a bit of enthusiasm about a civilized process. This is no more and no less than what we want for other lines of general education, too, but we do think that the final distinctions ought

to be sharp and the courses themselves fresh and vital.

Can we expect such a course in college to become a reality? It will mean a sweeping change in policy in most colleges and a meeting of the minds both inside and outside of the art department. It is conceivable that something like the Albers mystique of organization might play a part in such a program, but hardly in the dogmatic form in which it was recently presented at Yale. We have been assuming at least that art has a broader root base than this, more interest in ordinary individuals, in democratic education.

Notes

1. *Art at Yale,* reprinted from the *Yale Alumni Magazine,* New Haven, April, 1958.
2. Quoted from a conversation with Richard Bassett, 1954.

Supplement 7
Color Harmony
and the Theory
of Percival
Tudor-Hart

According to the Tudor-Hart theory of color, an elaborate formulation worked out in Paris and London in the early part of the century, there is a natural color scale corresponding to the diatonic scale in music. If the spectrum colors yellow, green, blue, violet, red, orange are arranged in a circular diagram in that order and six more intermediaries are placed at halfway points between to form yellow-green, blue-green, blue-violet, red-violet, red-orange, and yellow-orange, we find the "color circle" divided into twelve approximately equal intervals, just as the diatonic scale is divided into twelve half tones. You have only to pick out a succession of eight colors, separated by "whole tones" and "half tones," and you have your scale.

To make such a scale useful, however, and to use combinations as a musician uses chords, you have to mix your colors very exactly; the theory maintains that the normal human eye recognizes the correct intervals, recognizes stopping points in an evenly gradated spectrum where the effect of harmony is greatest, and recognizes the "key" or starting point. If a student wants to experiment with this, it is suggested that he take an oil palette and a flexible painting knife, draw a circle on a white sheet of paper, and place an arbitrary color, say yellow, at some point on the circle. This will be his starting point, the first note of his "octave." He will then try to find by mix-

ture the green that goes best with the yellow, then the blue that goes best with both, and so on with blue-violet, red-violet, red-orange, and yellow-orange, according to the diagram. If he likes his combinations, represented by little dabs of paint on his circle, he can extend their resources by mixing black, white, or gray with any of the colors. The addition of a neutral color is not supposed to destroy the harmony, and it is a distinct advantage to have a range of light and dark as well. In actual practice these mixtures with black and white have to be corrected a little, because the commercial whites have a little yellow in them and the blacks a little brown, which is a dark red-orange.

The effect of the theory, if it is used successfully, is not to remove color combinations from the realm of taste and personal preference but to give the painter a tuned instrument, with whose resources he is familiar.

Percival Tudor-Hart was a Canadian painter and theorist who taught in Paris and London up to about 1925, and whose work on the color theory appeared in issues of the *Cambridge Magazine* during the twenties. C. K. Ogden, famous as coauthor of such books as *Basic English* and *The Meaning of Meaning* was working on a comparative study and statement of the theory at the time of his death.

The Training of Art Teachers

Many different kinds of people are involved in the teaching of fine arts in the schools, as should be apparent from the preceding chapters. In one form or another, *all* teachers teach visual studies, particularly those working with younger children in the elementary schools. The art teacher as a separate person may play only a minor part in the contact that the individual youngster receives with the world of the visual arts. And in addition to teachers generally and art teachers particularly, a strong school will have visiting artists themselves in its classrooms: painters, sculptors, engravers, and the rest. These people are, in a real sense, art teachers, but their roles in the school differ significantly from those of other teachers. Further, strong schools will have various kinds of assistants in their art programs, people who do everything from washing out paint jars to working alongside individual pupils. These people, without doubt, are teachers, but their roles are different again.

Thus when one talks about "art teachers" one hangs up on a problem of definition. The important person for us to know about, however, is the man or woman whose primary job is that of heading up the program of visual studies in a school. This art teacher has a responsibility to assist all teachers—to be a teacher of teachers—in their programs as they relate to his field. He is a person who arranges for and makes most appropriate use of visiting artists. He is the person who hires assistants and develops the program in the fine and visual arts as it relates to the entire curriculum of the school.

The question of how this person is trained is less important than to agree upon those characteristics and capabilities this person should have. First this art teacher must be willing to orchestrate the work of all teachers and visitors and assistants, to be able and eager to be a conductor rather than only a horn player. He must have the peculiar quality of mind that allows him to work well with people and the enthusiasm that

goes with this. Many art programs in many schools have foundered on the isolation of the person who is expected to speak for the visual studies across the school as a whole. It is difficult for the leading art teacher in a school to be an introvert.

More often than not it is desirable for this art teacher to be a producing artist himself, a person with a commitment to some one of the visual media and with a special skill in it. Even if the youngsters of the school are not expected to become practicing artists, there is something subtle and significant that is obtained by the student when he sees his own teacher practicing his preaching. It is easier to see the damage caused by the reverse practice: the teacher preaching a love of high art but never really proving that he loves high art himself, a person insisting on a high standard of performance when there is nothing to indicate that he could perform well himself. The ranks of art teachers include a good many people who turned to teaching before they were ever producers and people who never made a go of selling their work as professional artists. Some of the latter have found a new dedication to art through teaching, but woe unto those who have aroused any suspicion of pretense! The student may not always know what is good in art, but often he has an uncanny way of recognizing what is false.

In spite of the foregoing, the difference between an art teacher and a visiting artist is that the former has interest in and a fair competence in many of the media, not just that one or those few in which he is himself producing. The art teacher should have sufficient skills in painting and sculpture and photography and graphics and the rest to be able to organize instruction in each of these fields and to do it with zest and imagination. This is a tall order, one which many art schools and art departments are not able to meet. The problem of the art teacher is akin to that of his brother in science who must teach general science as well as his own specialty, perhaps physics. A physics major in college thus must have enough background in mathematics, biology, and chemistry to survive as a reason-

able teacher in those subjects. This demand for breadth as well as depth is perhaps the most difficult qualification for the prospective science teacher—and the prospective art teacher—to meet.

Further, it goes without saying that the art teacher must know and love the young. This remark is meant literally; distaste for the fumblings of youth is as quickly apparent to youngsters as is pretension. But it is not enough to desire to help and to love youngsters; love must include the willingness to experiment endlessly for better ways of teaching them and experiment in the best light that scholarship has shed on artistic training. Academics in psychology and the humanities have done significant work in the fields of aesthetics and in artistic upbringing, and while this is uneven in quality, incomplete in detail, or still theoretical, it is work in the front line, and its results must be part of the armament of the teacher. Provocative theories, in fact, are an essential means of developing new programs for youngsters. To remain divorced from them means to be out of the main stream of scholarly thinking about the process of education. Most of the art teachers in this country, remain so divorced, alas! Those in the future must not.

Finally, this art teacher must have the sense of the purposes of the arts in society as a whole that we have been speaking of, must know the place of visual life within a person's entire life. Only in this way can such a teacher constantly test his program for relevance. All youngsters beyond the early grades want to know why they are doing what they are doing, and while many of them potter around happily in the art room simply because it is so different from every other kind of room in the school, the serious ones will want to see some relationship between what they are doing in their visual studies and their lives. It is for this reason that most school art programs need far more emphasis on photography and on various forms of the multiple picture, as these media are the ones extremely close to youngsters in our time. This is not to suggest that the art teacher in his search for "relevance" exclude many of those personal arts

that have been so much the center of the Western tradition; it really is to say that a balance must be obtained for each child or group of children, which is sound in both an artistic sense and the consideration of the place these youngsters will play in the culture.

The qualities outlined here are clearly ones obtained neither solely from the accident of birth nor primarily from pedagogic instruction in a university; they are a combination of both. By and large the study of the art teacher's specialty and of other media must take place within schools and departments of arts. However, his work in the behavioral sciences and humanities and on broad questions of the place of art in society should take place as often as possible in settings where others besides art teachers are at work. Just as war can't be left to the generals, art can't be left to the artists, and the opinions of engineers and philosophers and mathematicians on the place of the arts in society are as important as those of painters, sculptors, and museum directors. In a word the training of the art teacher must not be isolated in either an art school or a pedagogical institution, such as a school of education, or in classroom learning "on the job." The art teacher must be a product of a variety of influences, not the least of which is his own background and his own personal chemistry. The personal qualities required and the training demanded are considerable.

Bibliography

Art in Education

Munro, Thomas, *Art Education, Its Philosophy and Psychology.* New York, The Liberal Arts Press, 1956.

Dewey, John, and others, *Art and Education.* Merion, Pa., Barnes Foundation Press, 2nd ed., 1947.

Read, Herbert, *Education through Art.* London, Faber, Faber, and Faber, 1943; also New York, Pantheon Books, 1948.

Kaufman, Irving, *Art and Education in Contemporary Culture.* New York, The Macmillan Company, 1966.

Conant, Howard, *Art Education.* Washington, D.C., The Center for Applied Research in Education, 1964.

Wickiser, Ralph, *An Introduction to Art Education.* Yonkers-on-Hudson, World Book Co., 1957.

Pearson, Ralph, *The New Art Education.* New York, Harper & Brothers, 1953.

Young, Arthur R., Ed., *This is Art Education* (Yearbooks for 1951 and 1952). Kutztown, Pa., the National Art Education Association.

Ziegfeld, Edwin, Ed., *Education and Art, A Symposium.* Paris, UNESCO, 1953.

The Visual Arts in General Education, by a large committee of authors. New York, D. Appleton-Century Co., 1940.

Logan, Frederick M., *Growth of Art in American Schools.* New York, Harper & Brothers, 1955. A historical account.

The Teaching of Art: General

d'Amico, Victor, *Creative Teaching in Art.* Scranton, Pa., International Textbook Co., 1942.

de Francesco, Italo L., *Art Education, Its Means and End.* New York, Harper & Brothers, 1958.

Lowenfeld, Viktor, *Creative and Mental Growth.* New York, The Macmillan Co., 1952. Criticized by psychologists, this book still makes a claim as a pioneer study in teaching method.

Schaefer-Simmern, H., *The Unfolding of Artistic Activity.* Los Angeles, University of California Press, 1947. An exposition of the Britsch theory of artistic learning.

Winslow, Leon L., *The Integrated School Program.* New York, McGraw-Hill, 1949.

The Teaching of Art: Primary Level

Viola, Wilhelm, *Child Art.* Peoria, Ill., Charles A. Bennett, Inc., 1949.

Gaitskell, Charles and Margaret, *Art Education in the Kindergarten.* Peoria, Ill., Charles A. Bennett, Inc., 1953.

Gaitskell, Charles, and Hurwitz, L., *Children and Their Art.* New York, Harcourt, Brace, & World, rev. ed., 1970.

Bannon, Laura, *Mind Your Child's Art.* New York, Pellegrini and Cudahy, 1952.

McFee, June King, *Preparation for Art.* San Francisco, Wadsworth, 1961. Addressed to the classroom teacher of the primary school.

Sproul, Adelaide, *With a Free Hand.* New York, Reinhold Publishing Corp., 1968.

The Teaching of Art: Secondary Level

Lally, Ann M., *Art Education in the Secondary School.* Washington, D.C., National Art Education Association, 1964. An excellent basic text written in the form of questions and answers.

Winslow, Leon L., *Art in Secondary Education.* New York and London, McGraw-Hill Book Co., 1941.

Reed, Carl, *Early Adolescent Art Education.* Peoria, Ill., Charles A. Bennett Co., 1951.

Gaitskell, Charles D. and Margaret R., *Art Education During Adolescence.* New York, Harcourt, Brace and Co., 1954.

Lanier, Vincent, *Teaching Secondary Art.* Scranton, Pa., International Textbook Co., 1966.

Michael, John A., *Art Education in the Junior High School.* Washington, D.C., National Art Education Association, 1964.

Rice, Norman L. and others, *A High School Curriculum in the Fine Arts for Able Students.* Carnegie Institute of Technology, 1966.

The Teaching of Art: College Level

Ziegfeld, Ernest, *Art in the College Program of General Education.* New York, Bureau of Publication, Teachers' College, 1953.

Ritchie, Andrew C., Ed., *The Visual Arts in Higher Education.* College Art Association of America, 1966.

Art and the Citizen

Read, Herbert, *The Grass Roots of Art.* New York, George Wittenborn, Inc., 1947.

Edman, Irwin, *Arts and the Man.* New York, W. W. Norton and Co., Inc., 1939; library and paperback editions.

Hayes, Bartlett H., and Rathbun, May, *A Layman's Guide to Modern Art.* New York, Oxford University Press, 1948; also in Tartan Books, David McKay Co., New York.

Hayes, Bartlett H., *The Naked Truth.* Andover, Mass., Addison Gallery, 1949.

Ulich, Robert, *The Condition of Civilized Living.* New York, E. P. Dutton & Co., 1946.

Pope, Arthur, *Art, Artist, and Layman.* Cambridge, Mass., Harvard University Press, 1937.

Beam, Philip C., *The Language of Art.* New York, Ronald Press Co., 1958.

Faulkner, Ziegfeld and Hill, *Art To-day.* New York, Henry Holt, 1956.

See also Moholy-Nagy, L., *The New Vision.* New York, Wittenborn, Schultz, Inc., 1947; library and paperback editions.

Panofsky, Erwin, *Meaning in the Visual Arts.* Garden City, N.Y., Doubleday Paperbacks, 1957.

Shahn, Ben, *The Shape of Content.* Cambridge, Mass., Harvard University Press, 1957; also in Vintage Books, Random House.

Giedion, Siegfried, *Space, Time, and Architecture.* Cambridge, Mass., Harvard University Press, 1949.

Kepes, Gyorgy, *The Language of Vision.* Chicago, Ill., P. Theobald, 1944.

_____, *The New Landscape.* Chicago, Ill., P. Theobald, 1961.

_____, Ed., *Structure in Art and Science.* New York, George Braziller, 1965.

_____, Ed., *The Nature of Art and Motion.* New York, George Braziller, 1965.

On Educational Theory Dewey, John, *Democracy and Education.* New York, The Macmillan Company, 1917; also a Free Press paperback.

Whitehead, Alfred North, *Process and Reality.* New York, The Macmillan Company, 1930; also a Free Press paperback.

_____, *The Aims of Education.* New York, New Ameri-

can Library, 1957; also a Free Press paperback.

Jacks, L. P., *The Education of the Whole Man*. London, University of London Press, 1931.

Bruner, Jerome, *The Process of Education*. Cambridge, Mass., Harvard University Press, 1960; also in Vintage Books, Random House.

————, *On Knowing*. Cambridge, Mass., Harvard University Press, 1962; also in Atheneum Publications (paperback).

————, *Toward a Theory of Instruction*. Cambridge, Mass., Harvard University Press, 1966; also a W. W. Norton & Co. paperback.

General Education in a Free Society (The Conant Report). Cambridge, Mass., Harvard University Press, 1945.

Ulich, Robert, *A History of Educational Thought*. New York, American Book Company, 1945.

————, *Three Thousand Years of Educational Wisdom*. Cambridge, Mass., Harvard University Press, 1950. Passages selected from many authors.

On Aesthetic
Theory

Ogden, C. K., Richards, I. A., and Wood, James, *The Foundations of Aesthetics*. New York, International Publishers, 1931. Important for its comparison of the various types of aesthetic theory, all of which, the authors assume, have their own validity.

Works
Written from
a Single Position

Croce, Benedetto, *Aesthetic as a Science of Expression and General Linguistic*. Tr. by D. Ainslie, New York, Noonday Press, 1953.

————, *Guide to Aesthetics*. Tr. by P. Romanell, Liberal Arts Press, Bobbs-Merrill, 1965.

Dewey, John, *Art as Experience*. New York, Minton, Balch, 1934; also in Capricorn Books, (Putnam's).

Tolstoi, L. N., *What is Art*? Tr. by Aylmer Maude, London, H. Milford, Oxford University Press, 1938; also a Liberal Arts Press paperback, Bobbs-Merrill.

Bosanquet, B., *A History of Aesthetic*. London, G. Allen and Unwin, Ltd., 1922.

————, *Three Lectures on Aesthetics*, Ed. by R. G. Ross, Liberal Arts Press, Bobbs-Merrill, 1963.

Focillon, Henri, *The Life of Forms in Art*. Tr. by Hogan and Kubler, New Haven, Yale University Press, 1942; also in paperback, George Wittenborn Inc., New York.

Malraux, André, *The Psychology of Art.* Tr by Stuart Gilbert, 3 vols. Geneva, Albert Skira, 1949–1950.

Less Comprehensive Works

Fry, Roger, *Vision and Design.* New York, Coward, McCann, 1924 or London, Peter Smith, 1947; also in Meridian Books, World Publishing Co.

Langer, Susanne, *Feeling and Form.* New York, Charles Scribner's Sons, 1953; library and paperback editions.

On Art as a Process

Arnheim, Rudolf, *Art and Visual Perception.* Berkeley and Los Angeles, California, University of California Press, 1960; library and paperback editions.

Greene, William Chace, *The Choices of Criticism.* Cambridge, Mass., The M.I.T. Press, 1965.

The History of Art

Robb and Garrison, *Art in the Western World.* New York, Harper & Brothers, rev. ed., 1965.

Gombrich, E. H. J., *The Story of Art.* New York, Phaidon Publishers, 1962; library edition and paperback.

Gardner, Helen, *Art Through the Ages.* Reworked under the editorship of Sumner M. Crosby by the Department of the History of Art, Yale University, New York, Harcourt, Brace, 1959.

Janson, Holst W., *History of Art.* Englewood Cliffs, N.J., Prentice-Hall, 1962.

Larkin, Oliver W., *Art and Life in America.* New York, Rinehart, 1949.

On Artistic Blight

Blake, Peter, *God's Own Junkyard* (the planned deterioration of America's landscape). New York, Holt, Rinehart, and Winston, 1964.

Kouwenhoven, John, *The Beer Can by the Highway.* Garden City, N.Y., Doubleday and Co., 1961.

Tunnard, Christopher, and Pushkarev, Boris, *Man-Made America: Chaos or Control?* New Haven, Conn., Yale University Press, 1963.

Index